SAN DIEGO
THEN & NOW

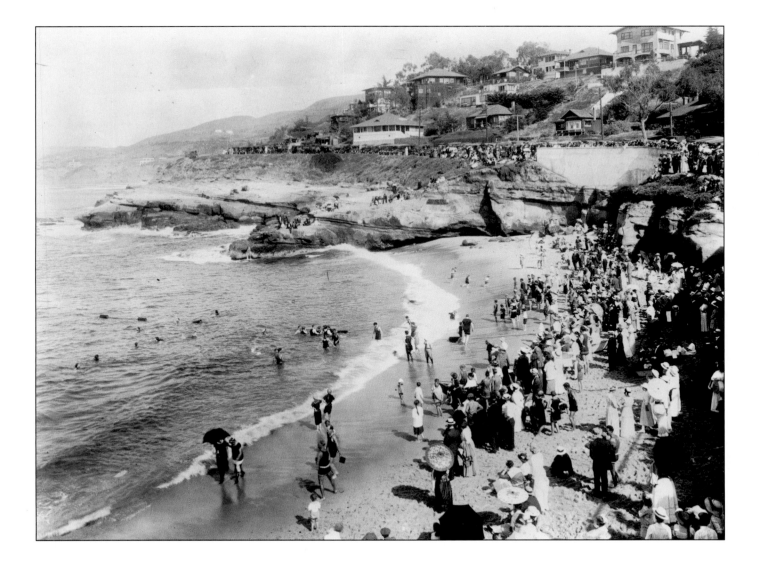

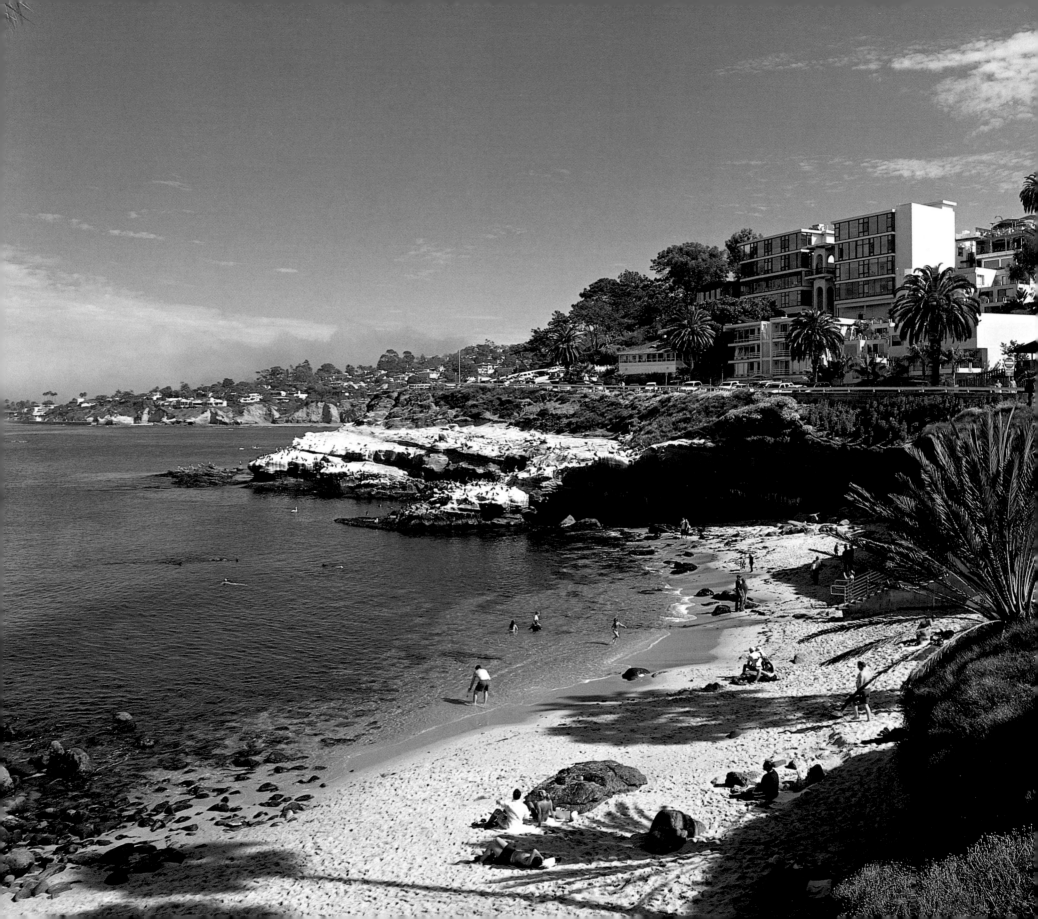

SAN DIEGO
THEN & NOW

NANCY HENDRICKSON

THUNDER BAY
P·R·E·S·S

San Diego, California

Thunder Bay Press
An imprint of the Advantage Publishers Group
5880 Oberlin Drive, San Diego, CA 92121-4794
www.thunderbaybooks.com

Produced by PRC Publishing,
151 Freston Road, London W10 6TH, U.K.
An imprint of Anova Book Company Limited

ISBN-13: 978-1-59223-126-3
ISBN-10: 1-59223-126-8

Library of Congress Cataloging-in-Publication Data

Hendrickson, Nancy, 1947 Feb. 9-
 San Diego then & now/ Nancy Hendrickson.
 p. cm.
 ISBN 1-59223-126-8
 1. San Diego (Calif.)–Pictorial works. 2. San Diego (Calif.)–History–Pictorial works.
 I. Title: San Diego then and now. II. Title.

F869.S22H46 2003
979.4'985'00222--dc22
 2003059730

Printed in China

3 4 5 6 7 10 09 08 07 06

ACKNOWLEDGMENTS

The publisher wishes to thank the following for kindly supplying the images in this book:

"Then" Photographs:
All "then" photography was kindly supplied by the San Diego Historical Society Photograph Collection (www.sandiegohistory.org). Negative numbers are detailed after each page, as follows:

Pages 1 (4309), 6 (1447), 8 (#80:4626), 10 (931), 12 (5537), 14 (198), 15 (3742), 18 (11764), 20 (792), 22 (#803), 24 (#455), 26 (#483), 28 (#80:9147), 30 (6560), 32 (#1681), 34 (UT8241-1174), 36 (#88:16523), 38 (310), 40 (#15342), 42 (1211), 44 (#3219), 46 (209), 48 (195), 50 (#79 SDHS 632), 52 (#1877), 54 (#21675), 56 (#84:15121), 58 (#1366), 60 (main) (#764), 60 (inset) (18223-8-A), 62 (#2562), 64 (99), 66 (98:19751), 68 (82:12997), 70 (10907), 72 (91:18564 2770), 74 (Sensor 5-273), 76 (3723-1), 78 (#7788), 80 (7885-B), 82 (429), 84 (13426), 86 (#3904), 88 (888), 90 (#3875-A), 92 (13947), 94 (1409), 96 (#2600-3), 98 (Sensor 5-196), 100 (80:6906), 102 (99:19920-1), 104 (UT6353), 106 (#91:18564-1809), 110 (4119), 112 (18238-4-2), 114 (12091), 116 (86:15782), 118 (80:4855), 120 (8875), 122 (13346), 124 (4309), 126 (17859-A), 128 (80:5905), 132 (90:18110), 134 (80:5229), 136 (1711), 138 (1086), 140 (14176), and 142 (4306).

The photograph on page 130 (main) was supplied courtesy of © Underwood & Underwood/CORBIS; and on page 130 (insert) courtesy of © Malcolm Lubliner/CORBIS.

The photograph on page 108 was supplied courtesy of the Library of Congress (Pan 6A27739).

"Now" Photographs:
Thanks to David Watts for taking all the "now" photography in this book (© Anova Image Library), with the exception of those listed below.
All inquiries regarding images should be referred to Anova Image Library.

Page 129 courtesy of David Cortner. Page 129 (insert) courtesy © Jan Butchofsky-Houser/CORBIS. Page 137 courtesy of James Helbock. Page 111 (insert) courtesy of © Richard Cummins/CORBIS.

Pages 1 and 2 show: La Jolla Cove, c. 1912 (photo: San Diego Historical Society Photograph Collection), and as it looks today (photo: David Watts/© Anova Image Library); see pages 124 and 125 for further details.

For front and back cover acknowledgments please see jacket.

INTRODUCTION

San Diego's history is as diverse as its landscape. Dubbed "America's Finest City," the area was originally settled by San Dieguito and Kumeyaay Indians. In the mid-sixteenth century, Juan Rodriguez Cabrillo anchored his flagship, *San Salvador*, off Point Loma and named the bay San Miguel, claiming it for Spain. Cabrillo didn't linger though, and it was another sixty years before another Spanish sailor, Sebastián Vizcaíno, returned to the sleepy Indian village. Arriving there in 1602, on the feast day of San Diego de Alcala, Vizcaíno renamed the village San Diego. After his brief stay, San Diego went virtually unnoticed for 167 years.

In 1769, a Franciscan priest named Junipero Serra came north from Mexico with a military force to establish a string of missions. San Diego was the first of the Alta (Northern) California missions and the beginning of a major Spanish settlement. Serra later wrote about San Diego, "It is beautiful to behold and does not belie its reputation." When Mexico declared independence in 1821, the town came under Mexican rule. But Mexico's domination was short-lived, and in 1847 San Diego became an American possession.

Becoming part of America did nothing to boost settlement in San Diego. In fact, the city's population dropped by nearly half following the Civil War. However, all that changed when a wealthy merchant named Alonzo Horton came to town in 1867. Horton bought 960 acres of what is now the heart of downtown San Diego and set up an office in San Francisco, selling San Diego lots as the city of the future.

For the next twenty years, San Diego went through a boom-and-bust economy. Land sales skyrocketed and then crashed as the main railroad line was established north in Los Angeles. It would take the Panama-California Exposition to bring San Diego into the national spotlight. The expo was held in 1915 to celebrate the completion of the Panama Canal and took place in Balboa Park, a 1,400-acre "urban jewel" with gardens, shaded patios, a botanical building, and a lily pond.

On opening day, more than 40,000 visitors surged through the gates and marveled at the colorful tropical plants and warm Spanish architecture. The expo also introduced San Diego to an important partner—the military. Not long after the expo, the U.S. Army purchased the land where Miramar Marine Air Station now stands. At about the same time, the navy became interested in the harbor, and pioneer aviators like Glenn Curtiss came to test planes in the mild year-round climate. From then on, San Diego's future was assured.

Beginning in the 1920s and 1930s, San Diego became a tourist mecca.

With its ideal climate (an average temperature of 71 degrees in the summer), miles of gorgeous coastline, and the famous San Diego Zoo, the city became a favorite vacation spot. Hollywood filmmakers used San Diego, La Jolla, and La Mesa for hundreds of movies. The climate also attracted the fledgling aircraft industry: Charles Lindbergh came to town in 1927 and chose San Diego's Ryan Aeronautical to build his *Spirit of St. Louis*, and in later years, Convair and General Dynamics became major defense contractors.

San Diego experienced a major boom during World War II, when the military presence expanded to Camp Pendleton, the Naval Training Center, the Marine Corps Recruit Depot, and Miramar Naval Air Station. Thousands of marines and sailors went through San Diego on their way to Pacific stations, and many returned after the war to make San Diego their home.

As suburbs sprang up to the east and north, businesses left the downtown area and old Victorian palaces faded into disrepair or were razed for apartment complexes. San Diegans made an all-out effort to turn the historic downtown district into an area where tourists could enjoy dozens of eateries, nightclubs, and stores. The historic Gaslamp Quarter, located within walking distance of the San Diego Convention Center, is now the liveliest spot in the city. On almost any night of the week, visitors can hear music spilling out onto the sidewalks or catch a horse-drawn carriage for a ride to Seaport Village or the harbor.

Old Town, the area of original Spanish and Mexican settlement, was also renovated. Built around a plaza, Old Town hosts hundreds of thousands of visitors annually and features several original buildings from early California. Both tourists and locals flock to the area for some of San Diego's finest Mexican cuisine.

San Diego's architecture reflects the city's diverse heritage and can be seen throughout the sprawling neighborhoods. Styles range from Queen Anne Victorians in Hillcrest to traditional stuccos in Kensington, from the ornate Spanish Colonial architecture of the buildings in Balboa Park to the cozy cottages of North Park. Even the World War II navy and marine facilities adopted a Spanish style that blended easily into San Diego's Mediterranean-like ambience.

Although San Diego is the nation's seventh largest city, it retains its small-town character. The people are friendly, the climate welcoming, and the natural ocean setting one of the Pacific Coast's most stunning. Welcome to San Diego, then and now.

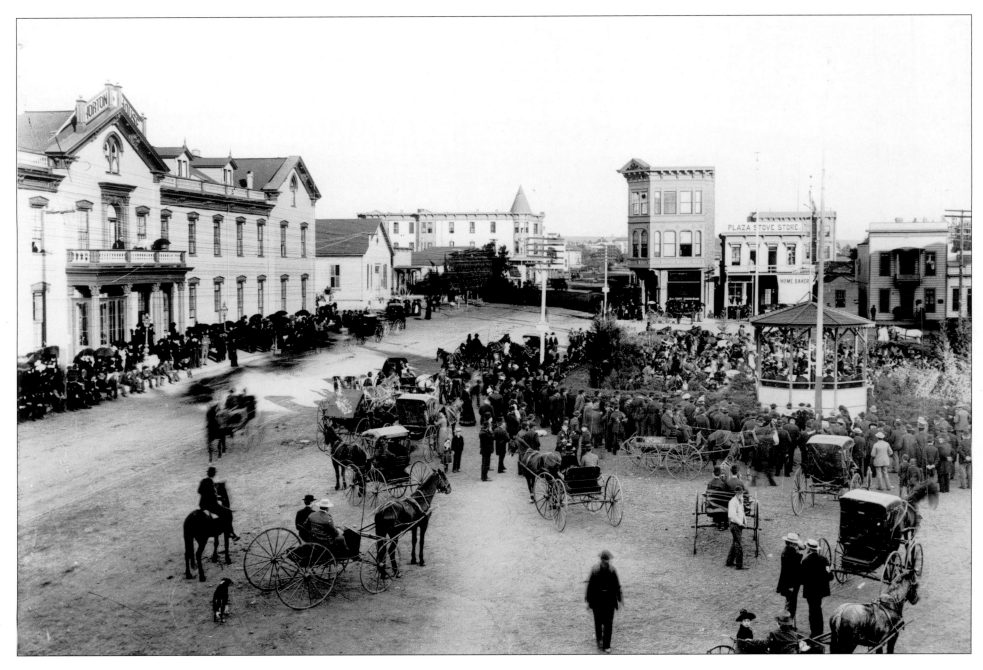

From the days of this 1885 photo to the present, Horton Plaza has been a central gathering place for San Diegans. Designed in 1871 by Alonzo Horton, it was originally known as the Horton House Plaza. Kate Sessions, the city's pioneering horticulturist, planted palm trees on the plaza. It was here that early San Diegans gathered to exchange local gossip and listen to political candidates. Horton originally purchased 960 acres for $264 in 1867, with plans to open the finest hotel south of San Francisco. However, Horton ran out of money for his hotel project and had to resort to trading lots to pay the laborers. Horton House eventually opened in 1870 and was to last just thirty-five years before its demolition in 1905.

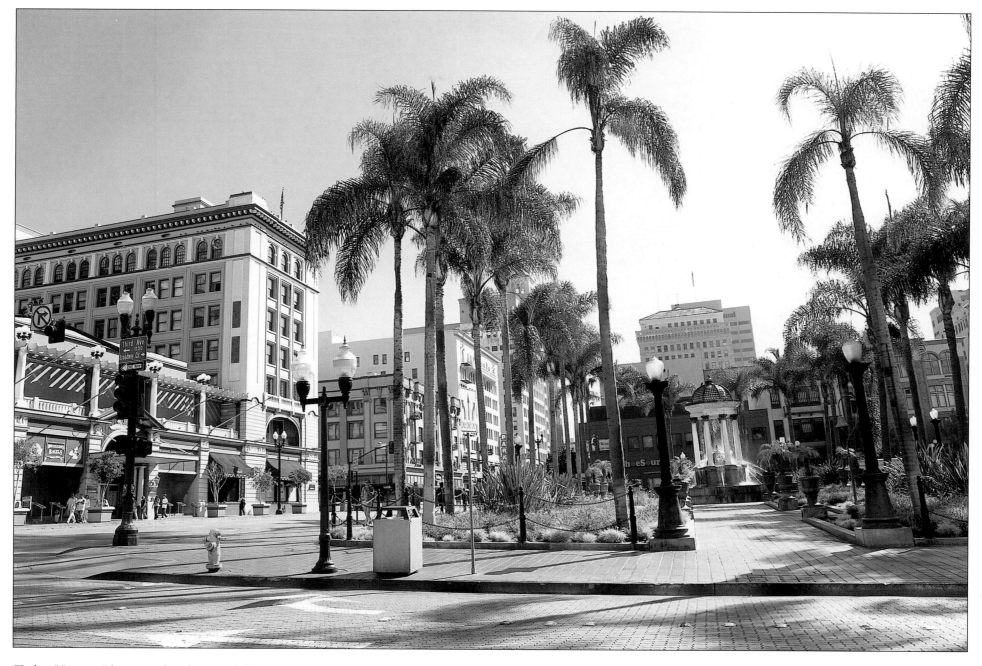

Today Horton Plaza is as bustling and thriving a location as it appears in the 1885 photograph, though the years in between have seen a checkered history of boom and bust. In the 1950s and 1960s, it had become seriously shabby and needed the intervention of Mayor Wilson in the early 1970s to drive forward a ten-year redevelopment plan that finally restored the plaza to its original glory. The fountain at its heart was designed by well-established San Diego architect Irving J. Gill (who studied in Chicago with Frank Lloyd Wright) and constructed in 1910. It is believed to be the first successful attempt to combine colored lighting with flowing water. These days horse-drawn transport is still available in the plaza but now it carries tourists between Seaport Village and the steps of the San Diego Repertory Theatre.

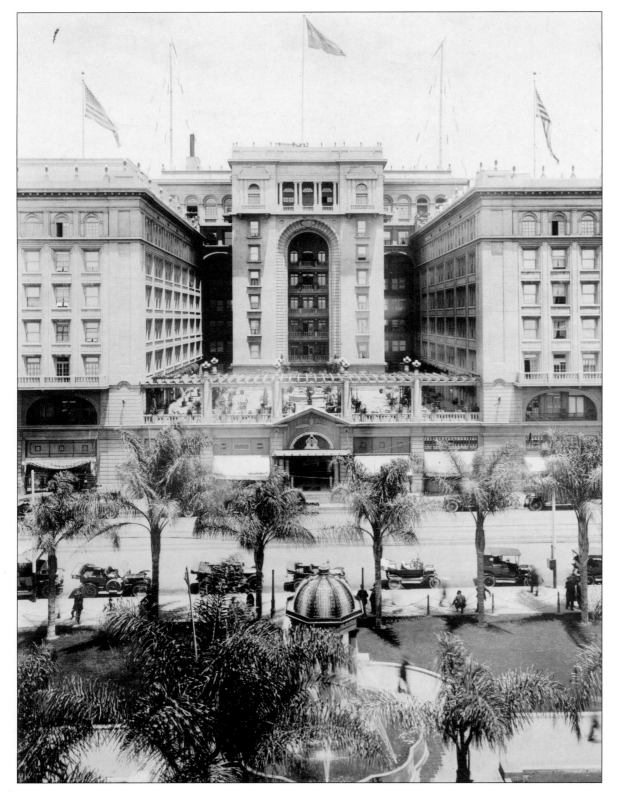

Ulysses S. Grant Jr. built the U.S. Grant Hotel to honor the memory of his father, the eighteenth president of the United States. Grant came to San Diego when ill health forced him to seek a milder climate. He bought the Horton House hotel with the intention of ripping it down and erecting a new hotel, with his father's portrait hanging in place of honor in the lobby. Instead, he decided he would manage the old place for a short period while accumulating the royalties from his father's memoirs. By 1905 the grand plan was ready, and somehow he managed to enlist the help of Alonzo Horton in a ceremony to remove the first brick. The 1906 earthquake delayed the project, but by 1910 the U.S. Grant was open.

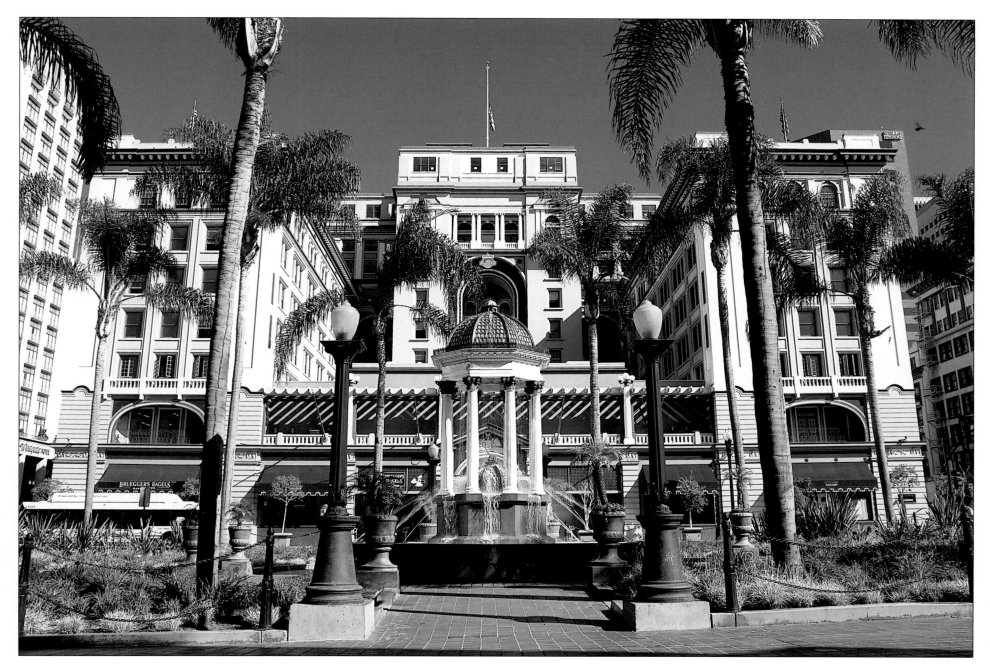

Thanks to a multi-million-dollar renovation, the hotel's 280 rooms have been returned to their original turn-of-the-century elegance. Soon after its opening the hotel was mocked as being a white elephant and too large for San Diego, much as Horton had been mocked before Grant. The Grant Grill restaurant has an interesting history itself, commemorated by a brass plaque at the door. The room admitted only men before 3 P.M. until 1969 when a group of lawyers booked a table under the name of Sydney. When the group arrived, restaurant staff realized that Sydney was one of the firm's female partners.

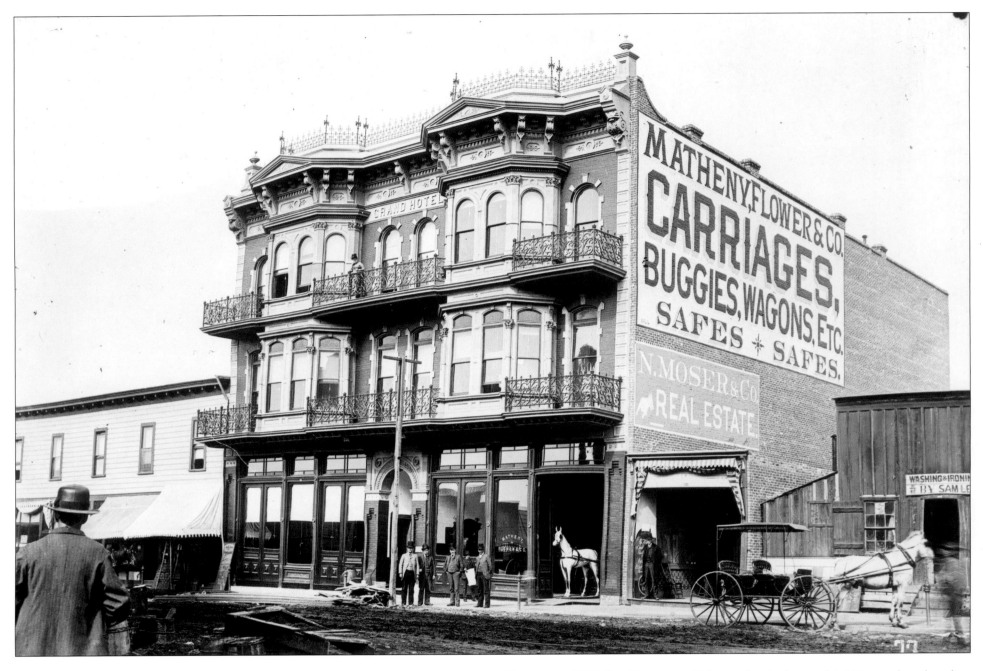

Visitors to 1888 San Diego could have checked into this F Street hotel and been within walking distance of the courthouse, Horton Plaza, and most of downtown's commerce. Or, for those seeking a little adventure, a quick turn south would take them into the bars and bordellos of the Stingaree. The Salvation Army band gave its first concert at the corner of the plaza on March 31, 1888. Spectators vented their displeasure at the quality of the music by jeering and tossing rocks.

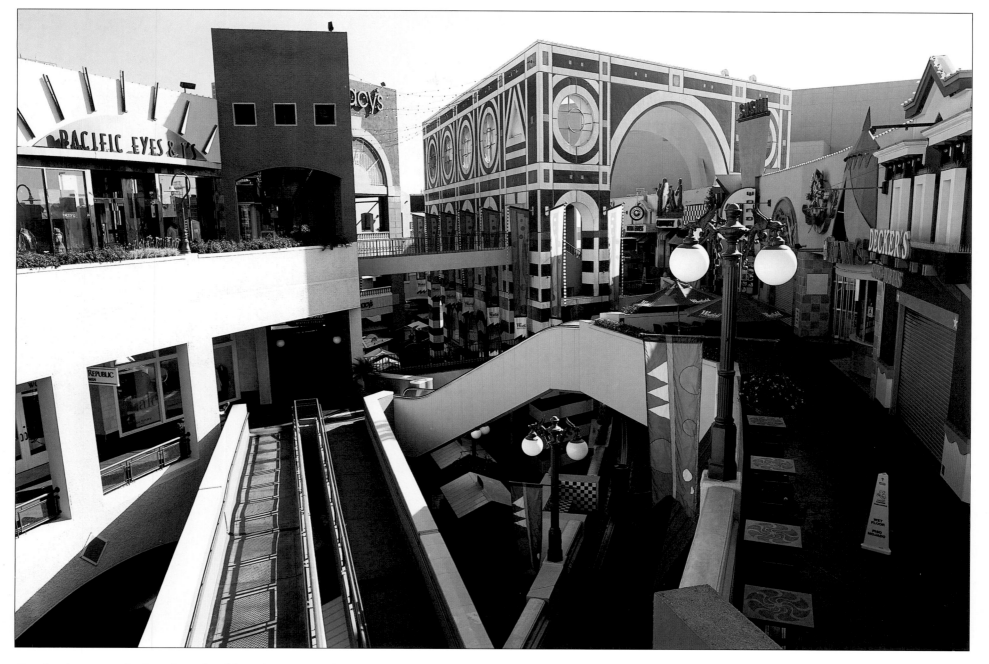

On this location, the hotels and stables of yesteryear have given way to San Diego's most colorful shopping area—the Horton Plaza mall. The mall has seven levels that twist through six city blocks, with 140 stores and restaurants. Visitors will find an almost circuslike atmosphere here, with overhead twinkling lights, bold colors, and a maze of walkways that only the most practiced shoppers can pick their way through.

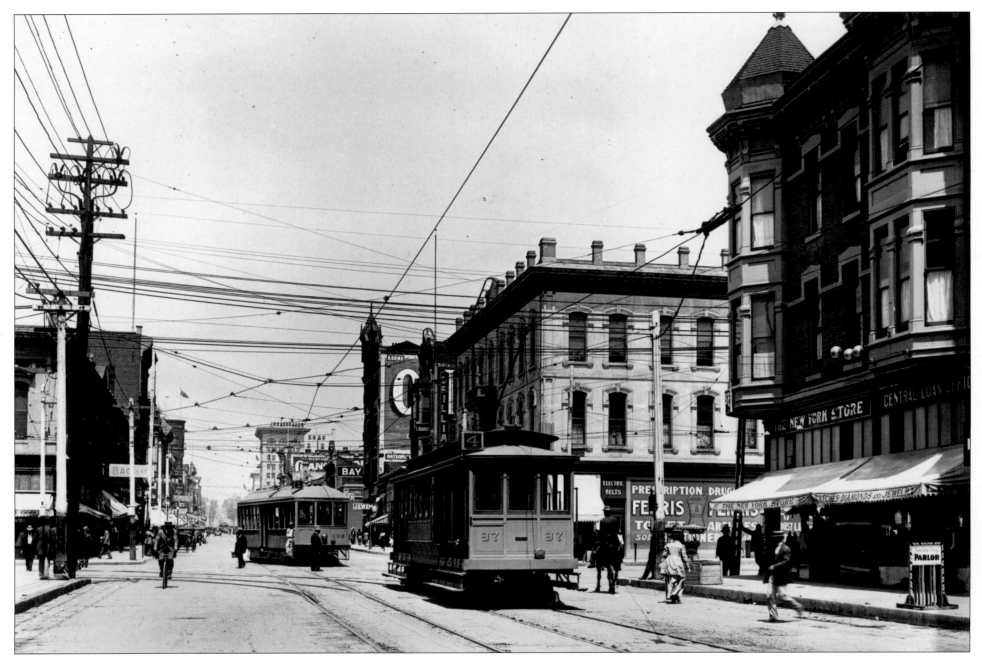

San Diego's infamous Stingaree District—so called because the sting of the district could be as bad as the sting of the stingrays in Mission Bay—was located south of Market Street and consisted of opium dens, gambling halls, and bawdy houses. The building of the railroad brought a large number of Chinese to the area, and several opened stores here. Ah Quin, who lived in the Stingaree, was a leader of the Chinese community as well as a labor broker for the California Southern Railroad. Because Quin encouraged Asian assimilation into American culture, San Diego does not have a noteworthy Chinatown. One of the Stingaree's best-known inhabitants was Wyatt Earp. Earp came to San Diego after his stint in Tombstone and invested heavily in San Diego real estate. At one time he owned or leased four saloons and gambling halls, the most famous being the Oyster Bar on Fifth Avenue.

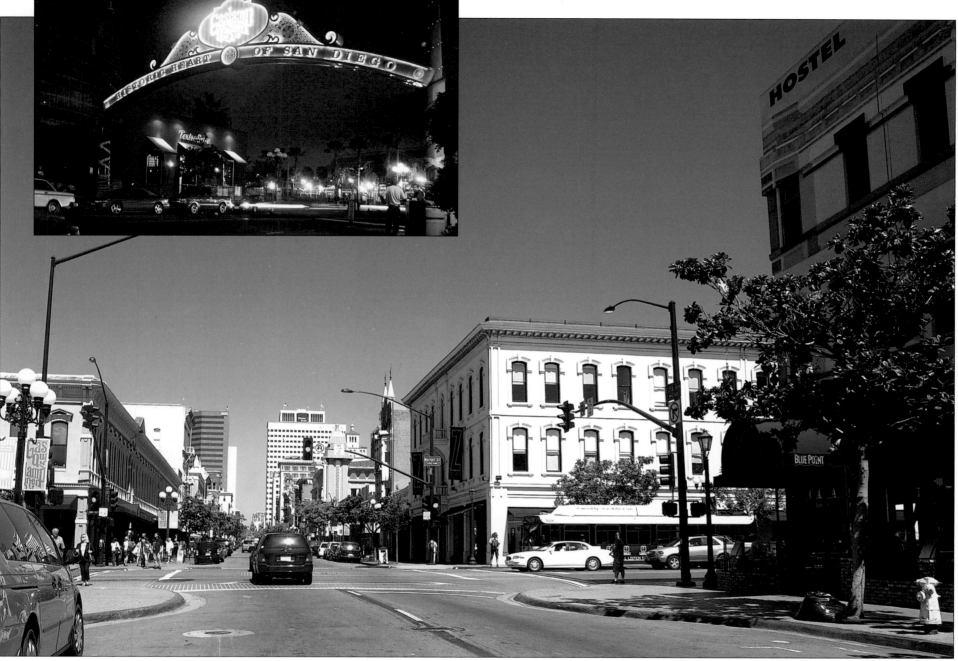

Today both the streetcars and the streetwalkers have departed. The siting of large numbers of service personnel (army, navy, and marines) in and around San Diego has proved a blessing for the economy in times of economic depression, but they have also brought problems. San Diego was a liberty port, and sailors with shore leave had pretty narrow ideas on what they wanted in terms of recreation. In 1974 the Gaslamp Quarter Association was formed to protect San Diego's historic district, and by 1976 the city had adopted a development manual to preserve historic structures while still allowing businesses to develop. Enough of the early architecture was preserved for the Gaslamp Quarter to receive recognition as a historic district under the National Register of Historic Places.

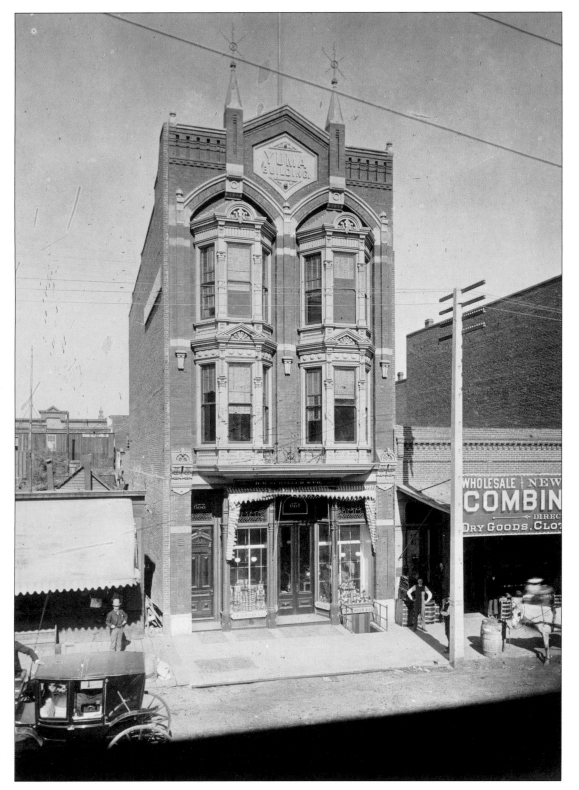

Located at 631 Fifth Avenue, the Yuma Building is in the heart of the Gaslamp Quarter. The Yuma was originally built for Captain Jack Wilcox, a steamboat captain whose company operated ships on the Colorado River, as well as to Baja California and San Francisco. When opened, the upper floors were used as a hotel and the ground floor for commercial enterprises. Wilcox, who married Maria Antonia Arguello of a prominent local family, first came to San Diego in 1849 as captain of the USS *Invincible*. He named the building to honor his Arizona business connections. During a period of San Diego history when the city was cleaning up the red light district, the Yuma was the first hotel to be closed.

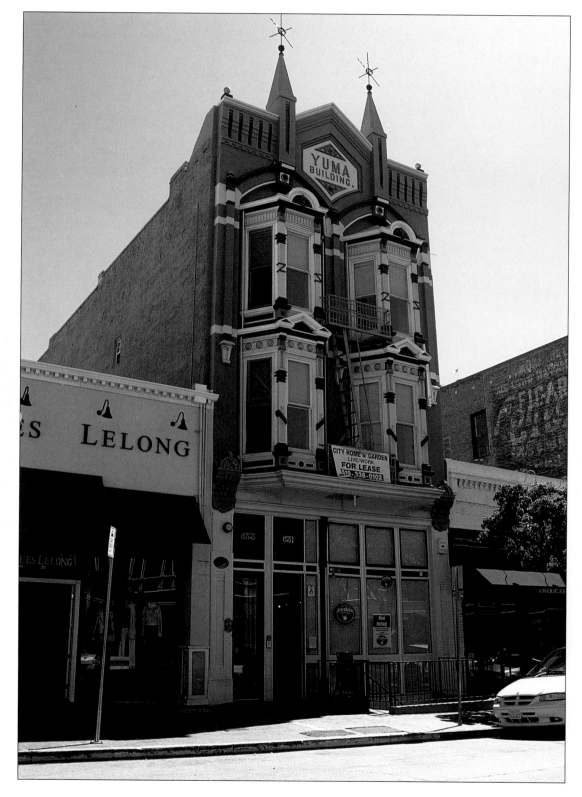

The Yuma Building is now one of the many stopping-off points on walking tours of the Gaslamp Quarter. Today the top two floors house residents, with a shop at street level. When current owners Marsha Sewell-Shea and her husband bought the Yuma in 1991, there were few restaurants in the Gaslamp, and despite Mayor Wilson's plan to preserve the buildings of historic interest in the area, it was still the hangout of prostitutes and drug dealers. In hardly more than a decade, Fifth Avenue has become a magnet for restaurateurs, and the area attracts a great variety of retailers, with transactions taking place in the store, not on the sidewalk.

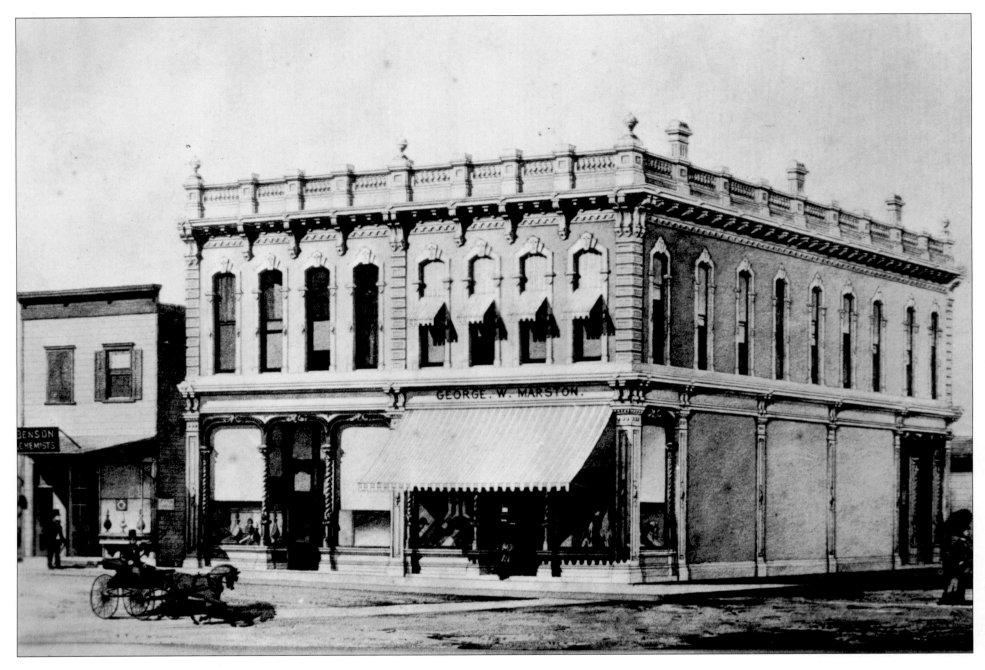

George White Marston was a pioneer merchant and one of San Diego's great benefactors. Born in Wisconsin, he came to San Diego in 1870, where he first worked as a clerk at the Horton House. Six months later, Marston went to work in a general merchandise store and eventually went on to open the Marston Company, San Diego's leading department store. The building in this 1878 picture was Marston's third store and was built in the Italianate-Victorian style, characterized by different-style windows on each floor.

Although Marston lost both of his bids to become mayor, he was a member of the city council, served on the first board of trustees of the library, and was instrumental in the founding of the YMCA in San Diego. Marston's 1917 mayoral race was known for its "Smokestacks vs. Geraniums" politics, with Marston on the urban planning and civic beauty side of the debate and his opponent favoring unchecked growth.

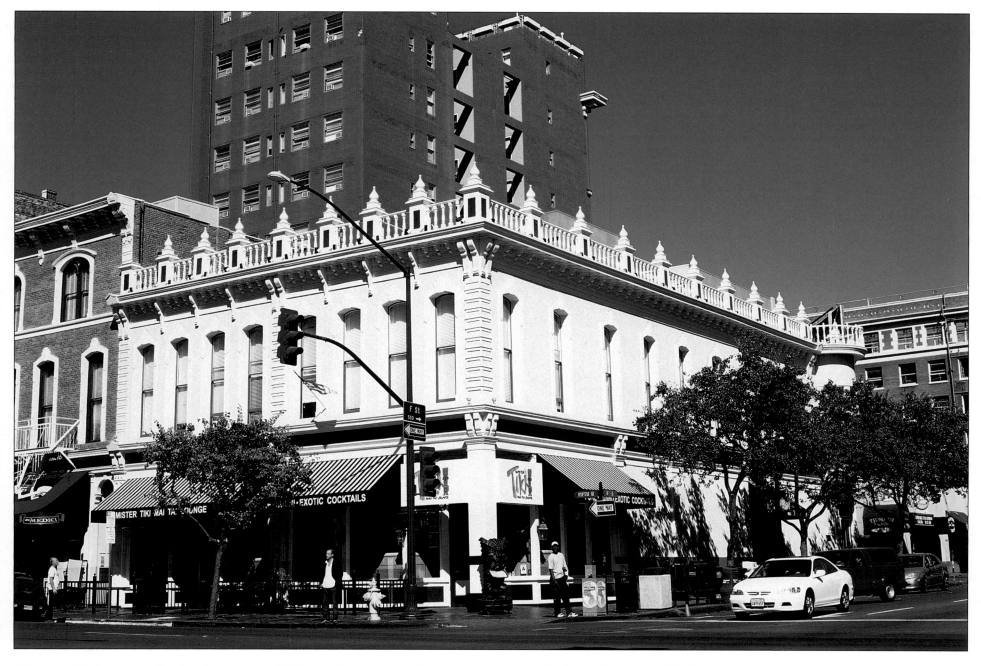

Marston didn't stay confined to his store on Fifth and F streets very long. By 1896 he'd opened his fourth store at the corner of Fifth and C streets—what was San Diego's first proper department store—and from there he moved to his last and largest store, located on C Street between Fifth and Sixth, in 1912. His third store no longer purveys dry goods to the people of San Diego; instead it hosts the Mister Tiki Mai Tai Lounge, serving Mister Tiki's Canoe of "grass-skirt" shrimp and a variety of Polynesian-themed cocktails—something that would have been heavily frowned upon by the members of the Prohibition Temperance Union, which held its meetings in the building in the late 1880s.

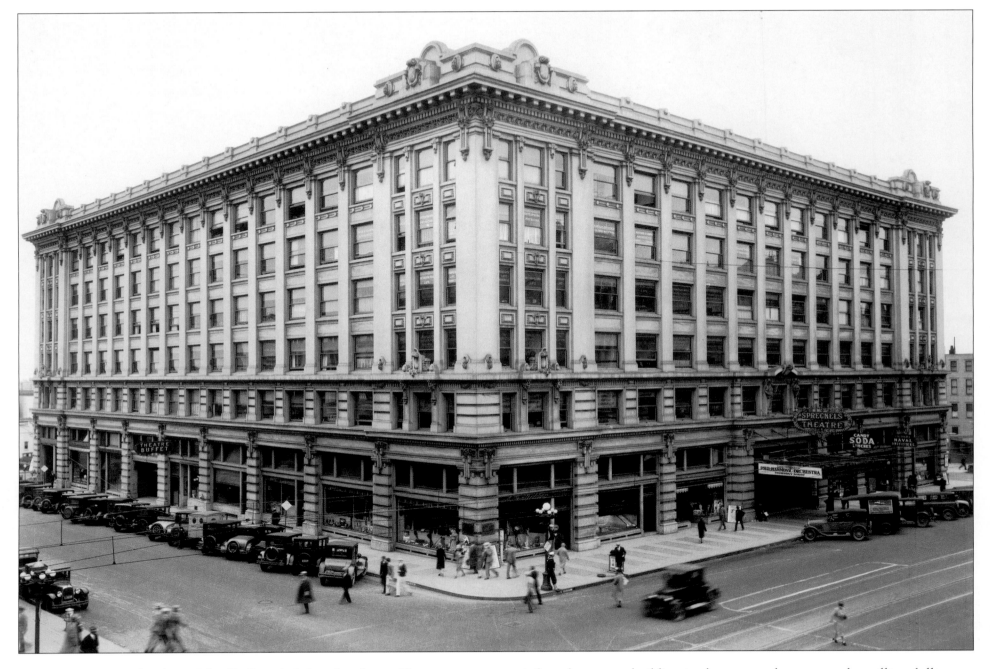

In 1912 San Diego developer John D. Spreckels hired architect Harrison Albright to build a theater to promote local art. At the time, only a handful of small theaters were in existence, available mainly to San Diego's elite. This theater was designed to have the finest acoustics possible and seating for 1,915 people, with the stage being the largest west of New York City. Built just after the San Francisco earthquake of 1906, the building was said to be both earthquake- and fireproof. The six-story structure was the largest

reinforced concrete building in the state and cost around a million dollars. When Spreckels, heir to a Hawaiian sugar fortune, first came to San Diego, he purchased eight full blocks of downtown San Diego on the south side of Broadway, the utility company, the streetcar system, and the water company. At various times the multimillionaire also owned the *San Diego Union-Tribune* newspaper, the San Diego–Coronado Ferry System, the Hotel del Coronado, and Belmont Park in Mission Bay.

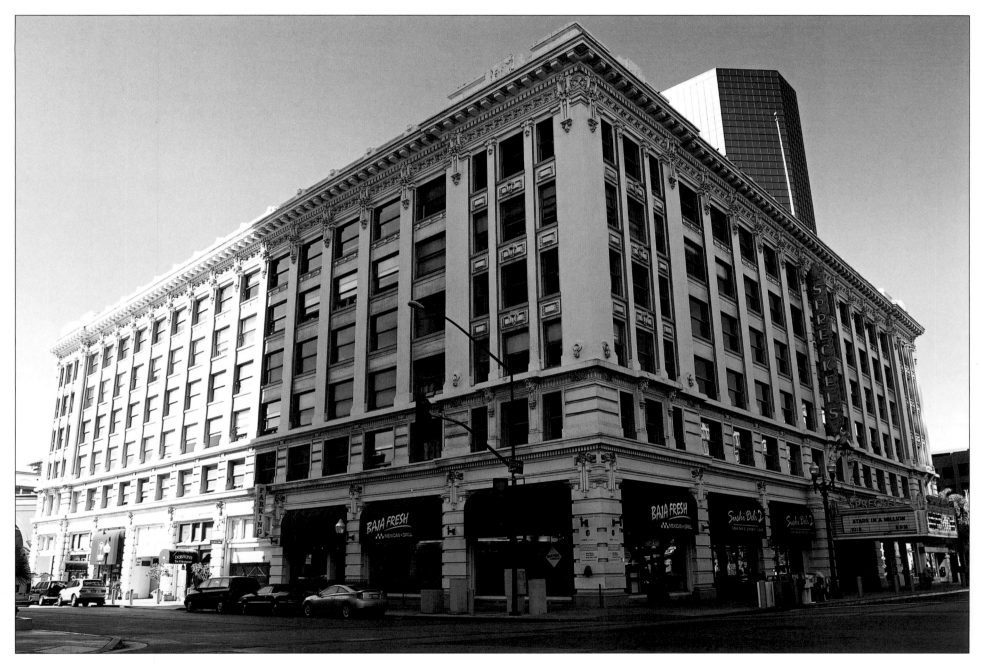

Today the Spreckels Theatre has escaped the fate of many smaller venues, and eluded redevelopment. In 1922 it was converted to film use and the number of seats was pruned from the original capacity. In the 1970s it was transformed back to live shows, which benefited from the good acoustics of the auditorium. The City Ballet holds its spring and fall shows here and it is often the venue for Mozart concerts.

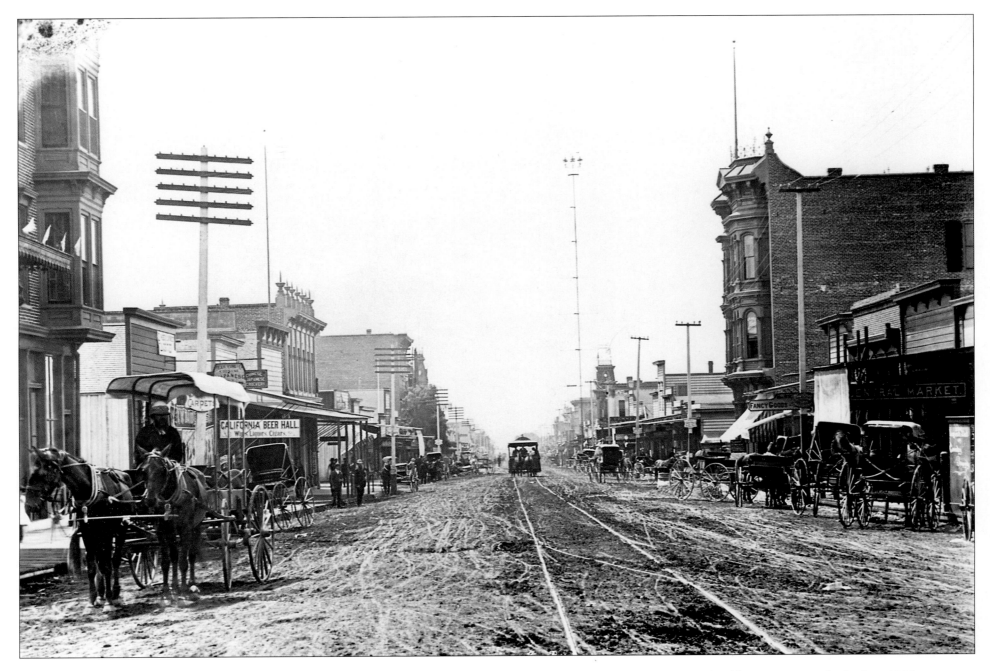

The intersection of Broadway and Fifth Avenue as it looked in 1888, complete with a horse-drawn streetcar approaching in the middle distance. Horse-drawn streetcars were operated by the San Diego Street Car Company for just five years between 1886 and 1891 when the company was acquired by the San Diego Electric Railway, which began the process of unifying a number of small, independent bus and streetcar lines. Once electrified, the prospect of crossing the street in San Diego became a far less messy business.

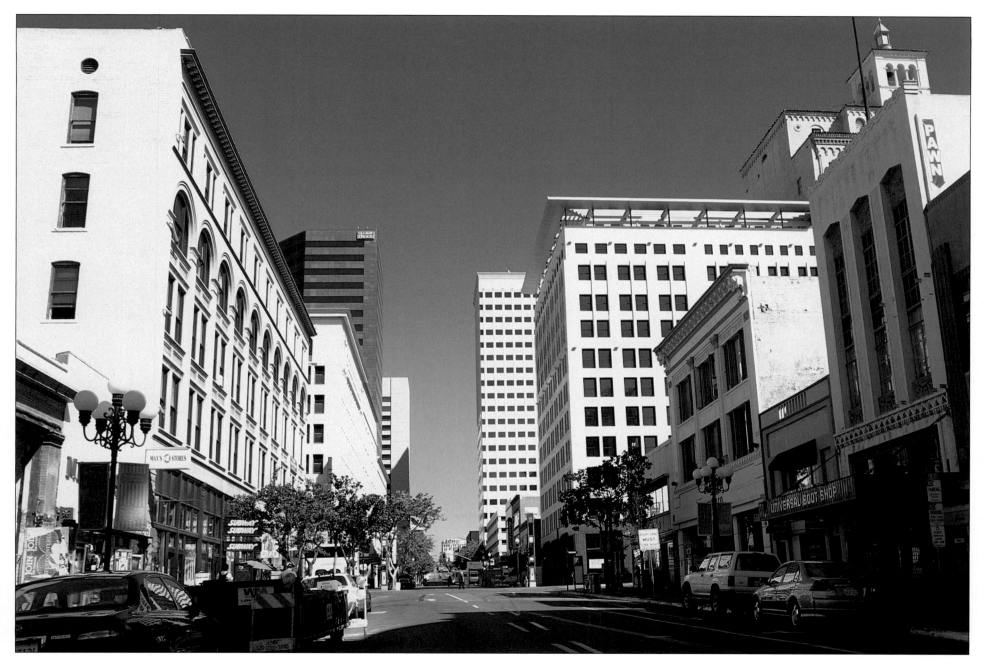

Today developers are attempting to re-create San Diego's downtown as a place to live as well as a place to work and dine out. One of the targets for redevelopment was the former First National Bank Building at Fifth and Broadway, San Diego's first office high-rise. The twelve-story structure—constructed in 1909 as an eleven-story building—has now been converted into the Broadway Lofts, comprising eighty-four loft units and 16,000 square feet of retail space. However, the Broadway Lofts are small in comparison to Bosa Development's forty-four-story residential tower with 243 units, intended for the southwest corner of Broadway and Kettner Boulevard. Construction on the project began in 2004 and, when completed, will incorporate the historic SDG&E Station B power plant building at its base.

The San Diego Electric Railway company, owned by John D. Spreckels, enabled land speculators to sell lots further and further out of town, because without a transit system a neighborhood was unlikely to be developed. After the horse-drawn system was converted to electric operation, it ran routes through downtown San Diego and into nearby neighborhoods using single-decked vehicles. The electric streetcars can be seen in this 1903 photo taken at Broadway and Fifth Avenue. Though short-lived, San Diego, like San Francisco, had its own cable-car system. The line ran from the foot of Sixth Street up to C, over to Fourth, out to University, and from there out to Mission Cliff Gardens. It opened on June 7, 1890, and the first paying passenger was the horticulturalist Kate Sessions. The cable company went into receivership in early 1892 and the last cable cars ran in October that year. The system lay idle until 1896, when the route was converted to electric-powered streetcars.

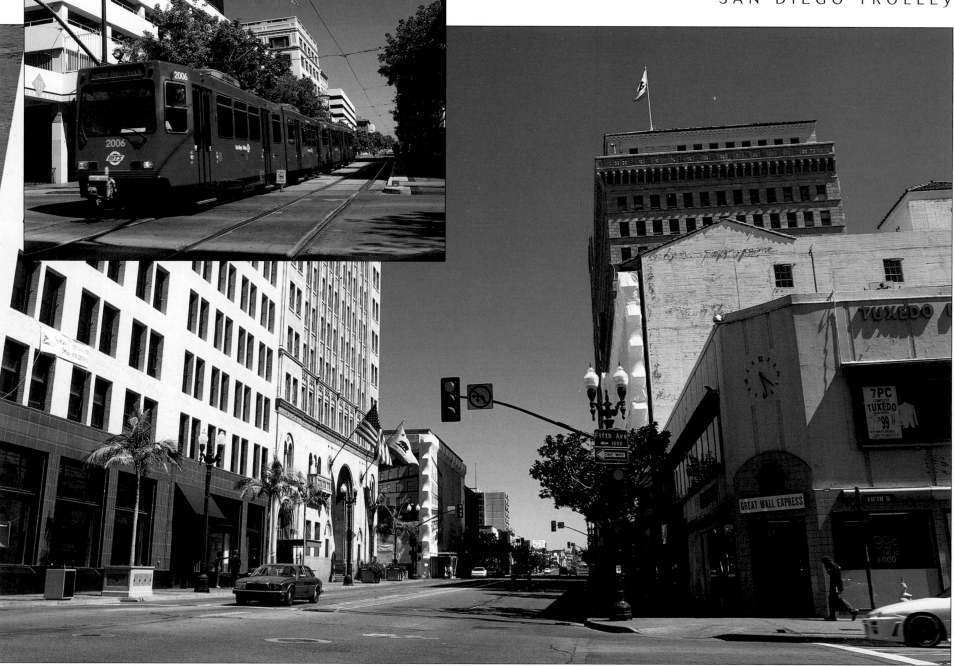

Today the bright red trolleys cover much of the county. The San Diego Trolley was the first new light-rail system in California. Much of the downtown system was built over original railroad branch lines, with the old lines upgraded and electrified. During the day, the trolley is used for passenger service; late at night, it runs freight. Visitors can take the Blue Line from Mexico to downtown, Old Town, Little Italy, Mission Valley, and Qualcomm Stadium. The Orange Line services the Gaslamp Quarter, Seaport Village, and East County. A major eastern expansion of the Blue Line is in progress through Mission Valley up to San Diego State University and on to Grossmont.

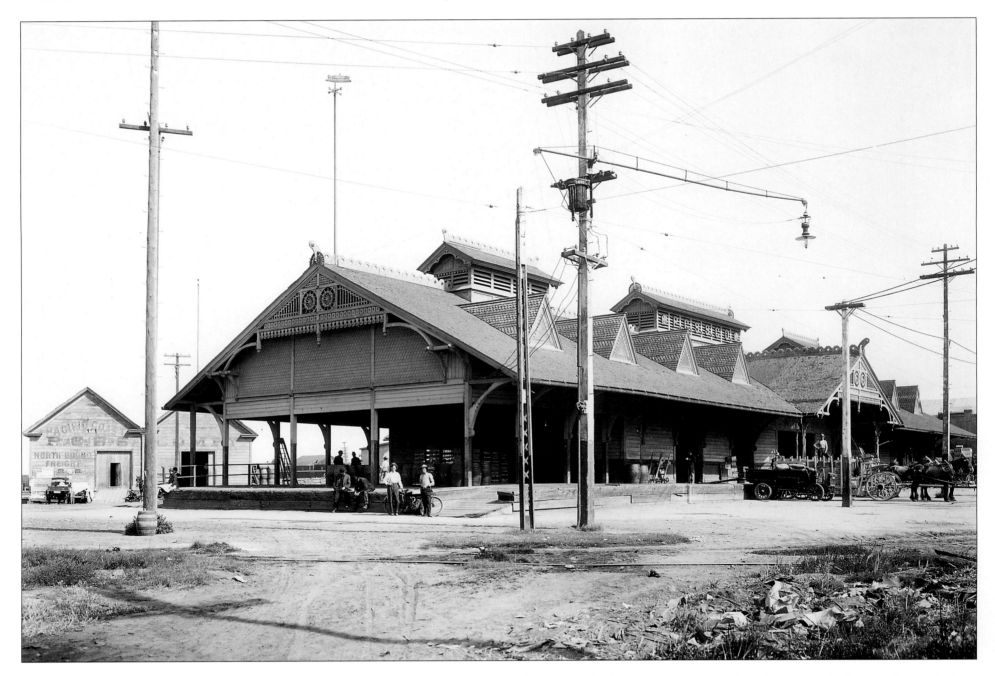

Since the 1870s, the Pacific Coast Steamship Company plied routes from Alaska to Baja California, hauling both passengers and freight. This 1913 photo shows workmen outside the San Diego warehouse. Main exports were oranges, lemons, fish, and hides. A favorite steamship voyage for early twentieth-century travelers was from San Diego to Seattle to Sitka, Alaska. Pacific Coast charged seventy-five dollars for the round trip, including first-class accommodations and all meals. The company went out of business in 1936.

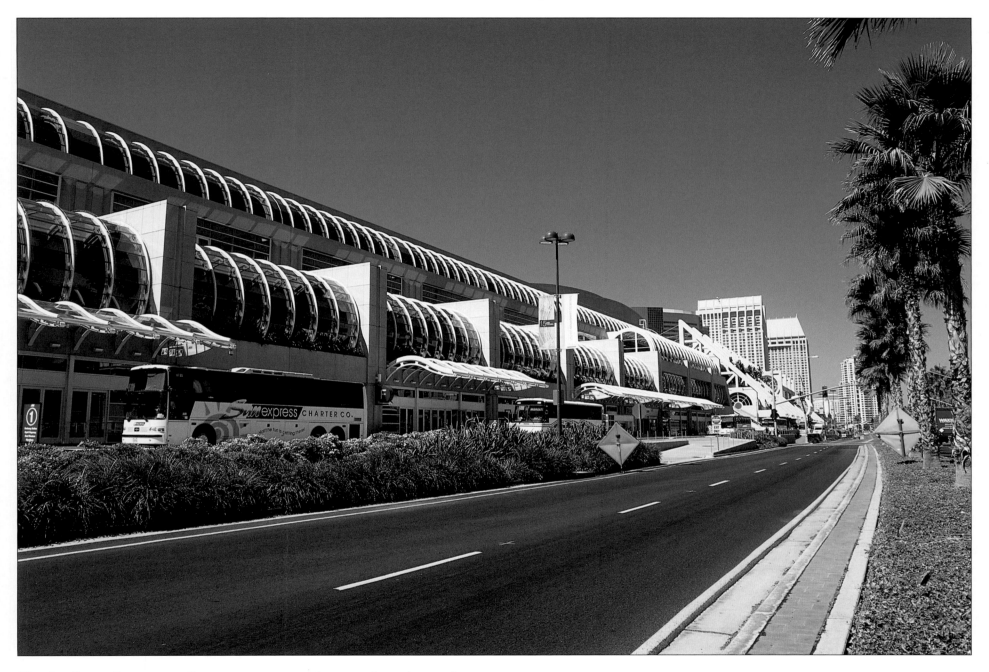

The San Diego Convention Center now occupies the spot where the warehouse once stood. The center's mainly glass design enables convention-goers to enjoy San Diego's stunning scenery, including the bay, Point Loma, and the ocean beyond. In the late 1950s, the Ford Building in Balboa Park was put forward as a suitable convention center, but it was soon realized that to suit convention visitors' needs, it had to be downtown. After many years the site at Navy Field was chosen, and the center finally opened to the public in 1989.

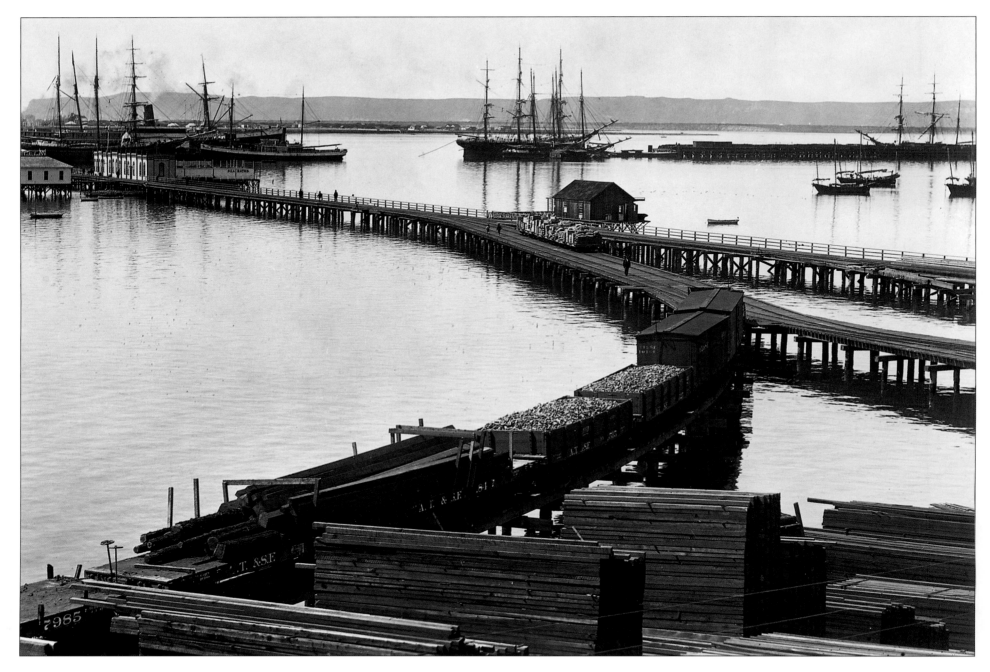

The Pacific Coast Steamship Company built docks running out into the harbor to service the paddle-wheel steamers carrying freight and passengers up and down the Pacific Coast. The docks had tracks for connecting with railroad lines running into San Diego. This enabled the easy exchange of freight to ships or from ships to the local businesses. At the time, most of the wholesale houses were located on the tracks.

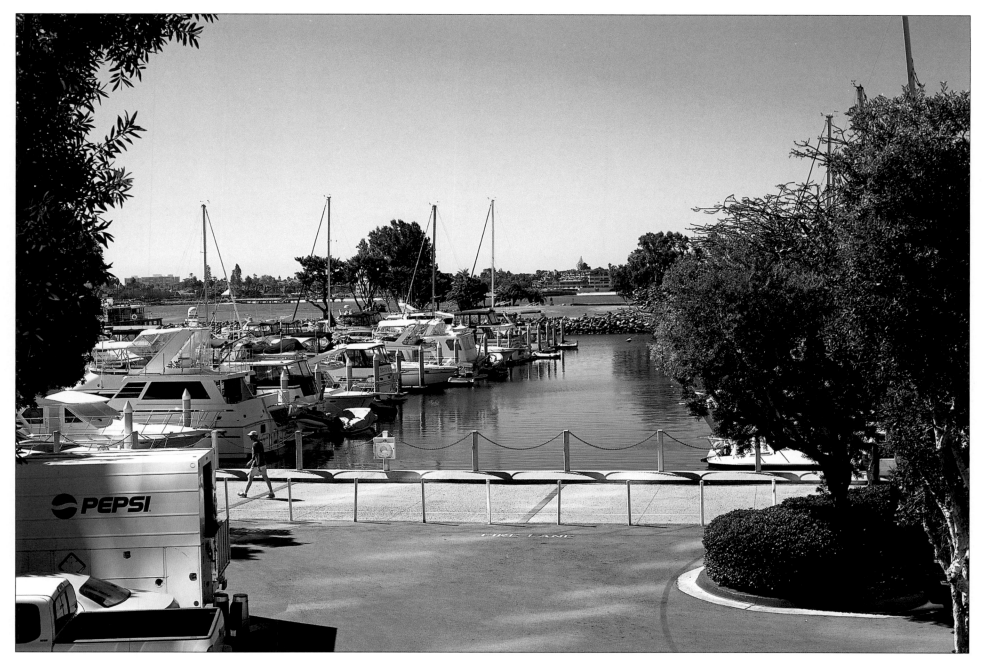

Today a fleet of private boats crowds the basin where the docks once stood. Behind the snug anchorage is the bay and North Island. The marina is within walking distance of Seaport Village, located on the harbor front, and the Gaslamp Quarter. San Diego has long been a lodestone for yachtsmen; the city has hosted two America's Cup competitions—in 1988 and 1992—thanks to the efforts of local skipper Dennis Connor, a luminary of the San Diego Yacht Club and an America's Cup veteran. After thirty-one years of competing in the Cup, Connor bowed out before the 2007 event in Valencia, Spain.

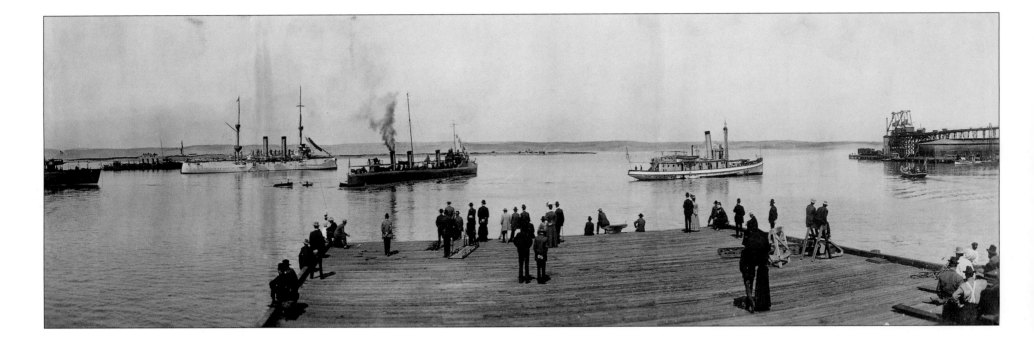

Although San Diego's Embarcadero has undergone several facelifts since this 1890 photo, things haven't changed all that much—people still like to watch ships in the harbor. Today's sightseers, however, aren't limited to standing on the dock or being taken out in a skiff to view visiting ships—they can board several harbor excursions for an up-close view of the San Diego waterfront and beyond.

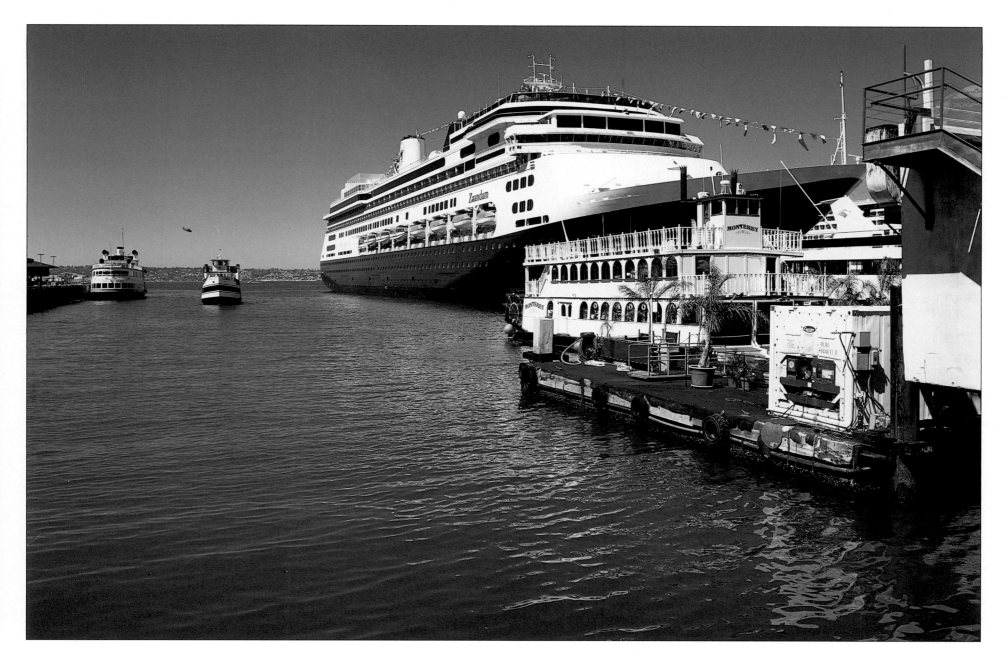

San Diego Harbor Excursion tour boats cruise by the submarine base, the Navy SEALs' training facility, the North Island Naval Air Station, America's Cup Harbor, and the lighthouse at Point Loma. From mid-December through March, boats are launched to watch the Pacific gray whale migration that began in the Arctic. Once whales reach the Baja coast, they give birth, then begin the 6,000-mile journey home. Boat passengers may be lucky enough to see young calves returning north alongside their mothers.

Commercial operation of San Diego's early waterfront was limited by the state of the tide, as can be seen in this 1908 photo. On April 14 that year, the U.S. Navy's "Great White Fleet" made San Diego its first U.S. stop on its worldwide tour. The fleet had been dispatched to circumnavigate the globe by President Theodore Roosevelt as a grand show of America's might. San Diegans flocked to the shoreline of Coronado—San Diego Bay being too shallow for battleships—to view the sixteen battleships, seven destroyers, and four auxiliary ships. Local businessman William Kettner was in charge of the welcoming committee and was so irritated by the fact that the ships couldn't anchor in San Diego Bay that, following his election to Congress in 1912, one of his first achievements was securing federal money to dredge the harbor so that deep-draft ships could enter it.

Today the waterfront of small merchants and chandlers has been replaced by a charming shopping area called Seaport Village. Built to resemble both an early California seaport and a New England village, this popular tourist destination contains over fifty unique shops and a dozen casual dining establishments. A walkway winds along its southern boundary, separating the village from the bay. Major hotels, like the Hyatt, were built next to

Seaport Village, taking advantage of the private boat basin and exceptional views of the ocean. In all, Seaport Village contains four miles of walkways along with the quarter-mile-long boardwalk. This is an excellent vantage point for viewing North Island, navy ships, and Coronado. In the summer, scores of adults and children fly colorful kites in the park next to the village or take rides on the restored 1890s Looff Carousel.

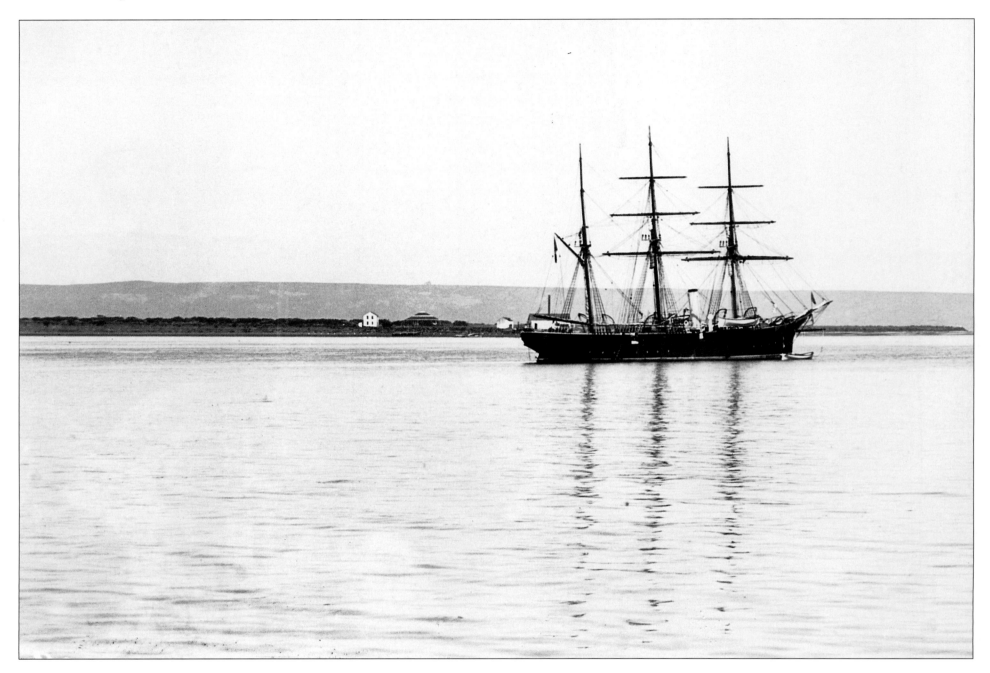

San Diego's protected harbor has long provided anchorage to scores of shallow-drafted military ships as well as pleasure craft and commercial tuna boats. This 1886 photo depicts the Spanish man-of-war *Democrata* lying at anchor off North Island. In 1892, the *Democrata* returned to San Diego to participate in a festival commemorating Juan Rodriguez Cabrillo's 1542 discovery of San Diego Bay.

The Navy first became interested in San Diego around 1915 when it changed its strategy from a one-ocean to a two-ocean fleet. Scores of military personnel in San Diego for the 1915 Panama-California Exposition recognized its value as a Pacific port. San Diego gained a naval facility after the U.S. government was deeded land by the City of San Diego in September 1919 to build a docking and fleet-repair base. It became the U.S. Navy Destroyer Base in 1922 and later, during World War II, changed its name to U.S. Naval Repair Base San Diego to reflect its vital role in restoring damaged vessels of the Pacific fleet. After World War II it became simply Naval Station San Diego. Aircraft carriers still operate out of the North Island base, and the city also boasts the Aircraft Carrier museum, the USS *Midway*, docked at Navy Pier.

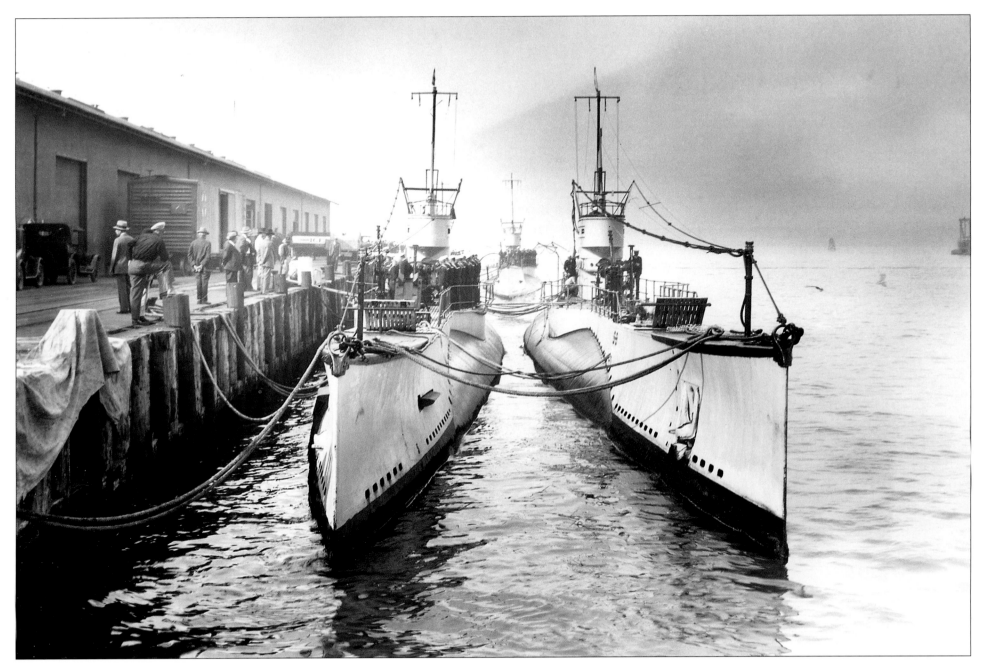

For decades, navy ships tied up to the wharfs along the Embarcadero. This 1926 photo shows two of them—navy submarines S-4 and S-9. S-boats were the first attempt by the navy to catch up with European submarine technology. The two subs pictured had very different careers. A year after this photo was taken, S-4 sank in a collision while surfacing beneath a Coast Guard cutter off Provincetown, Cape Cod. All hands were lost. The tragedy brought about the introduction of new escape devices from submarines and also led to the creation of segregated areas for submarine operations. The S-9 served the navy through April 1931, when she was placed in the Reserve Fleet and sold for scrap in 1937. S-4 was raised from her watery grave in 1928 in order to determine the grim fate of her crew and also to help design safety devices for the navy's future submariners.

Today these same wharfs are used for visiting cruise ships. Over 140 cruise liners a year dock in San Diego, representing the major pleasure lines: Celebrity, Royal Caribbean, and the Holland America line. The cruise ship industry is estimated to bring about $30 million a year to San Diego's economy. The terminal is within walking distance of the U.S. Air Carrier Memorial, which was erected in 1993—a black, granite obelisk that honors the nation's carriers and crews. It stands on the site of the old navy fleet landing. Just south of the memorial is Tuna Harbor, where San Diego's commercial fishing boats anchor. For ten weeks of the year, the San Diego Symphony takes its classical music outside and performs at the nearby Navy Pier.

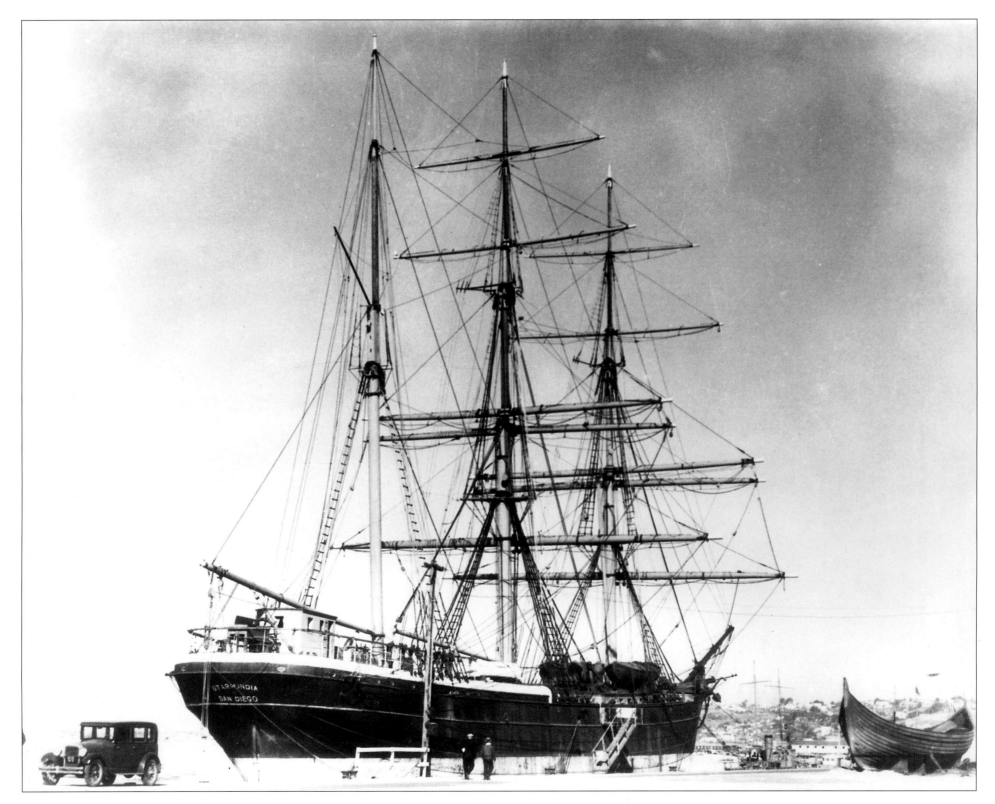

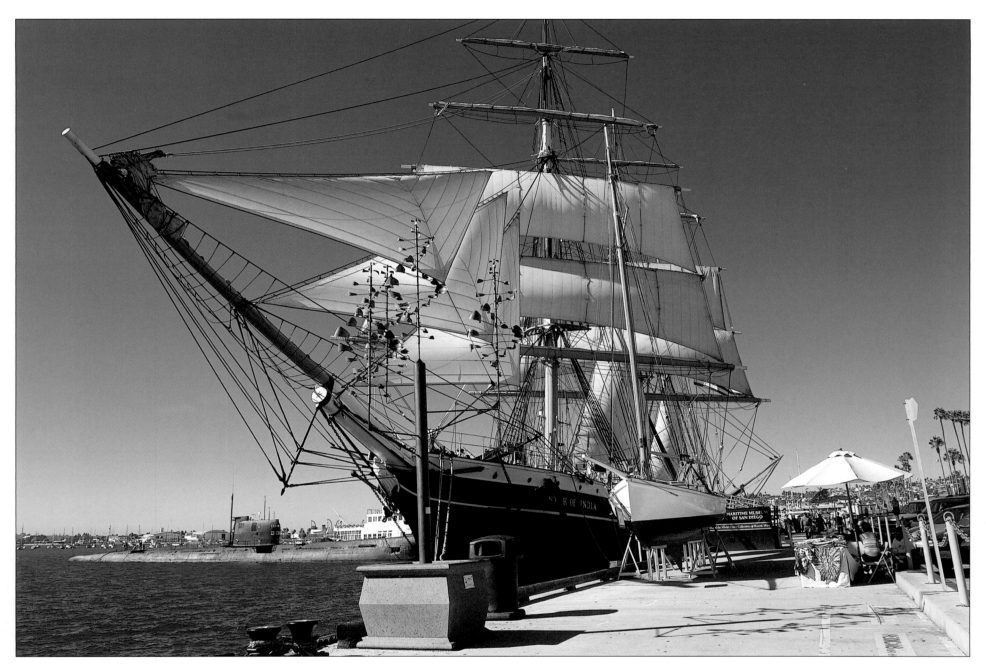

Left: Euterpe was launched in 1863 from the Ramsey Shipyard on the Isle of Man in the U.K. Named after the Greek Muse of lyric poetry, the ship endured much in her early years, including a collision, a mutiny, and the loss of her topmasts during a cyclone in the Bay of Bengal. After changing ownership and her name to *Star of India*, she hauled immigrants to New Zealand and later worked the salmon trade in Alaska.

Above: The *Star of India* was towed to San Diego in 1923, where local historians hoped to restore her to her original condition. However, due to a lack of funding, the old ship sat at anchor for fifty years before enough money was raised. In 1976, the fully restored *Star* sailed for the first time in fifty years to the cheers of a half a million spectators. She is maintained by the San Diego Maritime Museum.

Directly across the bay from San Diego lies a tract of land that was known historically as the Island, or Peninsula, of San Diego. The first owner was Don Pedro Carrillo (grandfather of actor Leo Carrillo), who received it as part of a land grant. In 1846 he sold it to two Americans for $1,000 in silver. It eventually became the property of the Coronado Beach Company, who changed the name to honor the Coronado Islands, just south of San Diego.

In 1886, the land was cleared, subdivisions laid out, and an advertisement placed for the sale of the land. On November 9, the day of the sale, every boat available in the harbor was used to ferry potential buyers to the site. A tent was set up to serve lunch, and ferryboats made trips every half hour. The first lot sold for $1,600, the lowest for $250. By April 7, 1887, over $1 million worth of land had been sold.

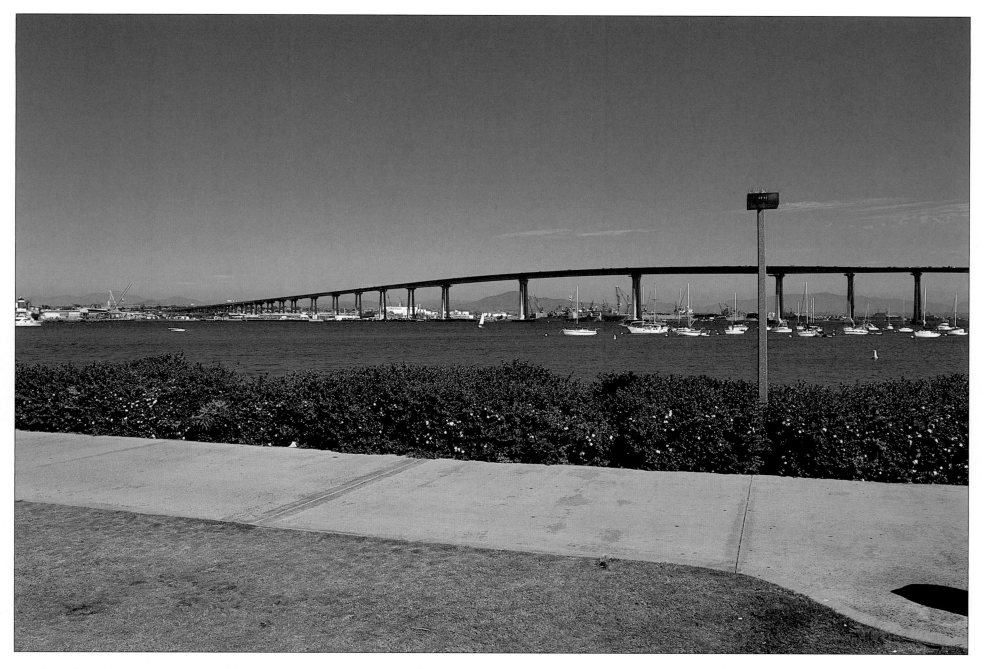

In 1969, the 11,288-foot-long San Diego–Coronado Bridge superceded the ferry service across the bay, though there are still regular commuter ferries shuttling people between Broadway Pier and the Coronado Ferry Landing. Construction of the $50 million bridge began in February 1967. Its distinctive towers and graceful curve brought it the "Most Beautiful Bridge" award of merit from the American Institute of Steel Construction in 1970. The bridge carries 68,000 vehicles a day. Up until 2002, drivers paid a toll for the privilege of crossing to Coronado, but after June of that year, the toll booths closed for good. Coronado welcomes more than 2 million visitors annually to its sun-drenched beaches and eighteen public parks.

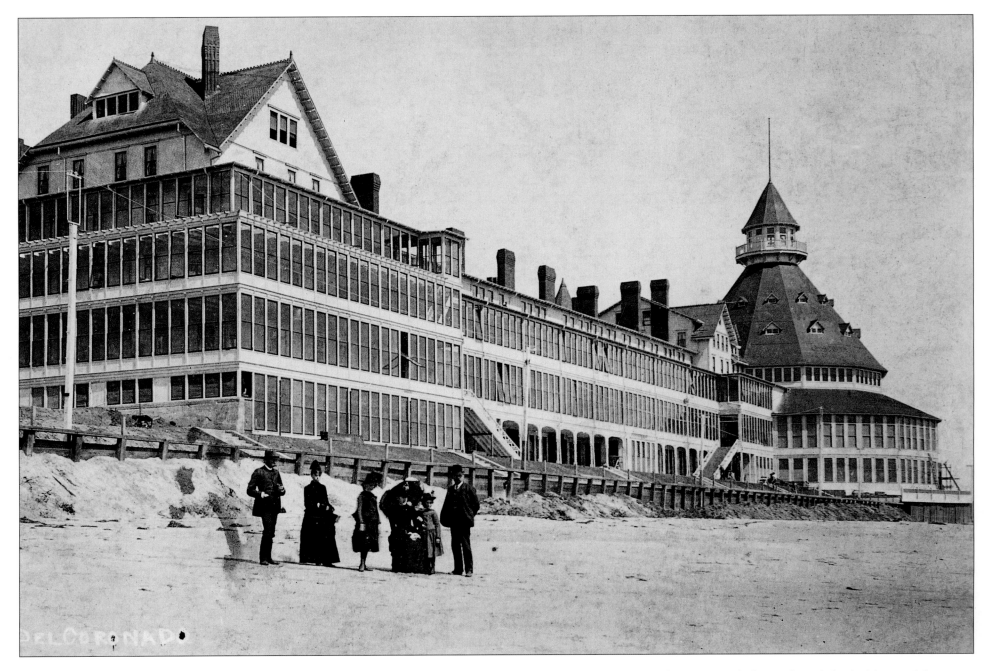

The Hotel del Coronado opened in 1888 after Elisha Babcock Jr., Hampton L. Story, Jacob Gruendike, Heber Ingle, and Joseph Collett bought Coronado with the intention of creating a world-class resort. When the hotel was opened, it had unheard-of modern conveniences, such as a fire alarm system, electricity, elevators, and private bathrooms. Construction began in January of 1887, and by March, one hundred barrels of cement were being used daily. The hotel was planned to have 720 rooms, a 10,800-square-foot ballroom, and its own boathouse. John D. Spreckels purchased the holdings of the Coronado Beach Company in 1889 and put in the infrastructure for the entire village of Coronado, including adding streetcar and railway lines, dredging Glorietta Bay, and installing trees along Orange, Palm, and Olive Avenues. By 1913, the hotel even operated its own school for the children of long-term guests.

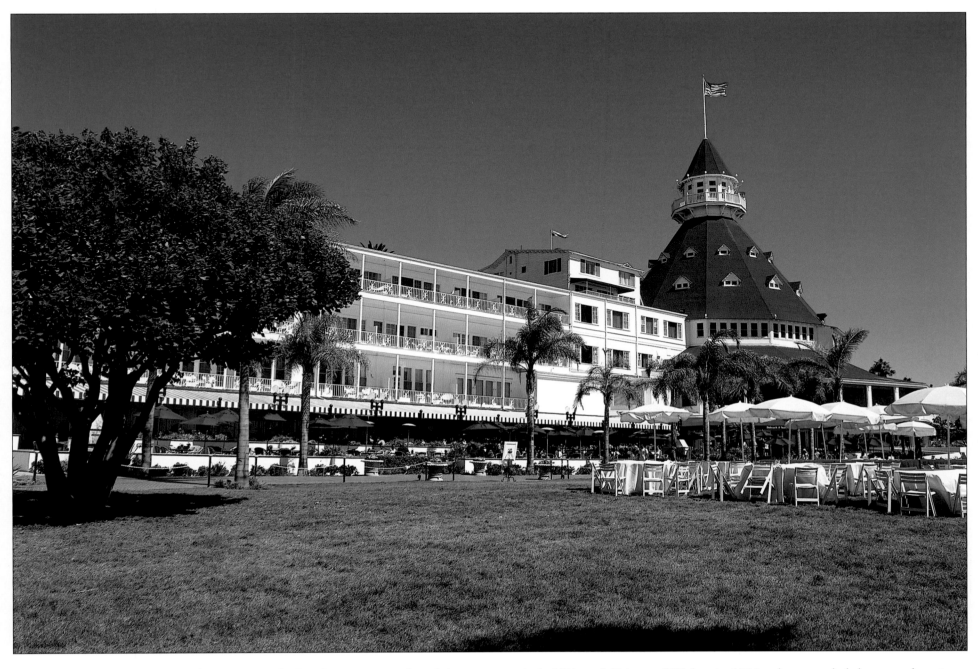

Though John D. Spreckels's influence on early San Diego was profound, his great love was for Coronado. In 1906 he built himself a mansion nearby in Glorietta Bay (now the Glorietta Bay Hotel). For more than one hundred years, the Coronado hotel has been host to the world's famous, including ten U.S. presidents and numerous actors and actresses. Its royal visitors have included Edward, Prince of Wales, in 1920, who attended the same function as Wallis Simpson, then married to a San Diego–based naval commander. It would be fifteen years before they were officially introduced in London. Some of the nineteenth-century guests are still there—the ghost of Kate Morgan, whose body was found in 1882, is still believed to roam the halls.

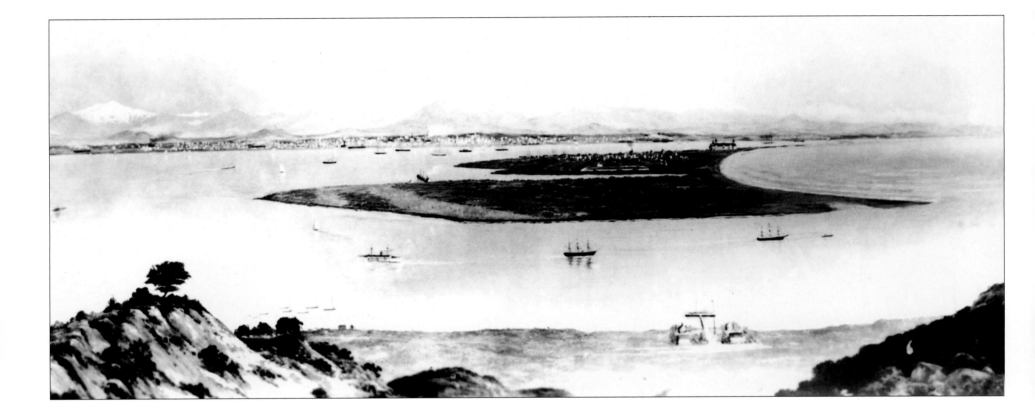

The view of San Diego from Point Loma is one of the most beautiful in the city. This 1892 photo features North Island and Coronado directly across the channel from Ballast Point. North Island derived its name from the original topography—in the nineteenth century, it was referred to as North Coronado Island. In 1886, North and South Coronado Islands were bought by a developer and were intended to be transformed into one enormous residential resort. South Coronado became famous as the city of Coronado, but North Coronado was never developed. Instead, aviator Glenn Curtiss opened a flying school and leased the property until the beginning of World War I. Before the navy station was established, North Island was also used for horseback riding and hunting by guests at the Hotel del Coronado.

The current photo shows the many changes in the shape of the bay due to dredging. The main channel itself was dredged during World War II to allow aircraft carriers into the bay. The material from the dredge was placed in Spanish Bight—a hollow between North Island and Coronado. After the dredge, the two areas effectively formed one large body of land. During World War II, North Island was the major continental U.S. base supporting the operating forces in the Pacific. Those forces included over a dozen aircraft carriers, the coast guard, army, marines, and Seabees. The current Naval Air Station North Island (NASNI) site is part of the largest aerospace-industrial complex in the navy, the 57,000-acre Naval Base Coronado.

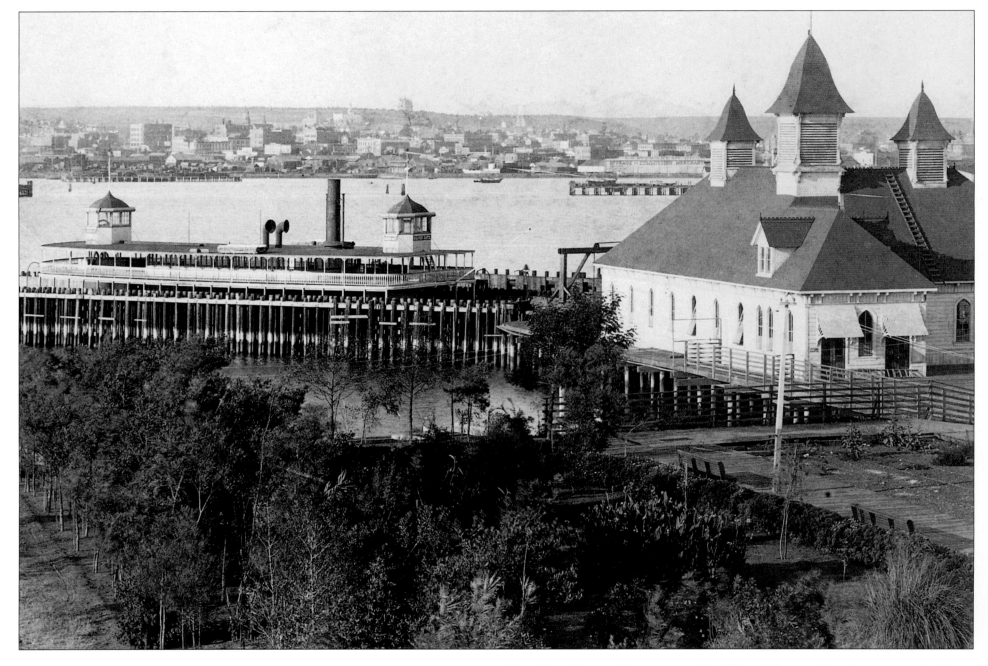

There's no better place to enjoy San Diego's beauty than from across the bay in Coronado. This 1888 photo, taken from the San Diego–Coronado Ferry dock, shows the downtown development, as well as the steamship docks at the foot of the Gaslamp Quarter. Until the completion of the San Diego–Coronado Bay Bridge, the ferry was the quickest way to travel from San Diego to Coronado.

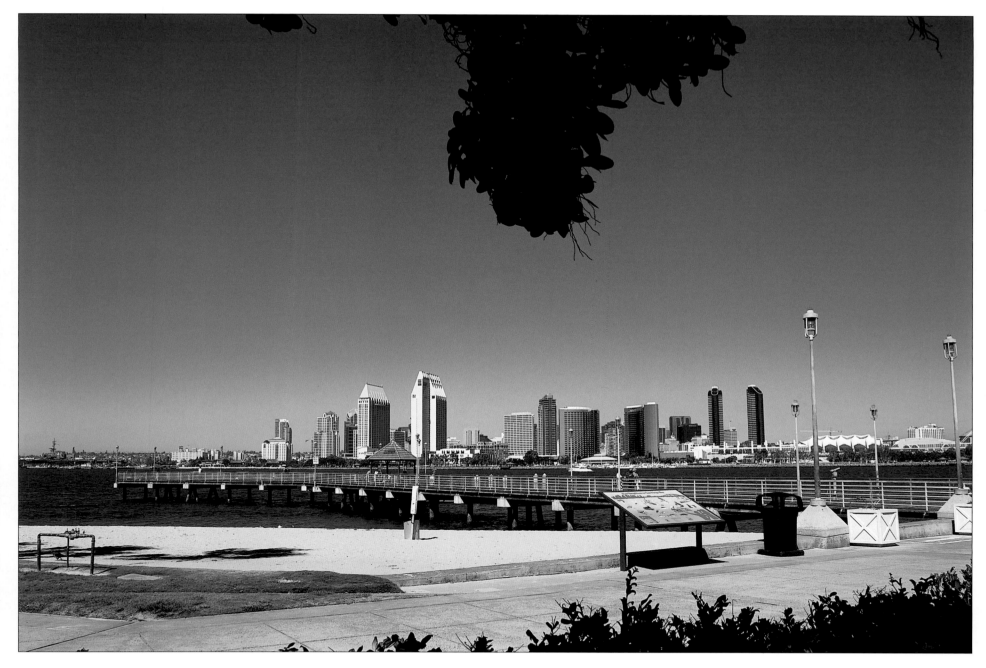

This current photo, taken just above the ferry landing, clearly shows the changing face of the San Diego skyline. Not only is the ferry landing a portal to Coronado and the group of stores and restaurants that cluster around the Marketplace Wharf; the long, wooden dock also gives tourists a great vantage point from which to view the San Diego waterfront and acts as a perfect location for local fishermen to cast a line.

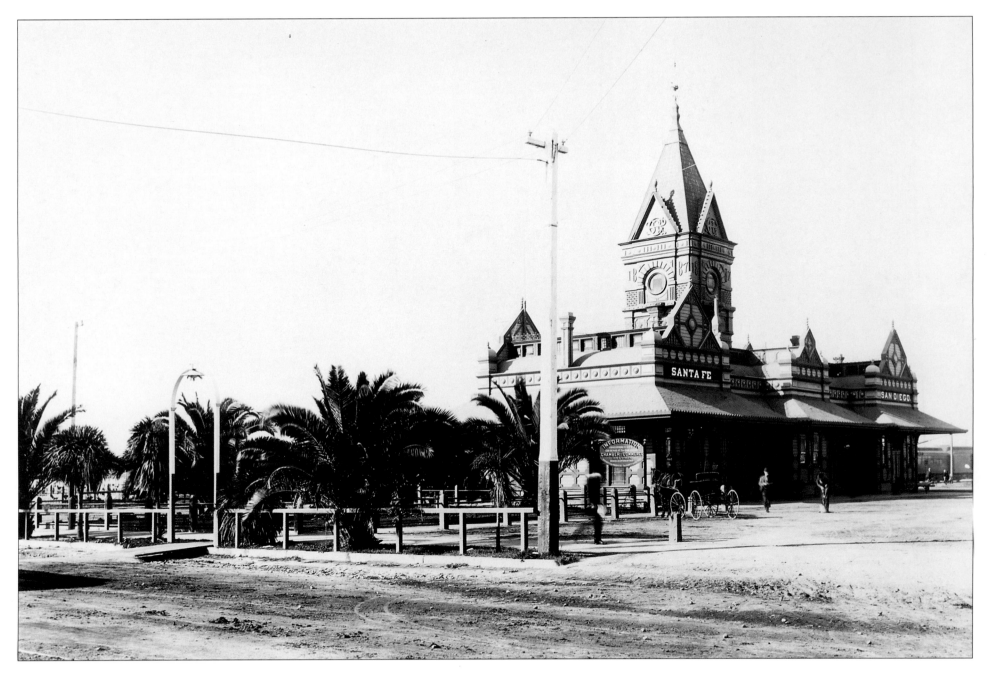

The original train depot, shown in this 1902 photo, was built in 1887 for the California Southern Railway. Early on it was thought that San Diego would become a major rail destination, with its harbor and port facilities delivering freight and passengers for the network and acting as a major conduit for trade with the Far East. It never became a terminus of the Atlantic, Pacific, and Santa Fe Railroads, as had been envisioned, though it was an important center in West Coast commerce. It was designed in the style of early Santa Fe stations and sported dark red paint with dark green trim. In 1914, plans were made to build a new station that would combine a Spanish Colonial appearance with the requirements of a modern train station. The goal was to design the new depot to blend with the buildings in Balboa Park that were being constructed for the 1915 Panama-California Exposition.

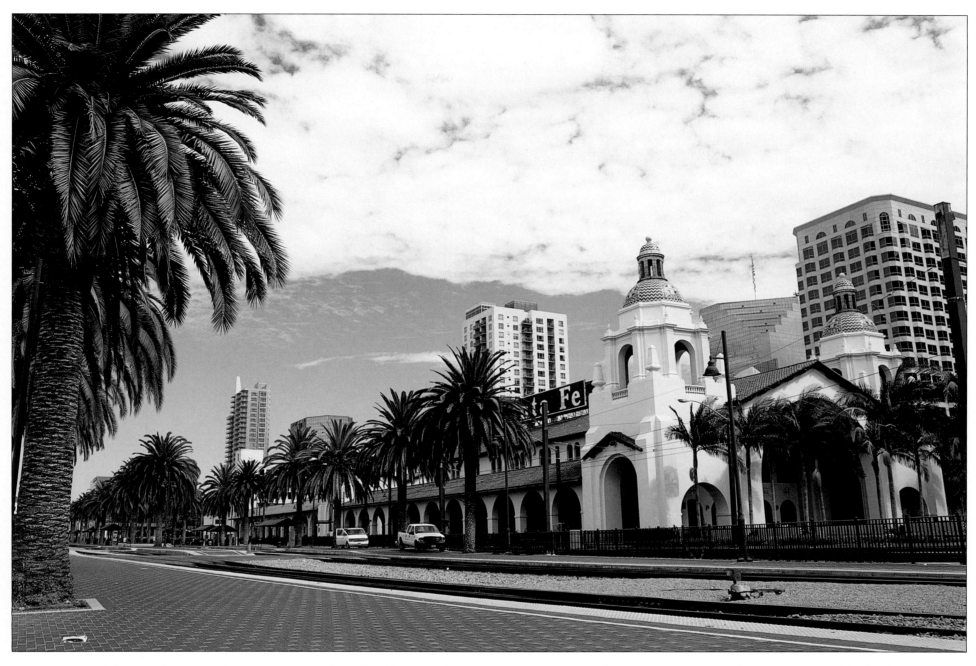

Construction of the new depot was begun in 1914 and it officially opened on March 8, 1915. To ease the disruption on passengers, the new depot was built in what had been the 1887 station's forecourt. Oliver Stough, San Diego's last surviving veteran of the Mexican War, purchased the first ticket. Ironically, the new depot could have opened earlier, but was delayed because of a feud between the city council and the railroad over the closing of part of B Street.

A 1971 attempt by Santa Fe to tear it down was opposed by local residents, and in 1972 the depot was placed on the National Register of Historic Places. The Museum of Contemporary Art San Diego, located across the street, is planning to turn the historic baggage building into an additional exhibition space, with the help of various charitable donations.

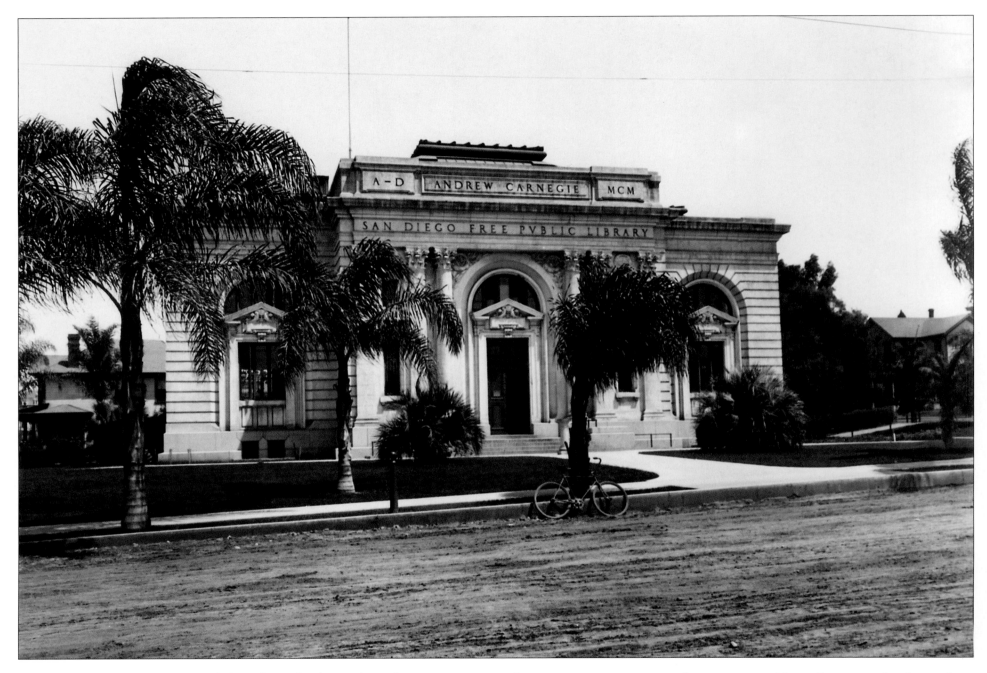

Located on E Street, between Eighth and Ninth, the Andrew Carnegie Library was dedicated on March 19, 1901. Before the granite cornerstone was set in place, several mementos were placed inside. These included a portrait of Carnegie and "the father of San Diego," Alonzo Horton, as well as newspapers, coins, and city directories. It had been Horton's wife, Lydia, who had written to Carnegie and persuaded him to fund the library. At the opening ceremonies, a telegram was read from Carnegie, who donated $50,000 for the construction of the building. The site itself cost $17,000 and was paid for by a $9,999 gift from the city and the rest from private donations. The ubiquitous George White Marston, founder of Marston's Department Store and one of the city's principal benefactors, provided for the landscaping and iron hitching posts.

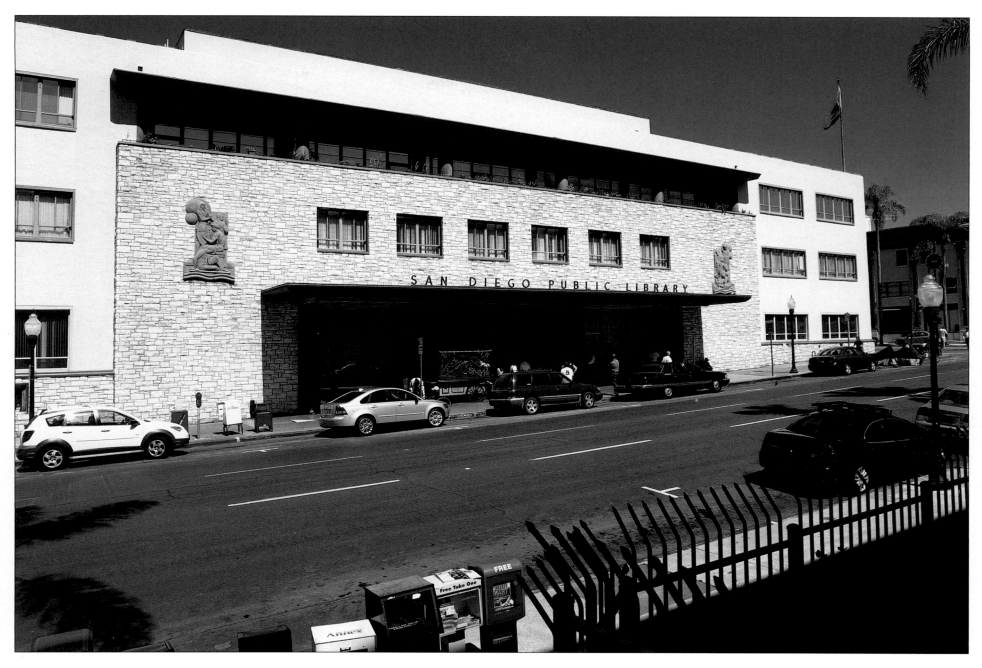

By the late 1920s the library had run out of space and was forced to rent nearby buildings. One of the early librarians, Cornelia Plaister, pointed out that the building had been established to serve a population of 17,000 and was built in horse-and-buggy days. The sorely needed replacement did not arrive until 1954, when the city's population had reached 450,000. Again, the rapid expansion of San Diego outstripped the library's ability to cope, and by the late 1990s it was heavily criticized for turning down valuable book collections bequested to it simply because it had no space to store them. The overcrowding of books and staff should be resolved by 2008, when a new state-of-the-art library is due to be completed between Park Boulevard, Eleventh Avenue, and J and K streets. The 366,000-square-foot facility was finally given the go-ahead by the city council in April 2005, with costs estimated to be around $150 million. Miss Plaister would approve.

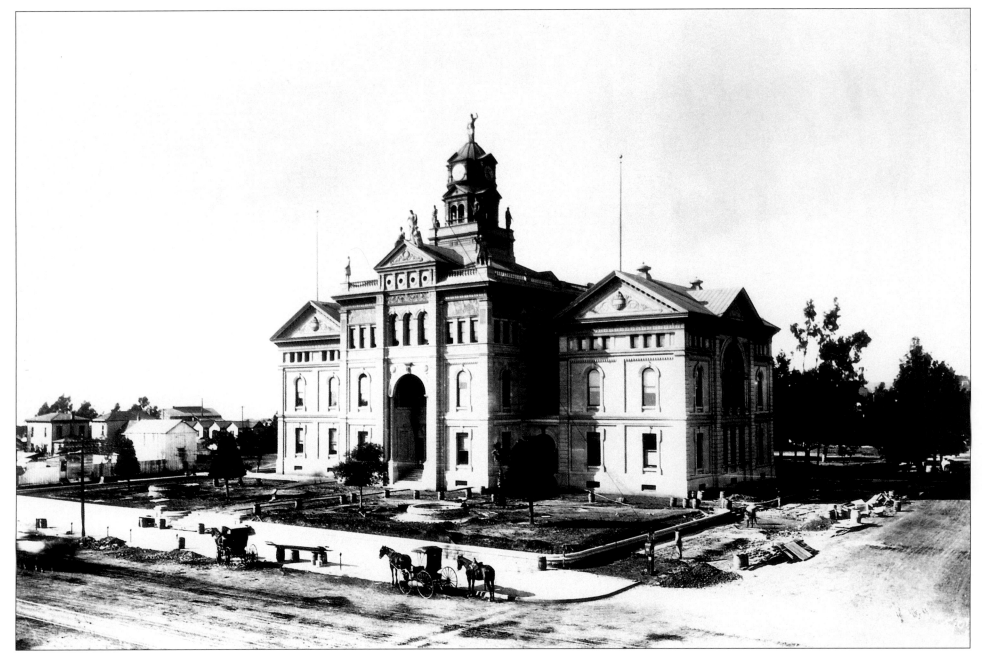

In 1871 bitter debate raged over the moving of the San Diego courthouse from the Whaley House to "new San Diego," also called New Town (now downtown). Before any official decision could be made, a county clerk took matters into his own hands. Commandeering two wagons, the clerk went to the old courthouse in the middle of the night and loaded the courthouse records. He then took them to a temporary location, a Wells Fargo office in the new town. The debate was over. This 1889 photo shows the new courthouse that was started in 1871.

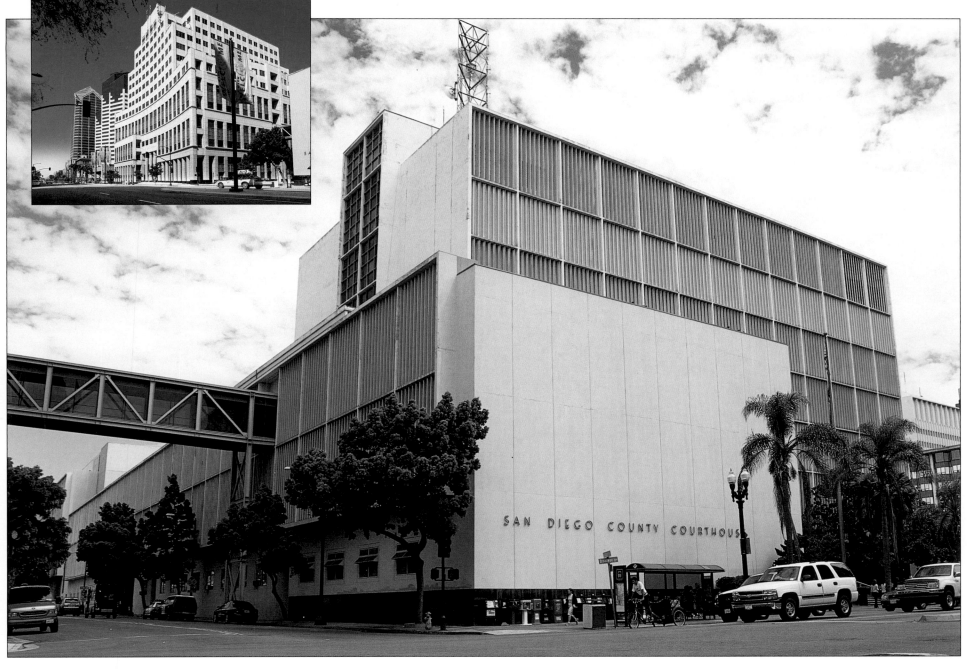

The San Diego Superior Courthouse was demolished in 1961 to make way for a contemporary court building. Forty-two stained-glass windows, representing all the states then in the Union, were retained from the original building, but a lack of sympathy for Victorian embellishment in the 1960s sent them into storage until their "rediscovery" in 1978. In 1996 the Hall of Justice (inset) was completed on the adjacent site, echoing the grandeur of its nineteenth-century predecessor. The two buildings are linked by an enclosed walkway. Twelve of the restored windows now overlook the central atrium of the Hall of Justice.

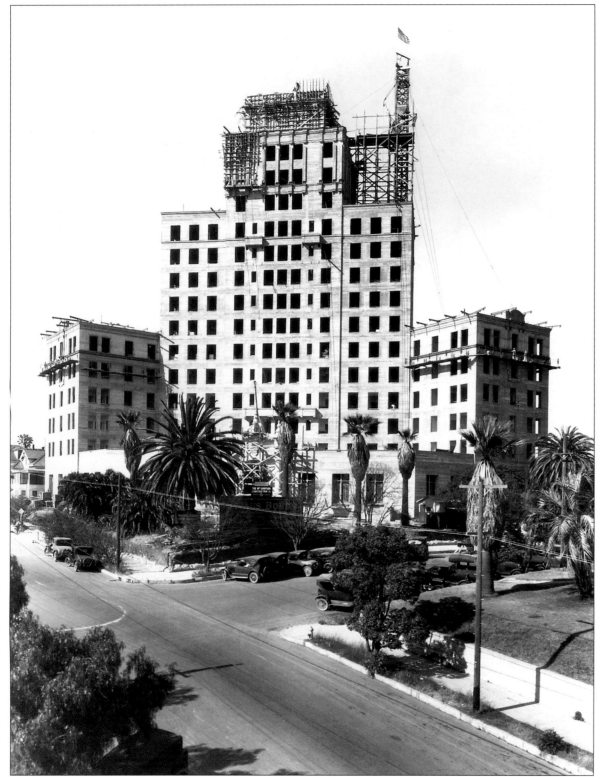

This fifteen-story hotel has been a San Diego landmark since its opening in 1927. Located on the highest elevation in downtown San Diego, it was visible for miles. Built on the site of Ulysses S. Grant Jr.'s home, it originally had eighty-five apartment suites and thirty-four hotel rooms. The famous Sky Room bar was added in 1940 and became a favorite watering hole for soldiers and sailors. In 1956, the owner, Harry Handlery, installed the world's first transparent exterior elevator as a solution for having no space inside the hotel to add one.

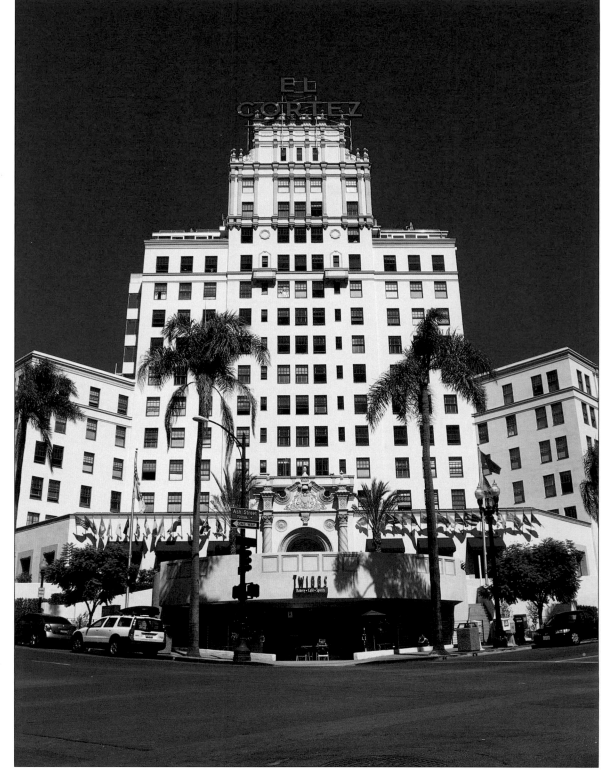

At the end of the 1970s, the hotel that was once the center of San Diego social life closed. It eventually became the hangout of transients, and its graffiti-covered walls became an eyesore. However, it has since been restored to a trendy apartment complex in its original Spanish Renaissance Revival architectural style. The octagonal-shaped Don ballroom, with its twenty-four-karat gold detailing in the ceiling, is a favorite spot for weddings, and tenants can enjoy either of the two sun terraces or the refitted 1950s swimming pool.

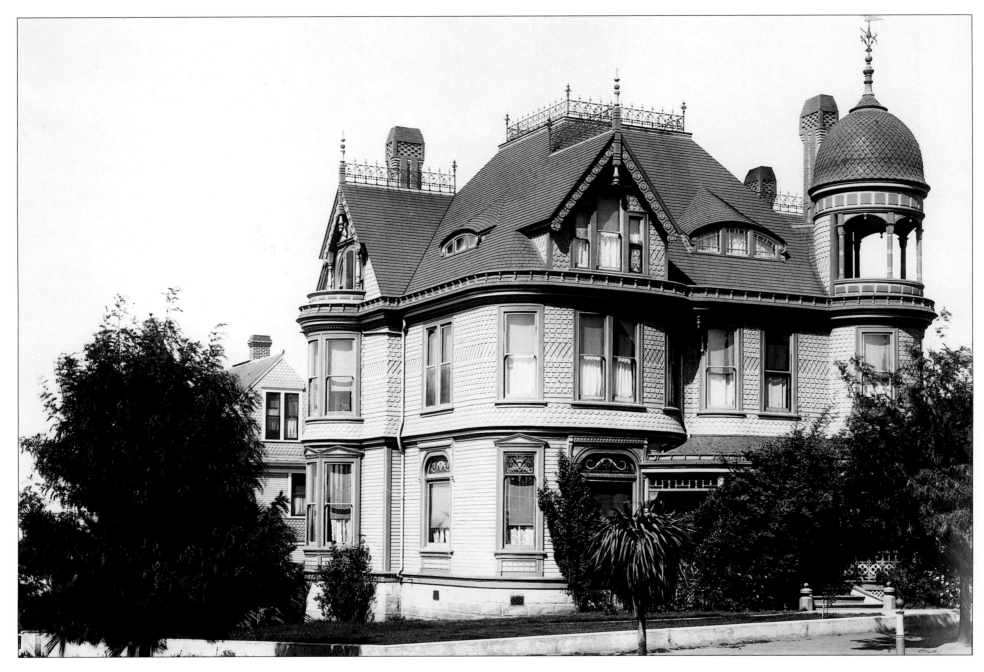

Built in 1888, this Victorian wood-frame mansion was originally the home of Kate and John Long. Long was the owner of the Coronado Fruit Package Company. The mansion was built using a variety of shingle patterns and boasted curved pane windows, rounded bay windows, stained glass, and a long, curved porch decorated with latticework. The property also has a carriage house that is still standing. Many prominent San Diegans have lived here over the years, including Robert Whitney Waterman, governor of California from 1887 to 1890 and owner of the Stonewall Mine and Cuyamaca Rancho. The house is located in the Banker's Hill neighborhood, so named for the many bankers and wealthy businessmen who lived there in the late nineteenth century.

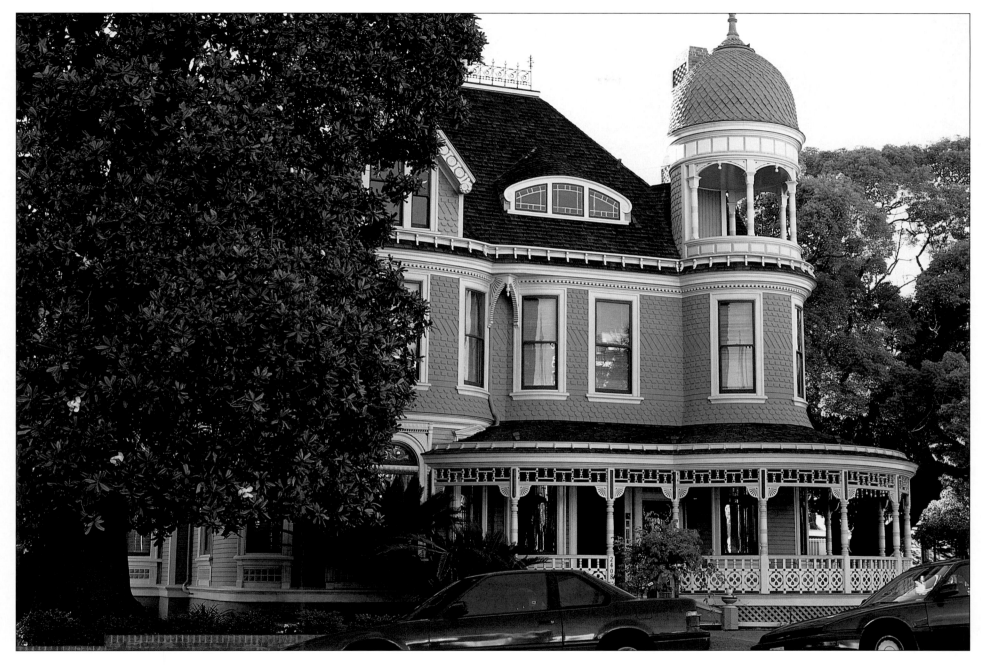

Today the Long-Waterman mansion is little changed from its nineteenth-century appearance, though it did survive a threat of demolition in 1977. Owners John and Allegra Ernst, like many heritage guardians, have made use of facade easements, federal tax incentives available to owners of properties listed on the National Register of Historic Places, to keep the mansion and the associated coach house in prime condition. It is one of the few mansions left on Banker's Hill and is close to the Quince Street bridge and the Spruce Street suspension bridge, two of San Diego's oldest footbridges. They were used in the early 1900s before the automobile became a facet of everyday life, when residents walked to catch the Fourth Avenue streetcar.

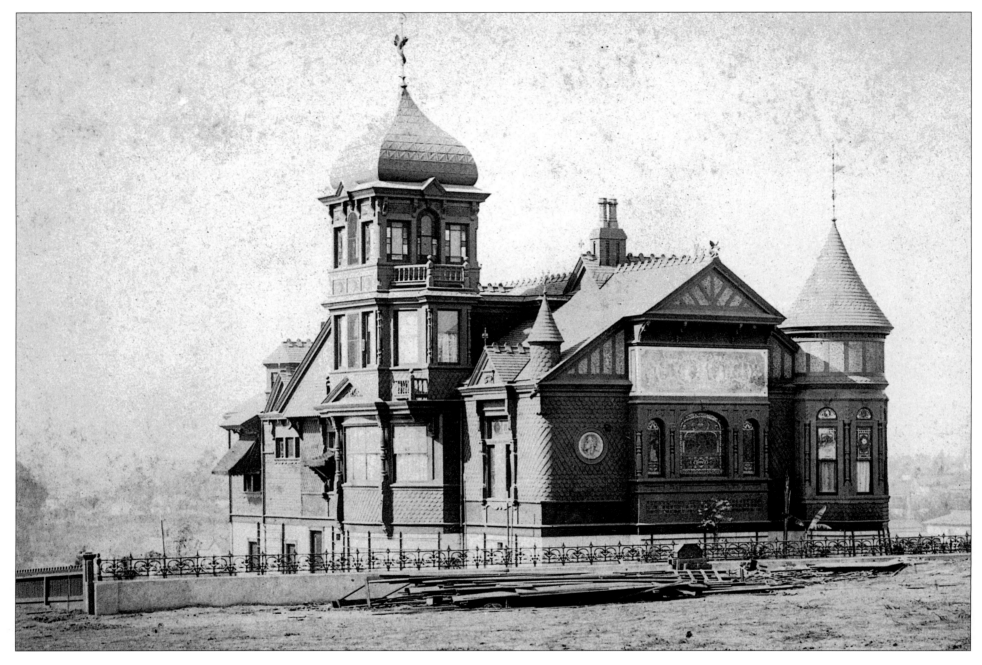

This Victorian "painted lady" is located at 1925 K Street, in San Diego's Golden Hills neighborhood. Jesse Shepard, a transplanted Englishman of exceptional creativity, built the home. The firm of Comstock and Trotsche, following Shepard's instructions, designed it in Victorian style. It is two stories high and has a tower room that was Shepard's study. Shepard made quite a splash in San Diego society for both his musical talents and his interest in spiritualism. His love of music is reflected in the music room that occupies one entire side of the house and has a huge art-glass window depicting the Greek poet Sappho. However he didn't remain in the villa long and within two years had put it on the market and returned to Europe to pursue a literary career.

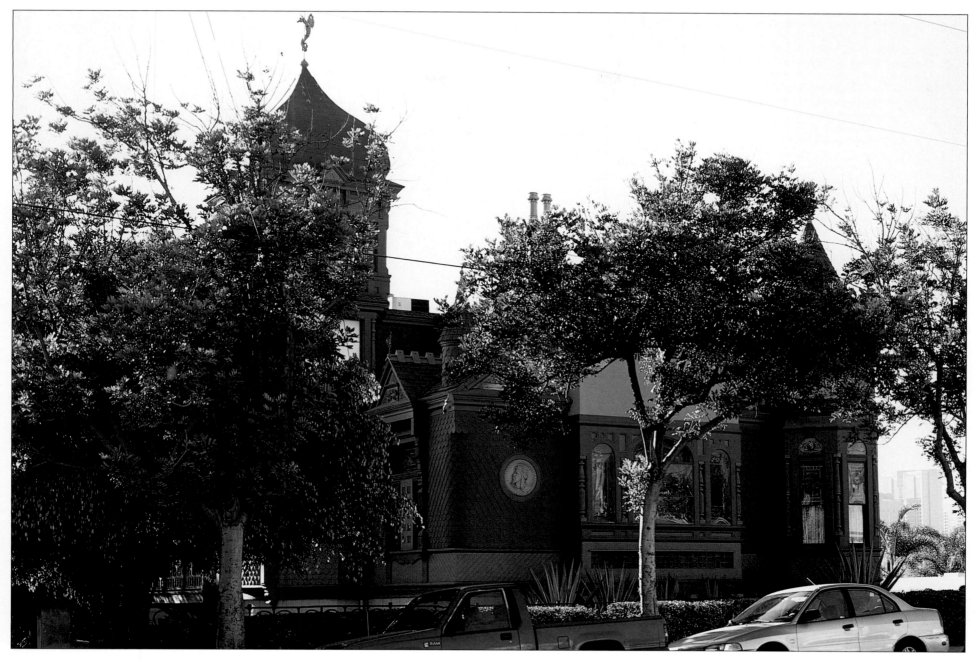

After Shepard departed, the villa passed regularly from owner to owner, with the longest occupant, Frank Lynch, living there from 1909 to 1942. During World War II it was split into a number of small apartments and several older homes were moved into the garden, hemming in the villa and restricting its views. In 1950 it was sold for $16,000—less than the original cost of building. The condition of the building was in severe decline through the 1950s and 1960s until 1970 when the San Diego Historical Society stepped in to rescue it. By 1972 the society was able to reopen the refurbished villa to the public. Fire seriously damaged the building in 1986, but by June 1987, further restoration work was completed and the reputedly haunted Villa Montezuma was reopened for its hundredth anniversary.

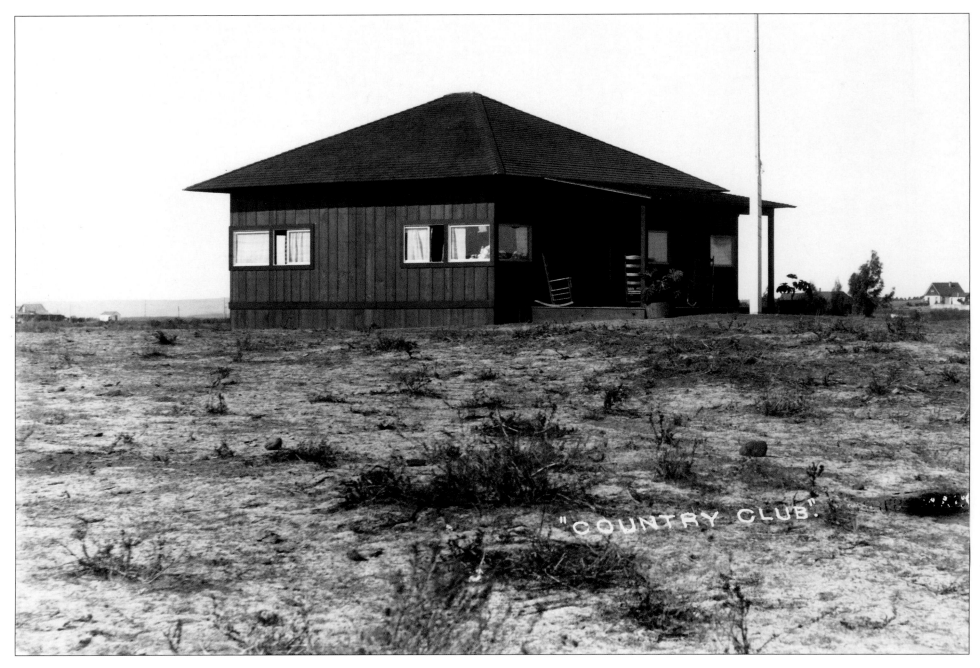

"COUNTRY CLUB".

The history of Balboa Park stretches back to May 26, 1868, when 1,400 acres were set aside as a public park. At the time called City Park, it was characterized by rocky canyons and scrub-filled hilltops. But in 1892, the city leased thirty acres of the park for a nursery to Kate Sessions, San Diego's leading horticulturalist. In return for the lease, Sessions agreed to plant one hundred trees per year throughout the park. Under her guidance, it became a wonderland of flower gardens and tree-shaded lawns. In 1910, City Park was renamed Balboa Park in honor of Vasco Nunez de Balboa, the first European to see the Pacific Ocean. The parkland would eventually house the buildings of two world fairs and the San Diego Zoo. This 1891 photo shows the Country Club House just north of where the zoo would be sited.

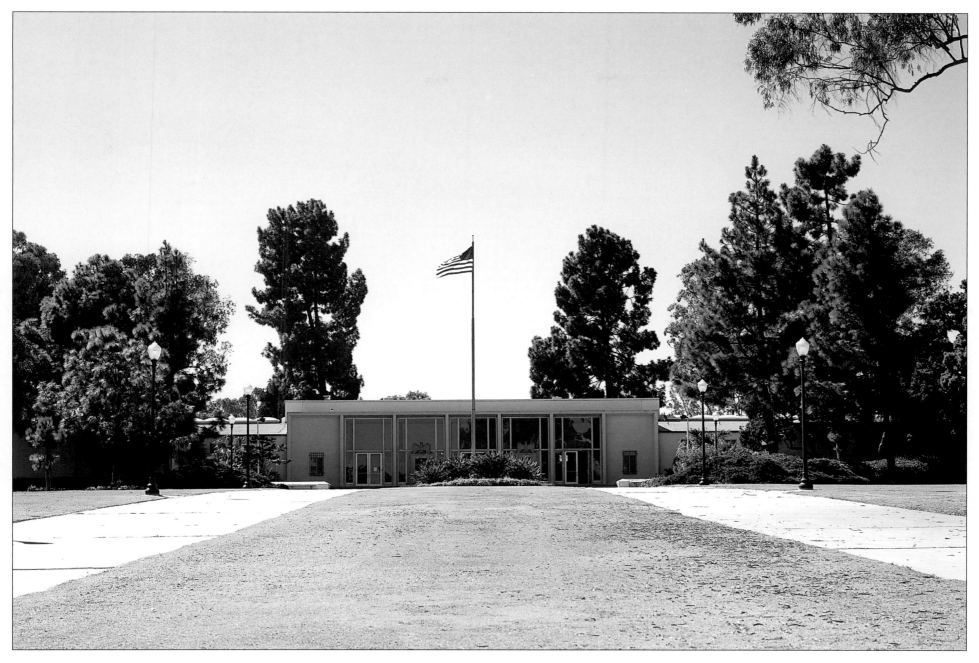

Today the same area houses the Veterans War Memorial Building. The building was one of San Diego's first public buildings designed in a contemporary modern style. It was used as the prototype for several neighborhood schools and libraries built from 1950 to 1970. The Veterans War Memorial Building was created to honor the memories of the men and women who have served in the United States Armed Forces, and historical objects and memorabilia dating back to the Civil War are on display. A statue commemorating Kate Sessions's work in San Diego stands at the Laurel Street entrance to Balboa Park among some of the trees she helped plant. Her name also lives on at the Kate Sessions Elementary School on Beryl Street and at the Kate O. Sessions Neighborhood Park set in the hills above Pacific Beach, an open space that offers commanding views of Fiesta Island and Mission Bay.

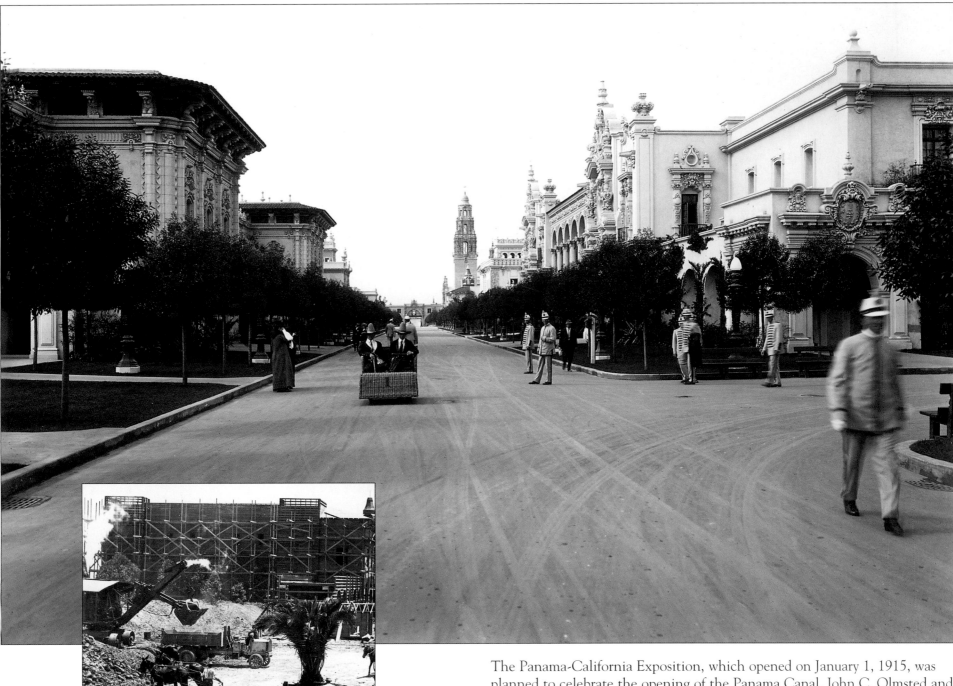

The Panama-California Exposition, which opened on January 1, 1915, was planned to celebrate the opening of the Panama Canal. John C. Olmsted and Frederick Law Olmsted Jr., architects of the 1905 Lewis and Clark Expo in Portland, Oregon, were chosen as site planners. Instead of the neoclassical style of other expos, it was decided that the San Diego buildings would be designed in a combination of Spanish, Mexican, and Native American styles. Running the length of the expo was a broad avenue called the Prado.

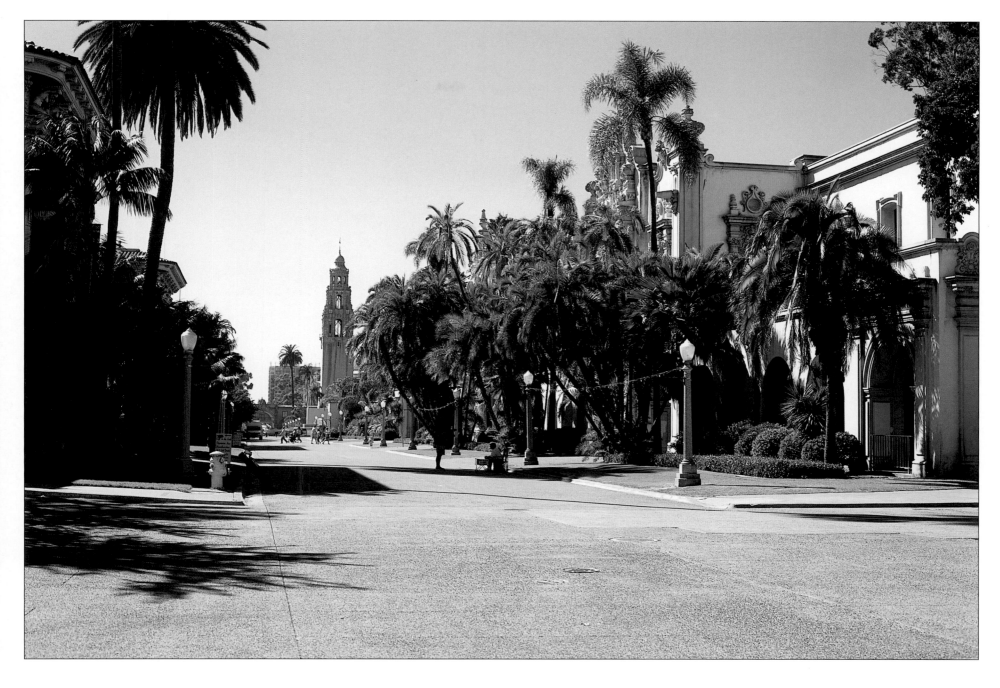

Though not dramatically different today, the buildings along the Prado have teetered on the edge of demolition before being restored to their original profile. The building on the right, now known as the Casa del Prado, was previously known as the (far less glamorous) Food and Beverage Building, as befitted its role in the 1915 exposition. During World War II, the park served as temporary military headquarters and afterward the building fell into decay with crumbling plaster, dry rot, termite infestation, and a jungle of palms outside. Molds were taken of the original ornamentation, and in 1971 two replacement buildings linked by an open arcaded court took its place.

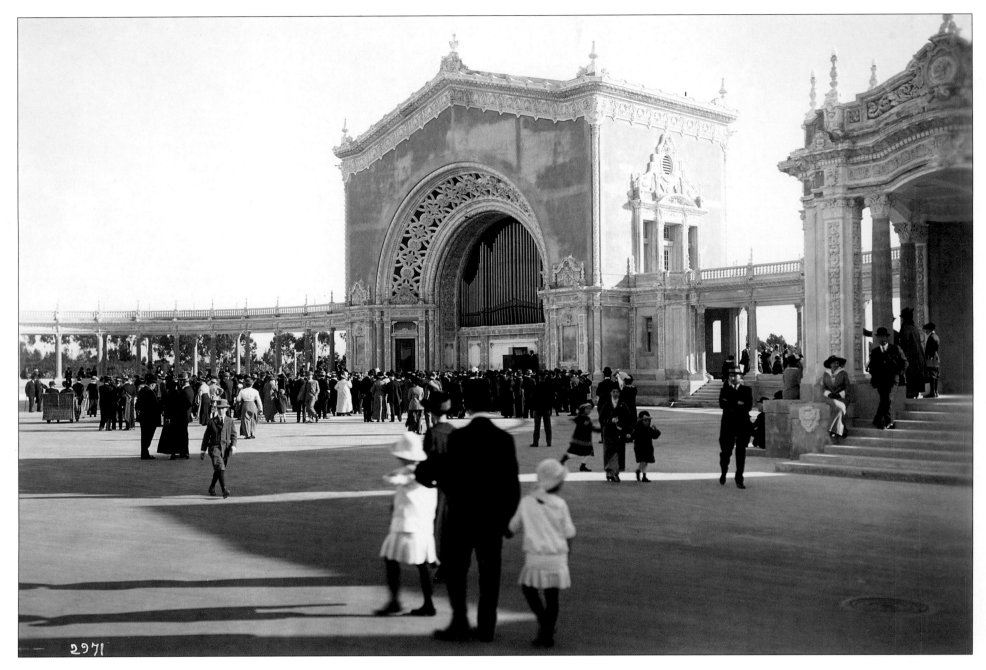

The organ and organ pavilion in Balboa Park were gifts to the people of San Diego from both John D. Spreckels and his brother Adolph. The Spreckelses owned the San Diego Electric Railway Company, and though on the surface the gift of the $33,000 organ for the 1915 Panama-California Exposition seemed to be an act of benefaction, there may have been an ulterior motive. The company wanted to put a connection through the center of Balboa Park for the exposition, and then afterward it would take commuter traffic from San Diego to alight north of Balboa Park. The addition of the railway meant a shift of the exposition from the south of the park to the center. The offer of the organ—along with an agreement to underwrite the exposition fund—is believed by some to be the price that John D. Spreckels paid for getting his way. Flanked by curved, Grecian-style colonnades and illuminated by 1,400 embedded lights, the organ, which weighs nearly 100,000 pounds, is protected by a 20,000-pound steel door.

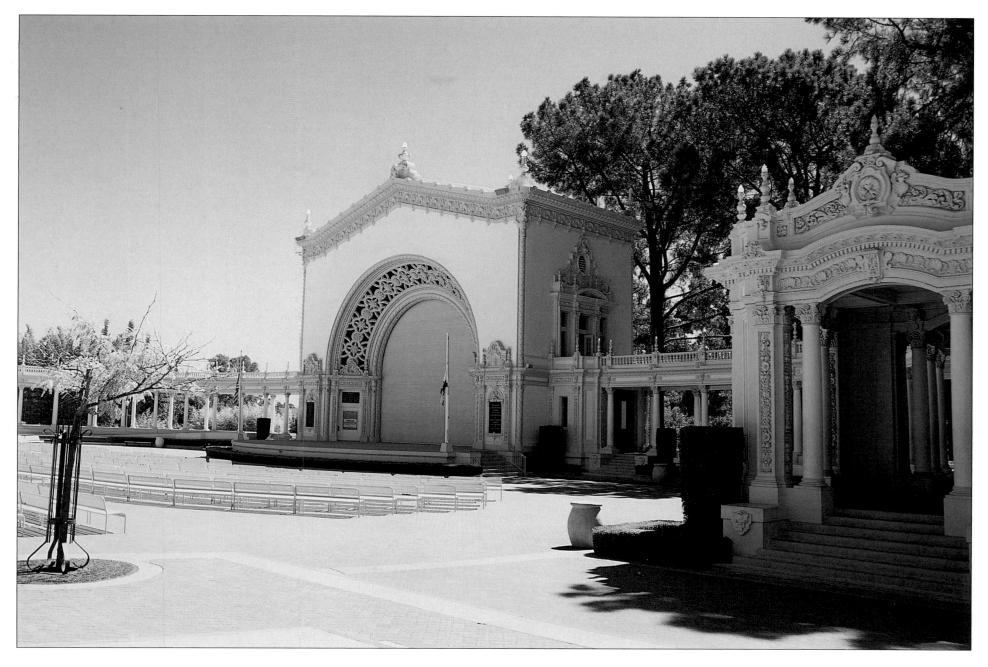

Since 1915, the Spreckels Organ, apart from providing regular musical concerts and interludes, has been a point of focus for San Diegans during times of national and local crisis. Memorial services have taken place for the victims of the air disaster over North Park in 1978, the Tiananmen Square massacre in Beijing in 1989, and after the tragedies of 9/11 in 2001. In 1986, the structure was renovated and new seating and landscaping was added.

The asphalt floor of the arena was replaced with 142,000 paving stones. The fountain, which had been added for the California-Pacific Exposition in 1935, was rebuilt, and a terrace was added where families could enjoy performances. The Sunday performances in Balboa Park draw close to 100,000 people each year.

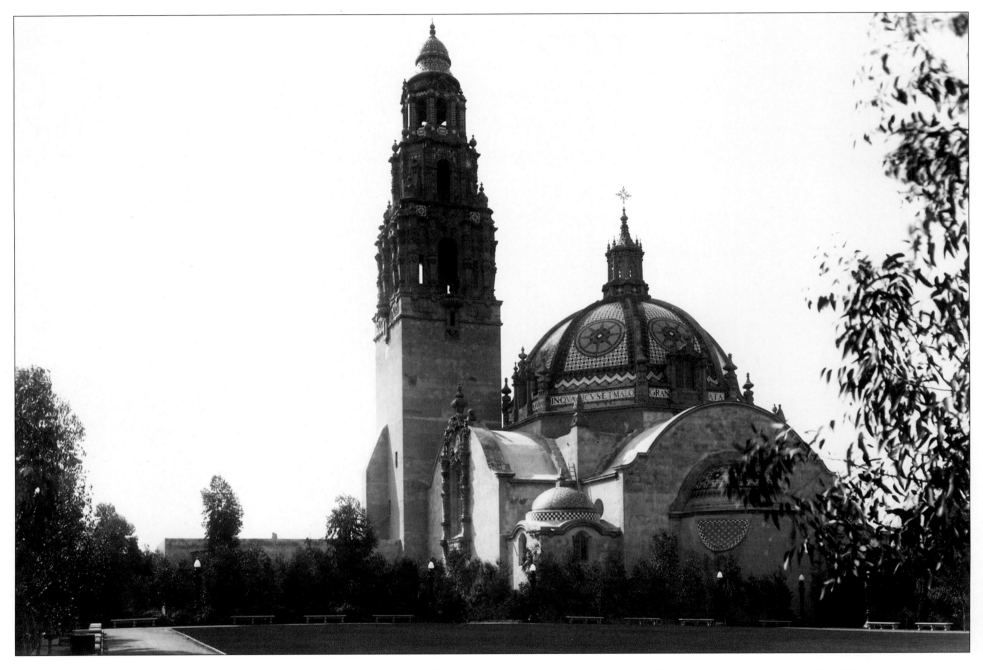

The 200-foot California Tower marks the Laurel Street entrance to Balboa Park and still does today the job that it was intended to do when it was built for the 1915 Panama-California Exposition. It provides a dramatic opening statement for any visitor to the park and is an easy point of reference for those within it. The tower's facade is adorned with statues of famous early Californians, including George Vancouver, the first English navigator to reach San Diego, and the vigorous, striding figure of Franciscan Father Junipero Serra. At the time he was in California, Serra was in his fifties and was disabled by a chronic leg infection, so his statue clearly harks back to earlier missionary days.

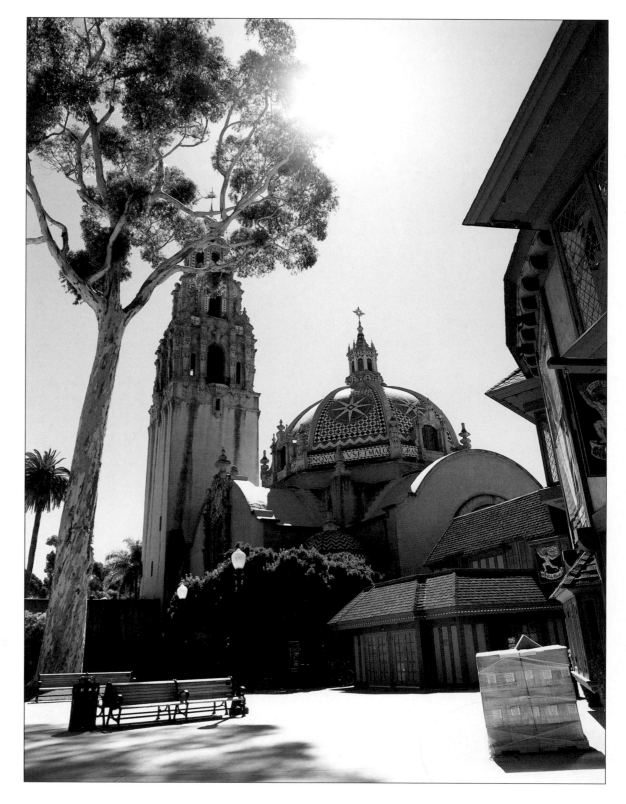

Today the California Tower still helps orient visitors within the park and the adjacent California Building also still serves its original role. For the 1915 exposition it was used to house exhibits that illustrated "The Story of Man through the Ages." In January 1916 it was officially designated a museum and has subsequently been renamed the Museum of Man, despite feminist attempts to have it called the Museum of Man and Woman. The Museum of Man is San Diego's only anthropological museum and houses one of the nation's great collections of artifacts, folk art, and archaeological finds connected with the ascent of man from hunter-gatherer to modern times.

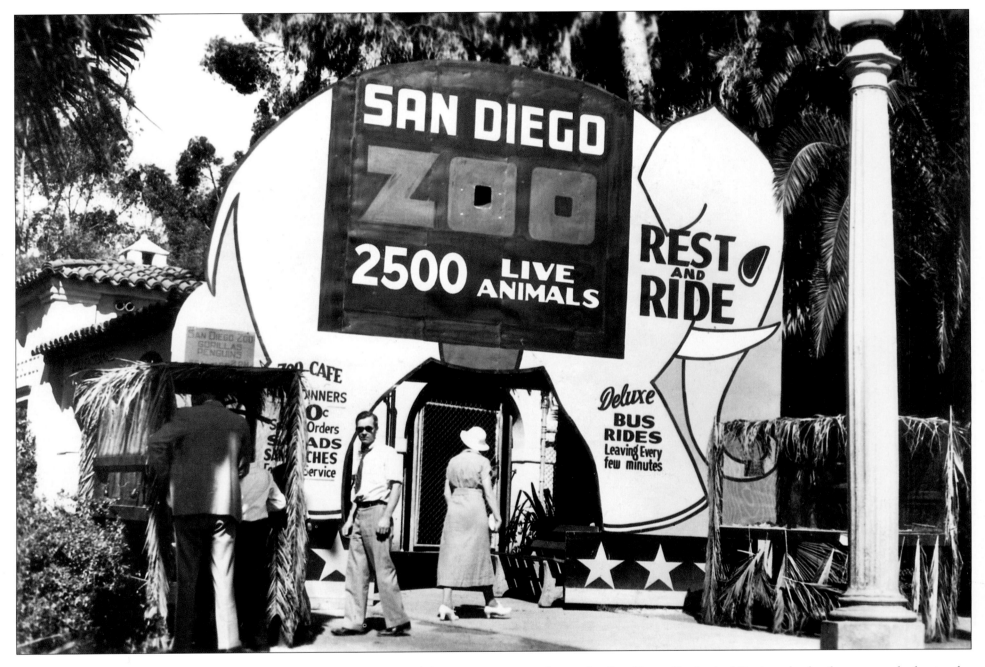

The history of the San Diego Zoo stretches back to the Panama-California Exposition when animals from foreign countries were brought to San Diego and put on display. A zoo was initially opened by Dr. Harry Wegeforth in 1916 with animals left over from the exposition. He quickly put the wheels in motion to get official and popular backing for his project. Donations poured into the San Diego Zoological Society, both of money and of animals. In 1922, the zoo moved into its permanent location in Balboa Park. Two of the zoo's earliest acquisitions were the elephants Empress and Queenie, brought from India by Frank Buck.

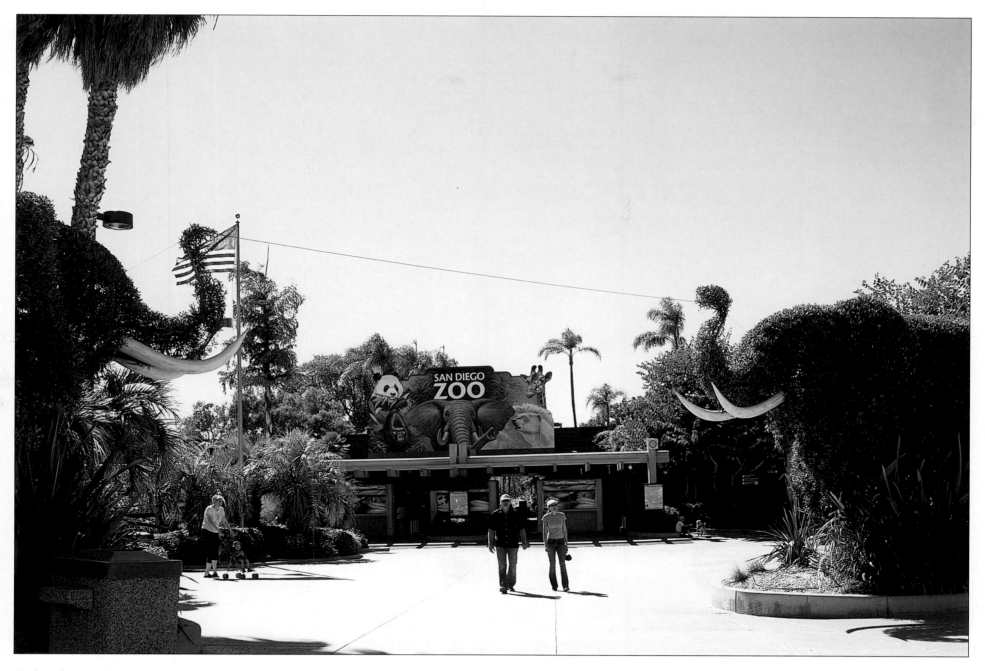

Today the zoo houses more than 4,000 animals from 800 different species and also boasts a collection of more than 6,500 species of plants. The zoo suffered attendance losses during World War II, but between 1949 and early 1951, there were over 2 million visitors. In 1975, the zoo developed a research arm called the Center for Reproduction of Endangered Species (CRES) in a bid to halt the slide toward animal extinction and also to help counter the worldview that zoos were not in animals' best interests. A major part of the project has been the successful mating of giant pandas. On August 21, 1999, Bai Yun gave birth to a cub, Hua Mei, whose progress was monitored the world over via a "panda cam" on the Internet. The proud father (by insemination), Shi Shi, was returned to China in 2003 and replaced by the far more ardent male Gao Gao. The new pairing produced a female cub, Su Lin, on August 2, 2005.

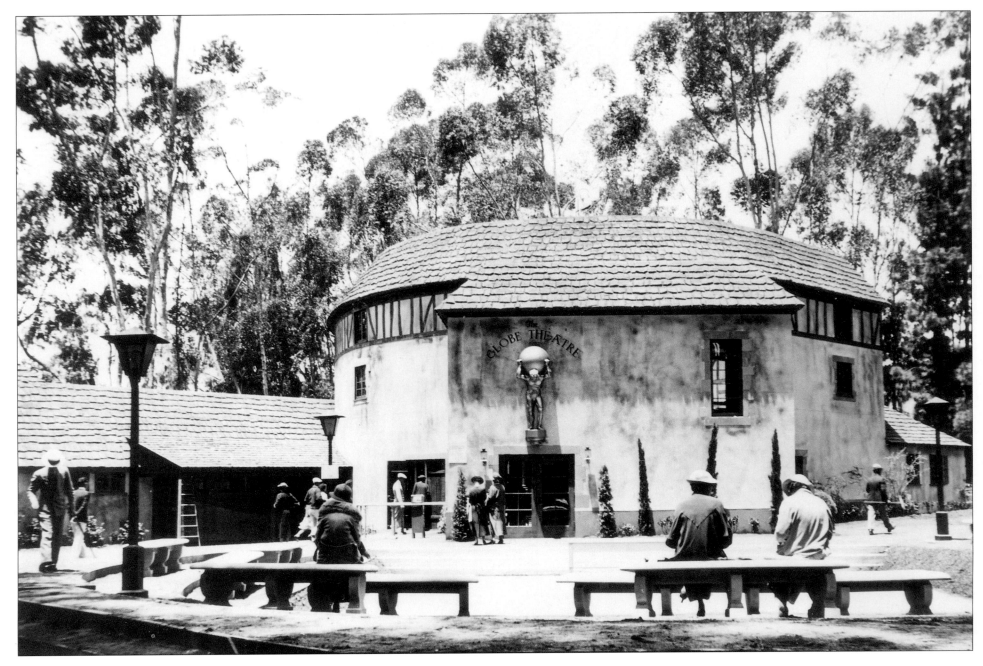

This circular theater was modeled on Shakespeare's own Globe Theatre in London. The intimate, 580-seat auditorium was built for the California-Pacific International Exposition of 1935 and featured a repertory of fifty-minute versions of Shakespeare's more popular plays. The theater continued to host a Shakespearean festival each year until an arsonist destroyed it in 1978.

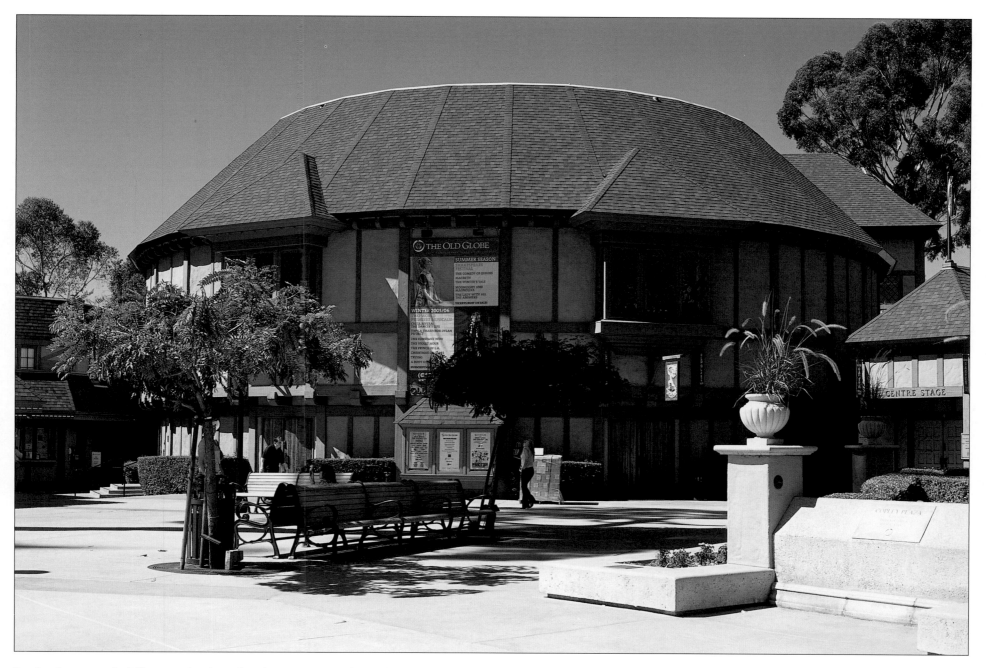

In the first month following the fire, the theater received nearly half a million dollars in unsolicited support. By 1982, a new Old Globe opened. Its first postfire performance was Shakespeare's *As You Like It*. Currently it produces fourteen shows each year and has a reputation for premiering new musical works. Its in-house artists make all of the costumes, sets, and wigs for each performance. The theater complex is the destination for over 250,000 people annually.

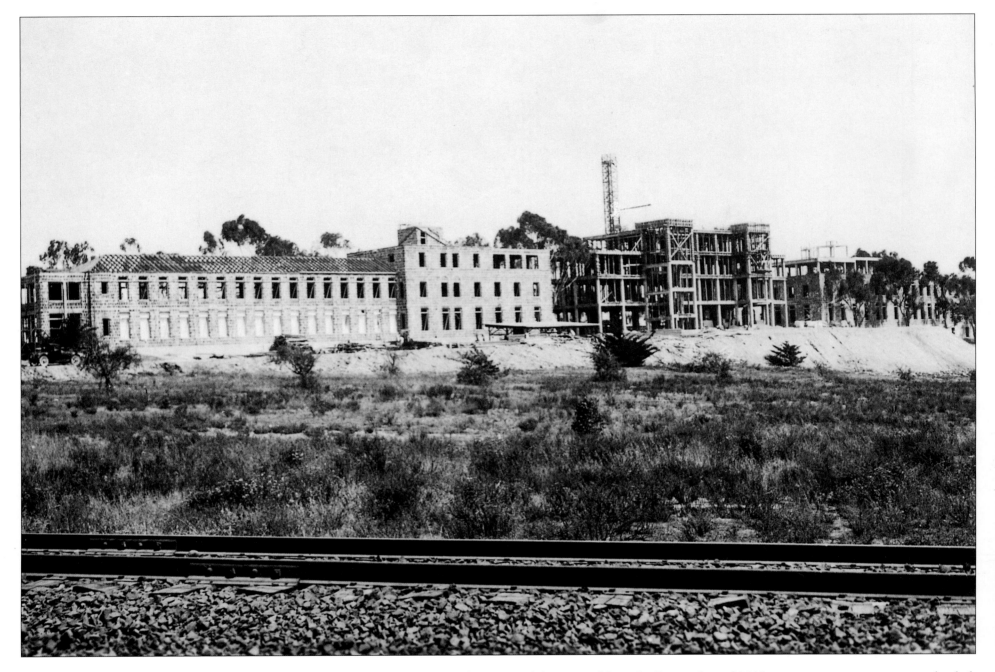

When San Diego opened its doors for the Panama-California Exposition, the military moved in. From 1914 to 1917, the Second Battalion of the Fourth Regiment of the marines were stationed in Balboa Park in conjunction with the exposition. Accompanying the battalion was a navy field hospital unit. After the expo, the navy stayed, and by 1918 it had an 800-bed facility, all operating out of tents. During World War II they also installed beds in the California Building. In September of 1919, over seventeen acres were deeded to the navy for a permanent hospital. A Spanish-Mediterranean style was adopted for the building to match the expo buildings. Subsequently the navy acquired more and more land in order to add several structures, including an X-ray building, chapel, gatehouse, and hospital corpsman school.

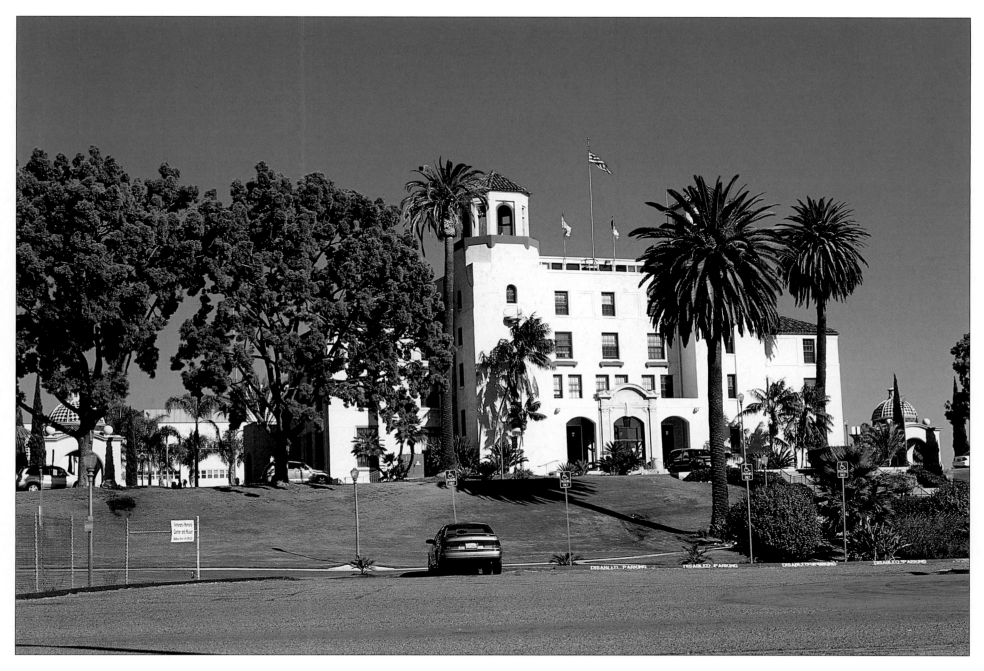

By the late 1970s the navy's presence in Balboa Park had become a hot political item. In 1979, 61 percent of San Diego voters approved giving the U.S. Navy a lease to about thirty-nine acres of Florida Canyon in exchange for parkland occupied by the navy. The vote was about 5.5 percent short of the two-thirds margin required by the city charter. The city then offered the navy fifty-eight acres at Helix Heights, which they turned down. Eventually the Florida Canyon option won out and the navy turned the old naval hospital site, including forty-two buildings, over to the city on June 30, 1988. The city council had already decided to demolish all but three of the buildings: the 30,000-square-foot administration building, the chapel (pictured above), and the 9,100-square-foot library.

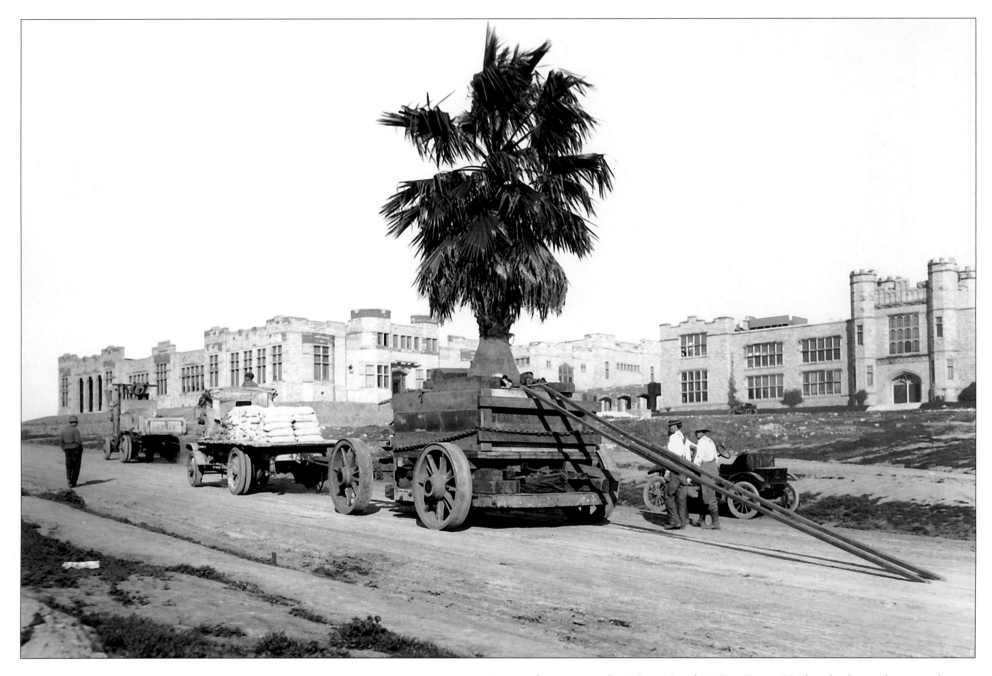

Known for years as the "Gray Castle," San Diego High is built on the site of one of the earliest schools in the area. An elementary school was first built here in 1882, with lumber donated by Joseph Russ. Ten years later, Russ High School took over the site. Work on the first San Diego High School started in 1906 with an initial $185,000 to pay for gothic doorways, turretlike structures, and castellated masonry veneered in native stone. Over the years, ivy covered the main "100" building, adding to its famous castlelike appearance.

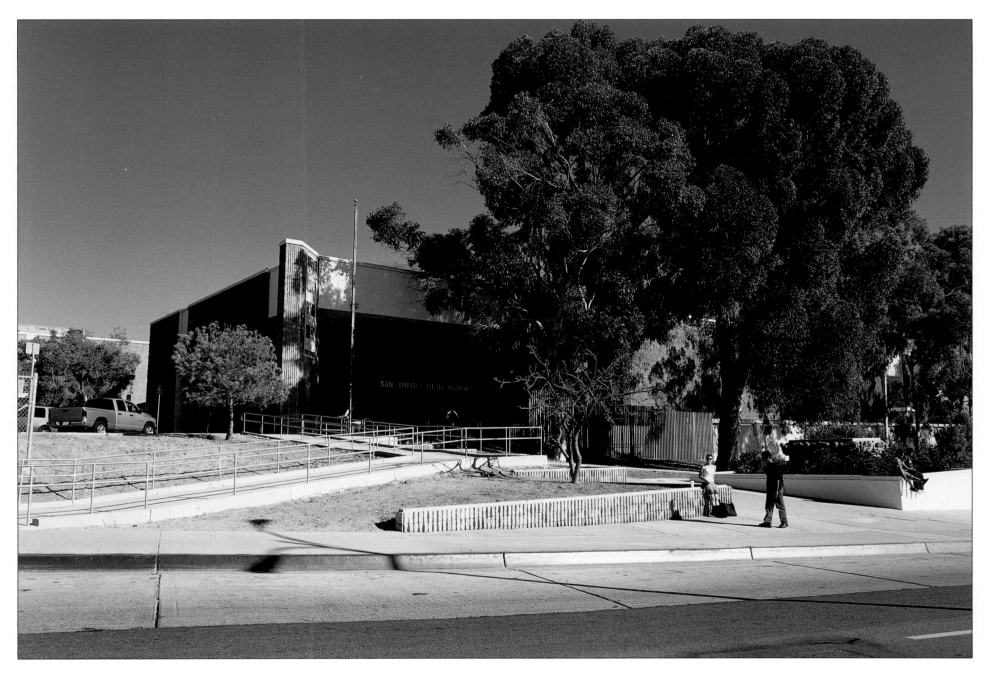

In the 1960s, legislation was passed requiring all school buildings constructed before 1933 to be demolished. The 1933 Long Beach earthquake and other California tremors made authorities fearful of the consequences of a major quake hitting a school. All buildings had to be replaced by June 1975. The demolition of the Gray Castle began in 1973, and once four new buildings were completed, the remainder of the old campus was destroyed. A San Diego landmark was gone forever.

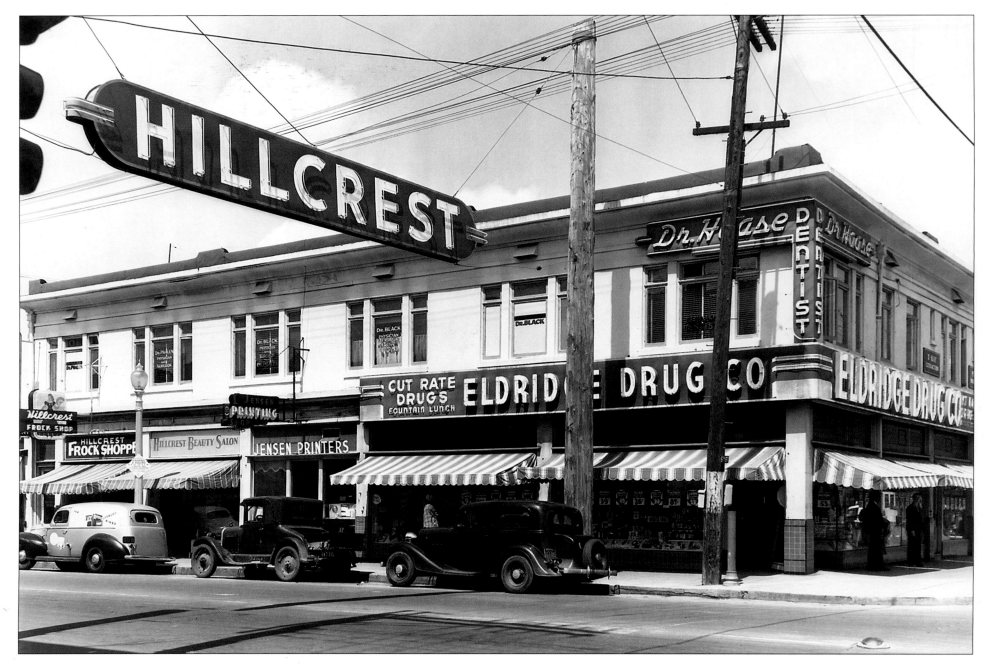

Neon welcoming signs stretch across the main streets in many old San Diego neighborhoods. Hillcrest was the first community to have such a sign: The Women's Business Association of Hillcrest donated the twenty-one-foot-long, thirty-one-foot-high Hillcrest sign to be placed at Fifth and University in 1940. Other neighborhoods, including Normal Heights, North Park, Kensington, University Heights, and Little Italy, would follow their lead.

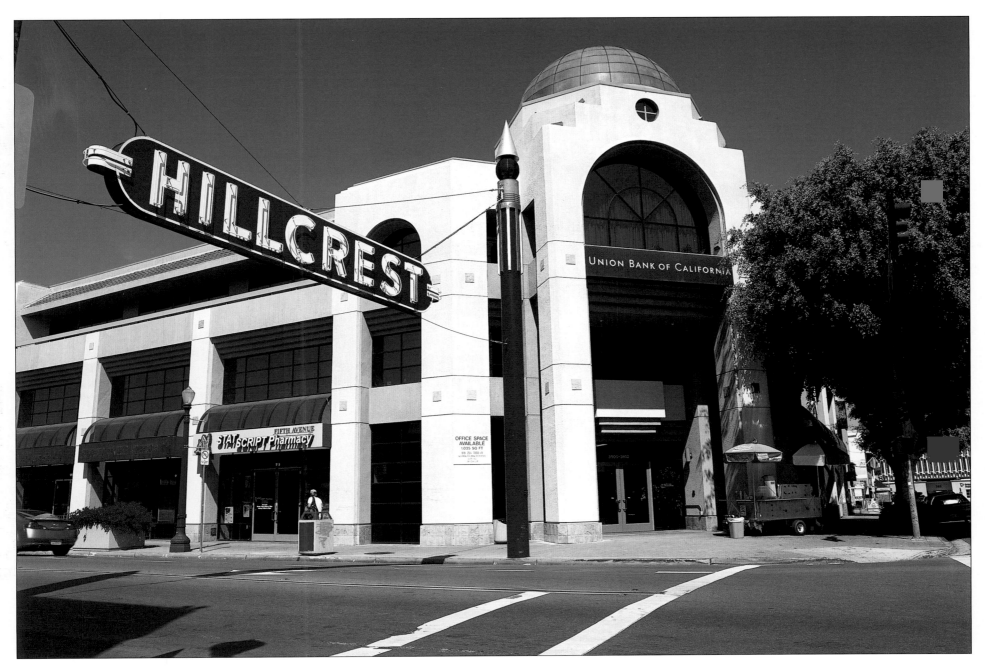

By the 1980s, the Hillcrest sign was showing signs of weathering and age. So in 1984, it was restored to its original condition, with new support columns on each side of the street. Newer neons blend elements from the neighborhoods' history; for example, the sign in University Heights features a streetcar, Craftsman-style rock columns, and ostriches! The signs are a reflection of the enormous sense of community felt throughout San Diego neighborhoods.

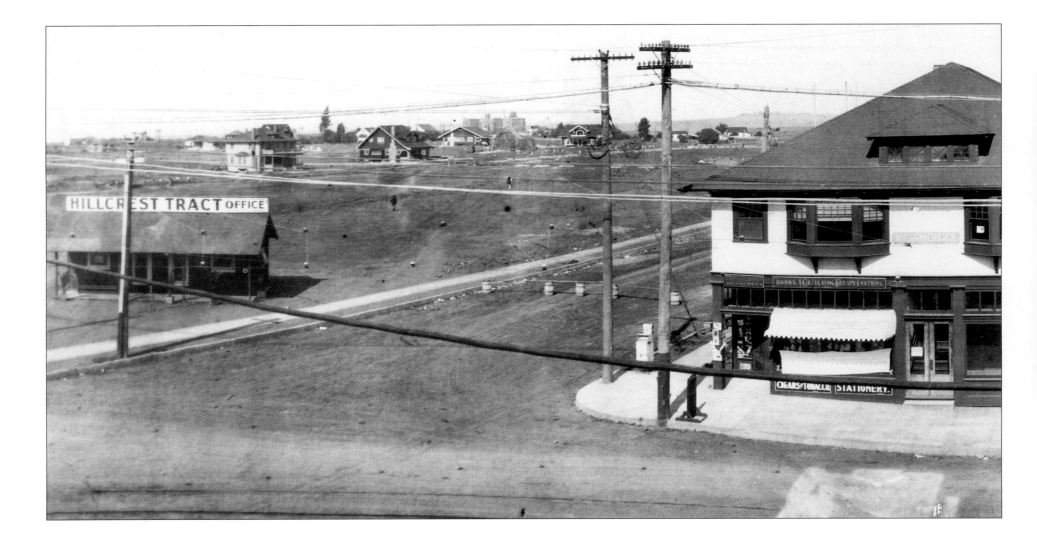

William Wesley Whitson purchased the forty acres comprising the Hillcrest neighborhood in 1906 for $115,000. Whitson, who only had enough cash to make a $1,000 good-faith down payment, went to work over the next month selling shares in his Hillcrest Company—the name suggested by his sister-in-law, Laura Anderson. At the time of Whitson's purchase, the only buildings in the area were St. Joseph Hospital (now Mercy Hospital) and a single one-story home. Land sales were made from the tract office seen in this photograph.

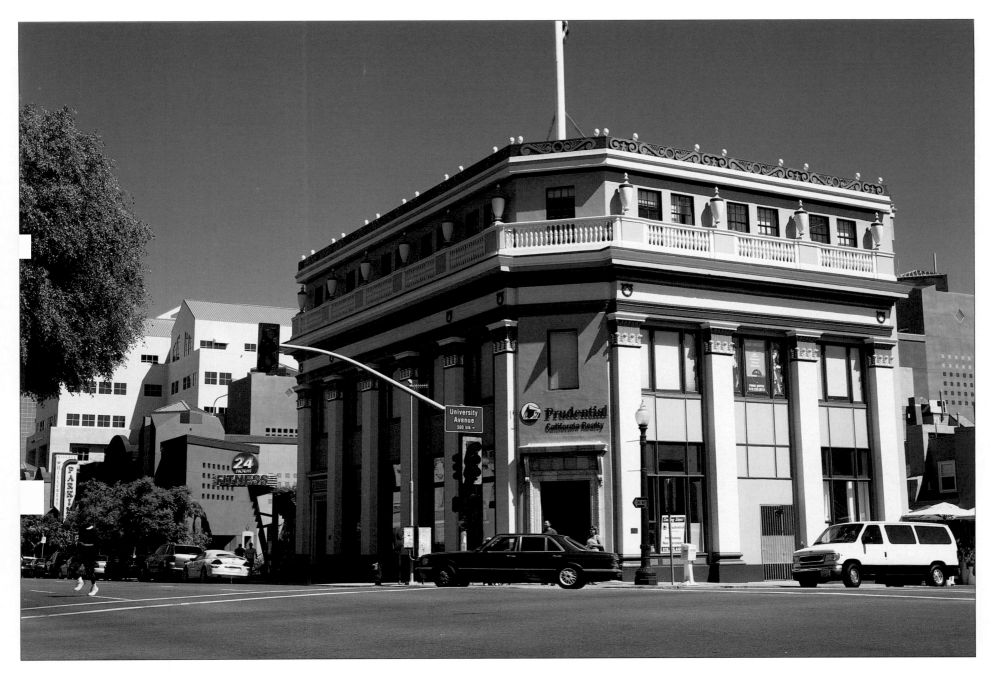

Considered San Diego's first suburb, Hillcrest is two miles north of downtown San Diego, home to 36,000 residents, and brimming with trendy shops and cafés. Restaurants of almost every ethnic specialty are located here. Hillcrest today has a thriving gay and lesbian community. Every July thousands of people come out to participate in and watch the annual Pride Parade, one of San Diego's biggest civic events, and attend the Pride Festival. In the spring, Hillcrest is treated to "purple showers" when the jacaranda trees planted along its main streets begin to blossom.

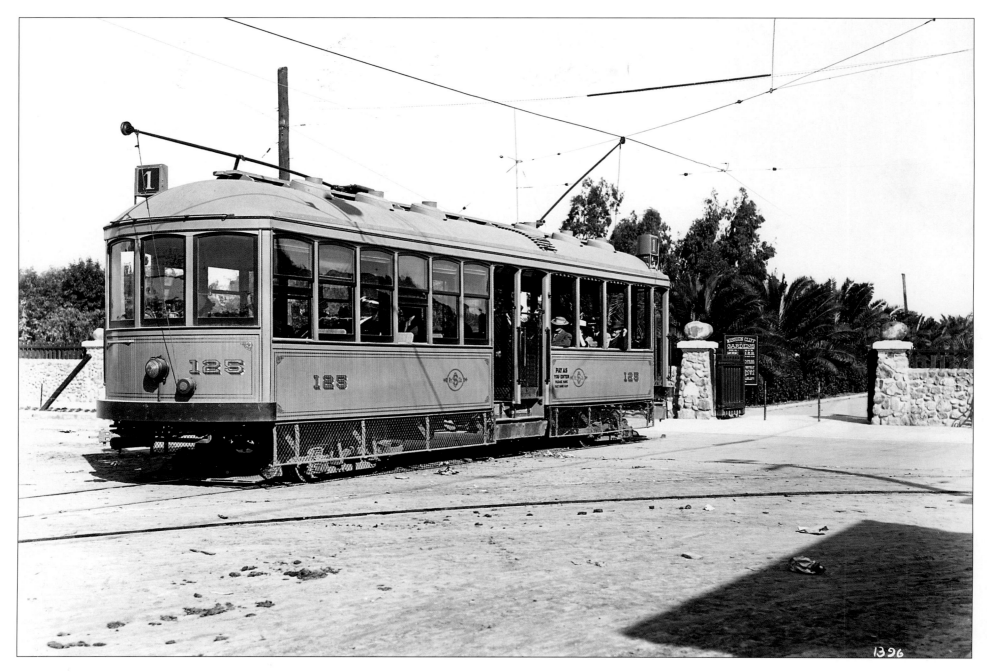

The University Heights neighborhood is one of San Diego's oldest. Once called the Bluffs, it is centered around the intersection of Park Boulevard and Adams Avenue. At the time of this 1910 photo, its Mission Cliff Gardens were a favorite recreational destination. Developed as a botanical garden, it contained an aviary, deer park, merry-go-round, picnic tables, and a soda fountain, plus a two-story pavilion known as "the tea garden" because of its resemblance to a Japanese teahouse. Just east of the main entrance was the Harvey Bentley Ostrich Farm, which opened in 1904, where locals could ride an ostrich for fifteen cents, though its main purpose was to provide ostrich feathers for women's hats and garments.

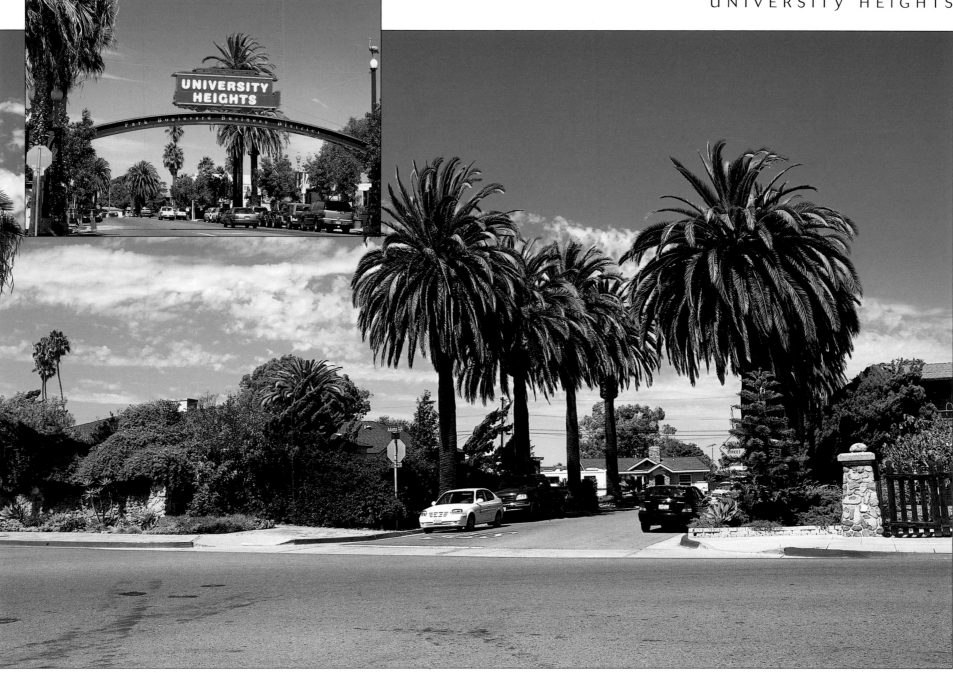

Although the streetcar no longer runs into University Heights, the community erected this neighborhood sign to honor both the streetcar and the ostrich farm. The rock wall that once surrounded Mission Cliff Gardens still stands. In addition, a stone pillar with an engraved ostrich greets visitors to the neighborhood. All that remains of the gardens themselves is the rock wall of what was once a lily pond. It was said that in 1914 you could sit in the arbor at Mission Cliff Gardens and hear the sound of cattle mooing and the rattle of milk cans down in the Mission Valley farms. These sounds can no longer be heard.

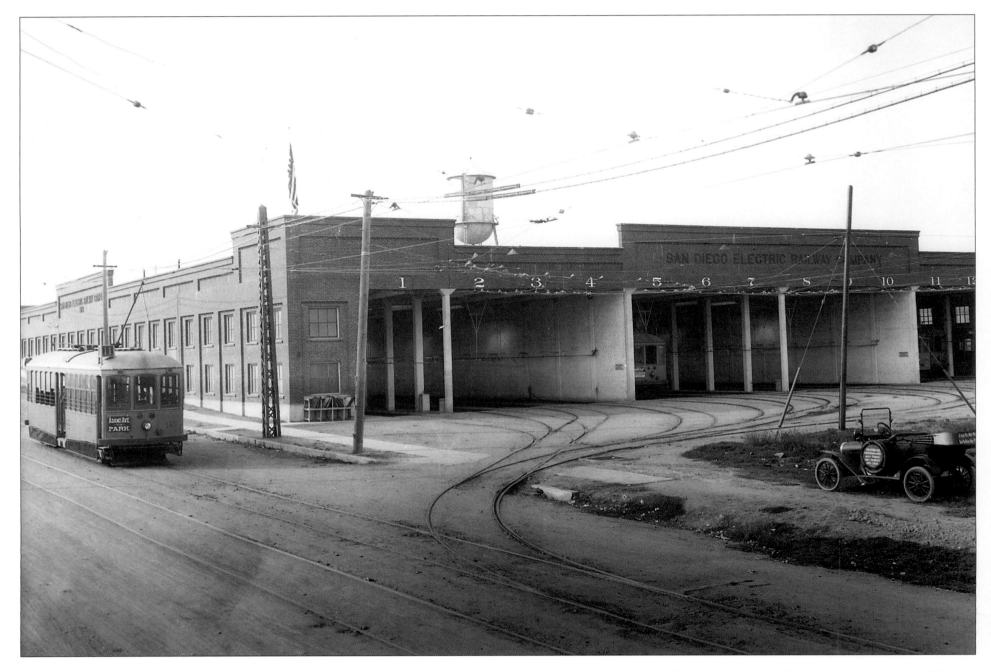

The Adams Avenue Streetcar Barn was built in 1913 and survived until 1980. Built as storage space for surplus streetcars, the brick building was located just east of Bentley's Ostrich Farm in University Heights and Mission Cliff Gardens. The first cars of the San Diego Cable Railway ran on June 7, 1890, and a few months later began operating to Mission Cliff Gardens. The cable company made use of the Eppelsheimer bottom grip system, enabling it to save money by operating on a single track. Alas, when San Diego's economy took a plunge, the bank backing the cable company failed and it was forced to close in 1892. John D. Spreckels bought the defunct company in 1896 and converted the line to electric streetcars.

In 1907, the line was extended out from Adams Avenue to the communities of Normal Heights and Kensington. However, in 1949 the streetcar service was discontinued on Adams Avenue. San Diego streetcars were replaced with buses and the streetcar barn turned into a box factory. In the latter part of the twentieth century, the building was torn down to make way for a community park, called, fittingly, Trolley Barn Park. The park was developed in conjunction with the University Heights Community Association and was awarded the prestigious AIA Orchid award in 1992.

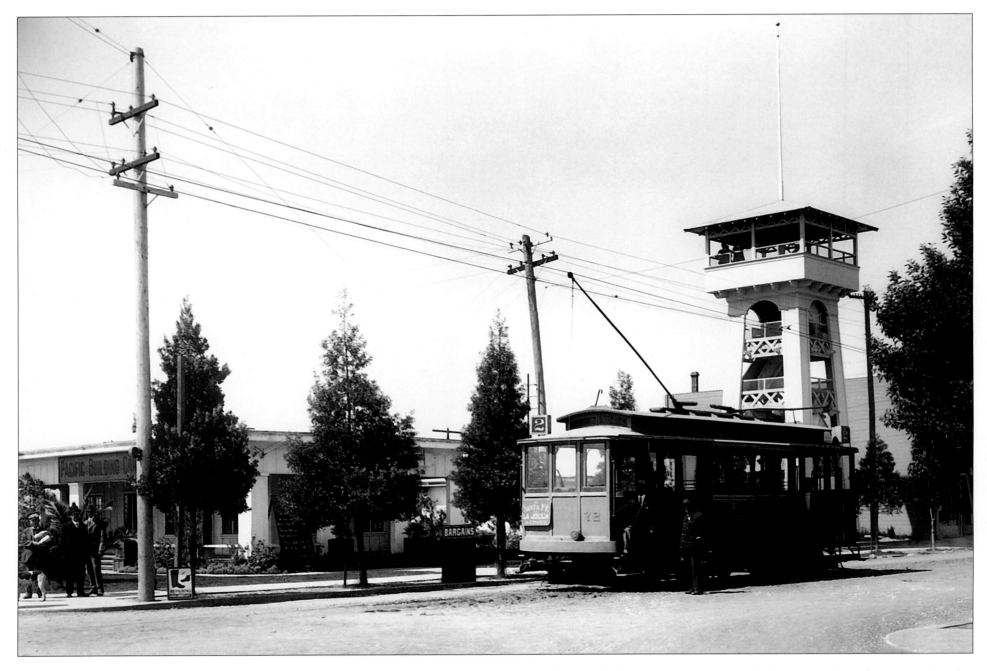

Once quite separate from San Diego, City Heights almost ended up being called Teralta. The local post office named its branch Teralta, but the developing real estate company, the Columbia Realty Company, was keen to stress the name City Heights for its own marketing purposes. Census figures show that the population in 1910 was just 400. The intersection of Fairmount Avenue and University became the center of City Heights after the San Diego Electric Railway company extended their route from the western border of City Heights to the intersection of University and Fairmount. City Heights was first incorporated in 1912, becoming the second-largest city in San Diego County. At the time, people moved here to escape the "immorality" of San Diego, because the city outlawed liquor sales, dance halls, gambling, carrying a gun, and driving faster than fifteen miles per hour.

The intersection of Fairmount and University is still one of the busiest in the neighborhood. Although it now houses a shopping center, it was once the location of a glassed-in octagonal tower that was used as a drive-in and soda fountain. By the 1920s the population of City Heights had soared to 10,000 and the water company supplying it was failing. The water shortage of 1923 moved City Heights residents to vote to become consolidated as a part of San Diego. The neighborhood is now home to more than 60,000 San Diegans, many of Asian descent, who are responsible for some of the estimated 105 dialects spoken in the community. There has been an ongoing program of urban renewal since the mid-1990s, centered on the City Heights Urban Village and aimed at providing affordable housing and community facilities in one of San Diego's once most blighted of areas.

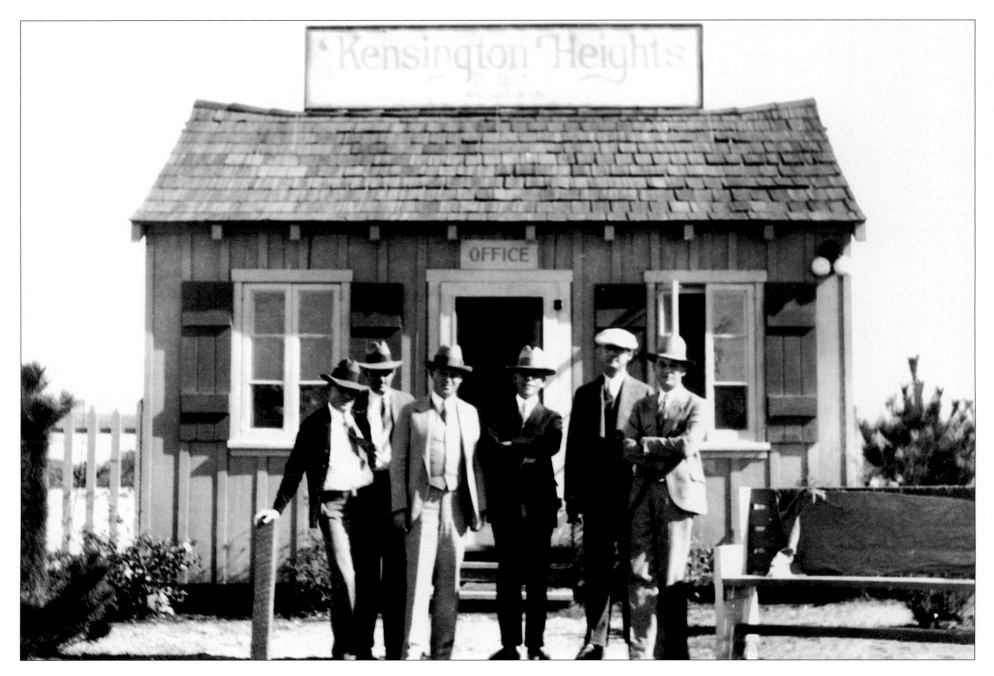

In 1909, a group of investors who wanted to build a luxury neighborhood chose an area east of San Diego perched on the canyons overlooking Mission Valley. Named in honor of London's Kensington, the new development was far enough away from the ocean to avoid fog and dampness, but close enough to benefit from cool ocean breezes. Building began in 1910. Although most of the streets were given English place-names like Middlesex, Canterbury, and Sussex, the homes were built in a Spanish style with red tile roofs.

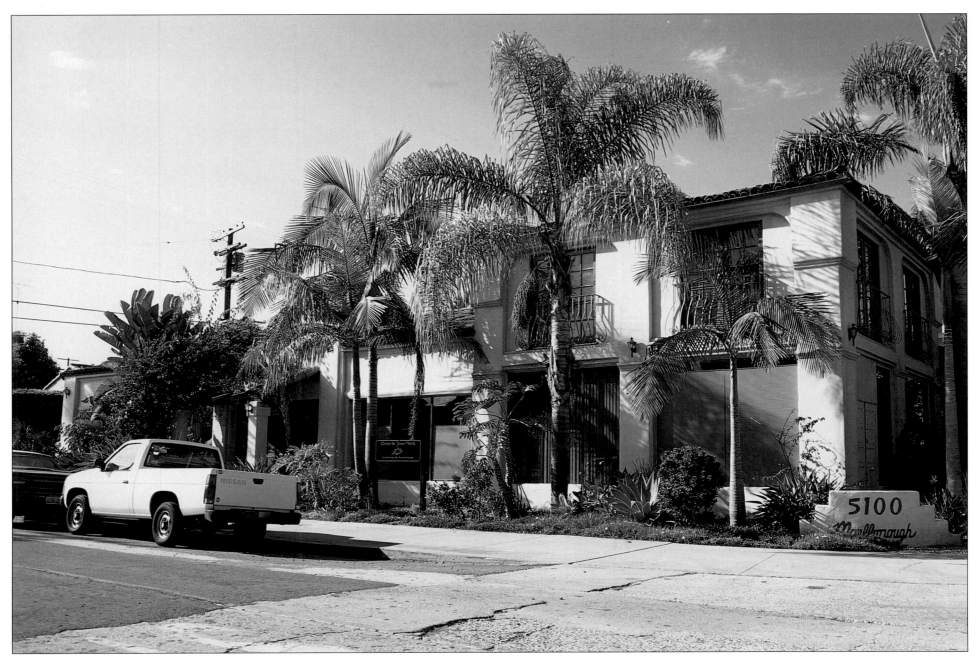

A building called Marl-Dale was constructed where the original real estate office once stood. It was hoped that Marl-Dale would be the first of a new commercial center in Kensington. However, the business district moved closer to the streetcar line, and today the building is surrounded by private homes and luxury apartments. Over the years, Marl-Dale has housed a bakery, a real estate office, a telephone company, and a beauty shop. Today psychotherapists occupy its offices.

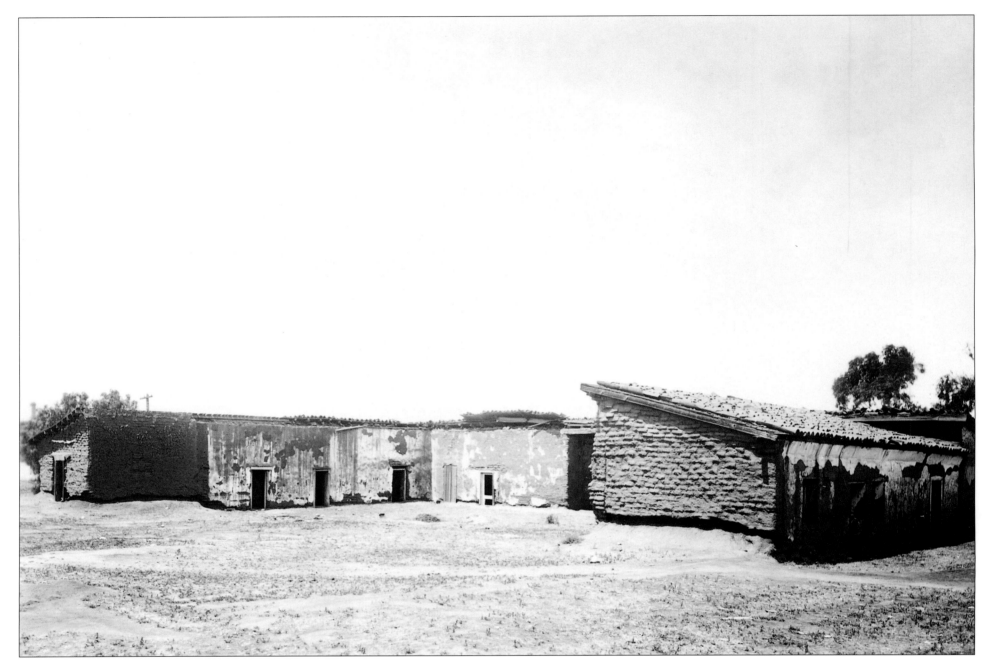

This adobe casa is one of five original houses that are part of San Diego's Old Town State Historic Park. Built around the same time and across the street from Casa de Bandini, it was the home of Don Jose Antonio Estudillo, the commandant of the San Diego Presidio. It was constructed using adobe bricks, heavy wood beams, thatched roofing, and sienna-hued clay-tiled floors. The home fell into disrepair after 1887 when Estudillo left, and the caretaker appointed by the family sold off tiles, locks, doors, and windows of the house.

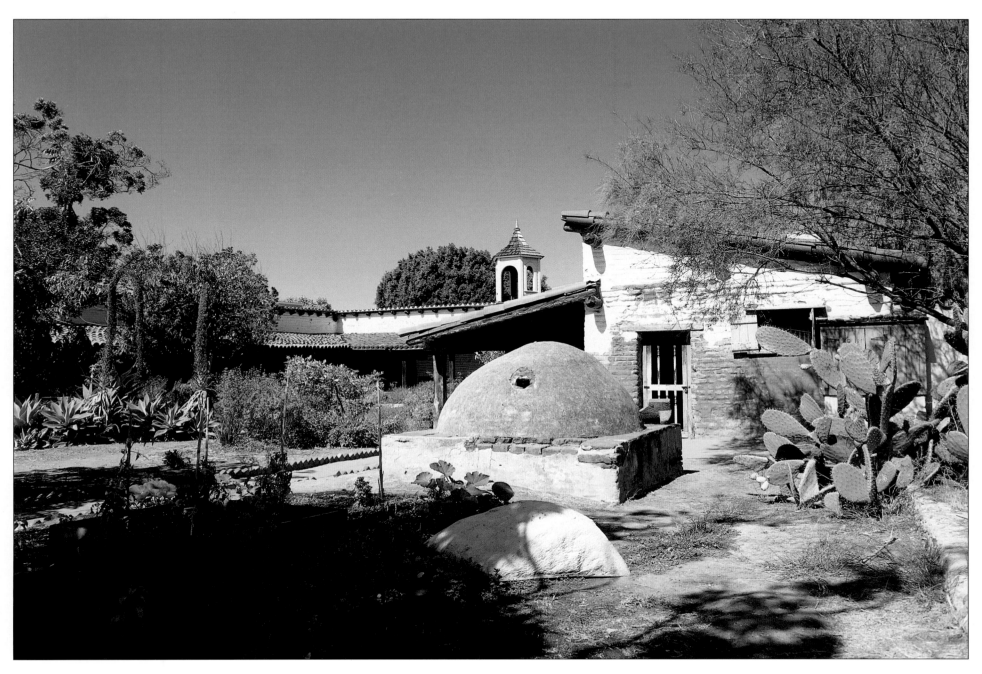

Sold by the Estudillo family in 1905, local benefactor John D. Spreckels took the house on in 1910 and restored it using traditional labor methods. It now houses a collection of antiques and curios worthy of one of the first Mexican Californian mansions. Gated doorways give visitors a glimpse into rooms decorated with authentic Spanish and Victorian furniture; there is also a working kitchen of the period, equipped with nineteenth-century utensils and kitchenware. When Helen Hunt Jackson used the casa's chapel as a setting in her novel, *Ramona*, the home became known as Ramona's Marriage Place.

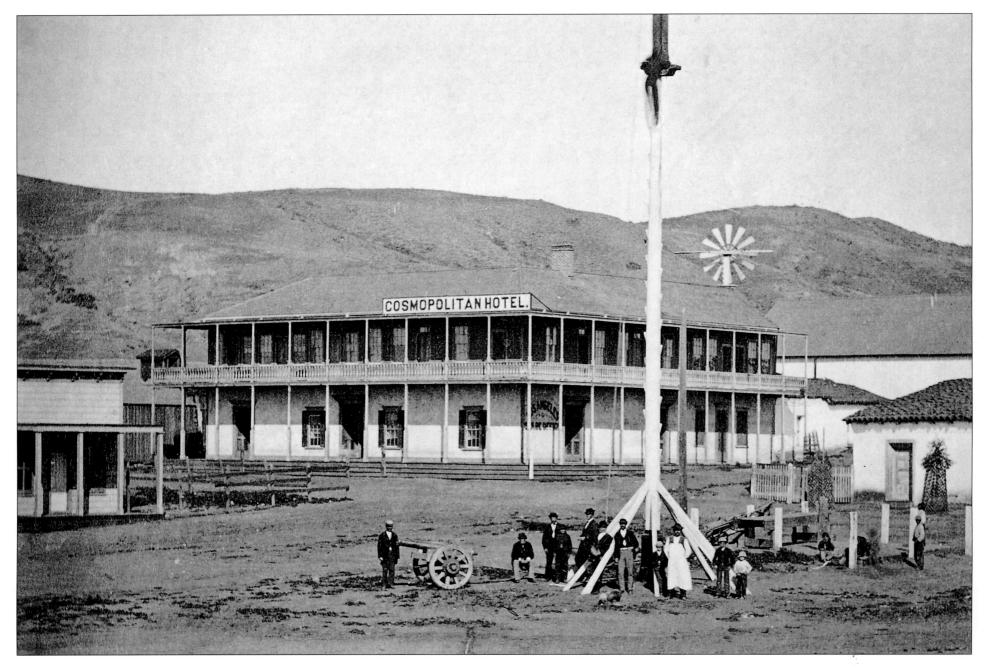

This 1872 photo shows the Mexican adobe home built in 1827 by Don Juan Bandini, an early Californian political leader. Bandini lived in the house with his wife, Dolores Estudillo, daughter of a prominent Spanish family. In 1846, Commodore Robert Stockton, commander of the Pacific Squadron of the navy, used Bandini's home as a headquarters. Kit Carson was at the house on December 9, 1846, requesting reinforcements for American troops near San Pasqual. In 1869 the home was remodeled and a second story added by A. L. Seeley, who operated the casa as the Cosmopolitan Hotel.

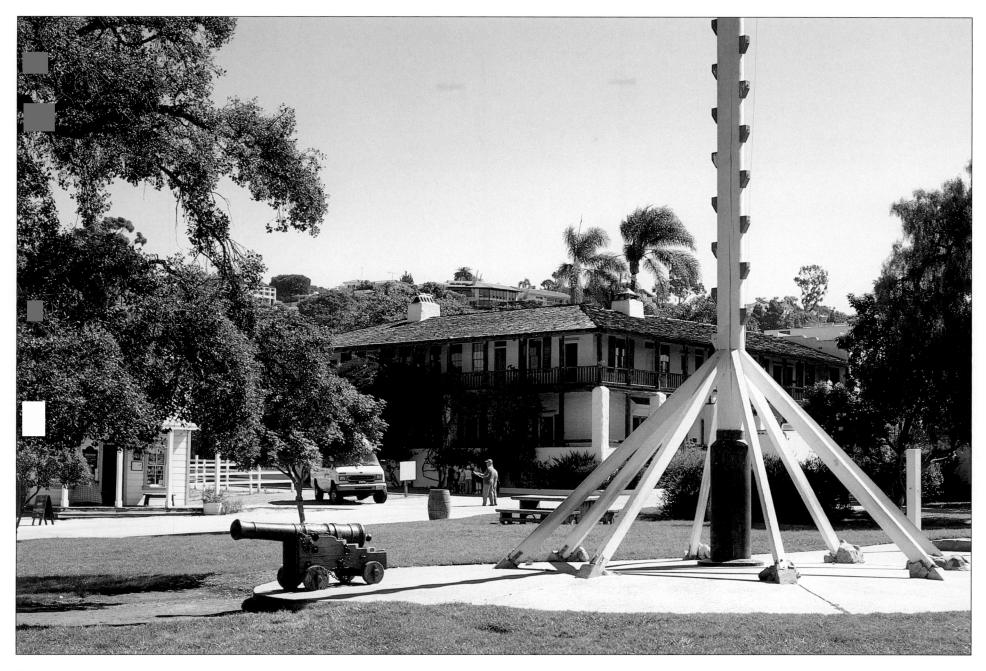

Throughout the building's history, a store and post office have been operated on the premises. It has also been pressed into service as a pickle factory and motel annex. Up until 2005, Casa de Bandini had a function that perfectly fit its cultural heritage; it was one of San Diego's favorite Mexican restaurants. Known for its giant margaritas served alfresco in the courtyard, diners sat amid a backdrop of playful fountains and the music of strolling mariachi bands. However, the restaurant has now closed in Old Town and is scheduled to reopen in the old police headquarters next to Seaport Village in 2007.

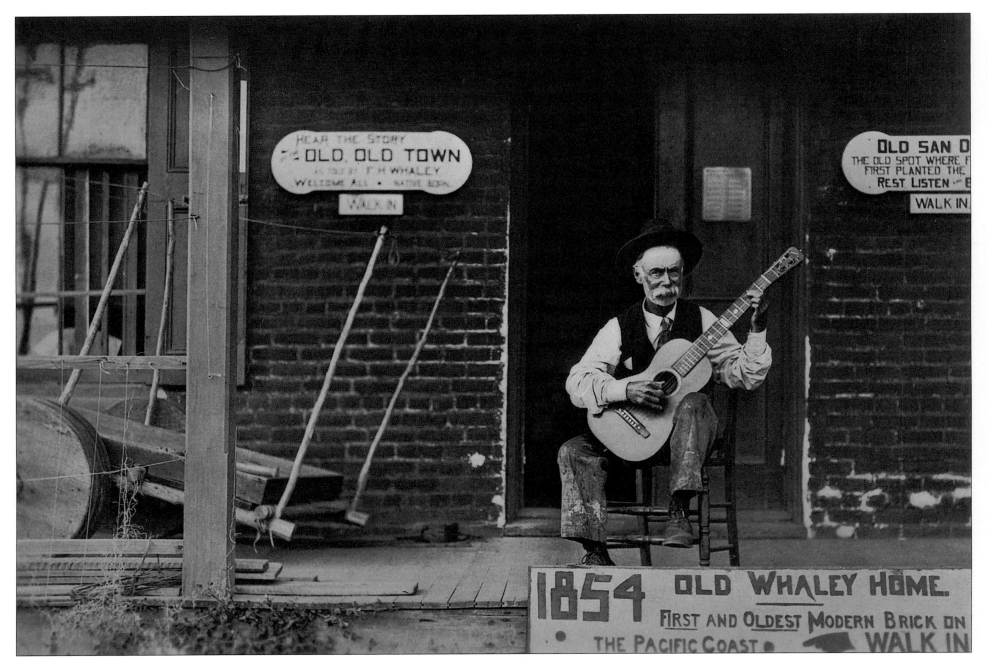

Located on the east side of San Diego Avenue, the Whaley House is the city's oldest brick home, built in 1857. Using plans he'd brought from the East Coast, Thomas Whaley created a home that would rival the New York houses of that period. The house, which cost him $10,000 when finished, was a showpiece, featuring mahogany and rosewood furniture, damask drapes, and Brussels carpets. Whaley came to San Diego during the 1849 gold rush intent on a trading career and bought land, a brick-making machine, and molds for $2,500. In its time, the building also served as a courthouse and theater, hosting sessions of the court, jury trials, theatrical events, musical soirees, and even formal balls. Pictured is Whaley's son Frank in 1915. Documents uncovered by the County of San Diego prove that the date of the house, proudly proclaimed on the sign, is off by three years.

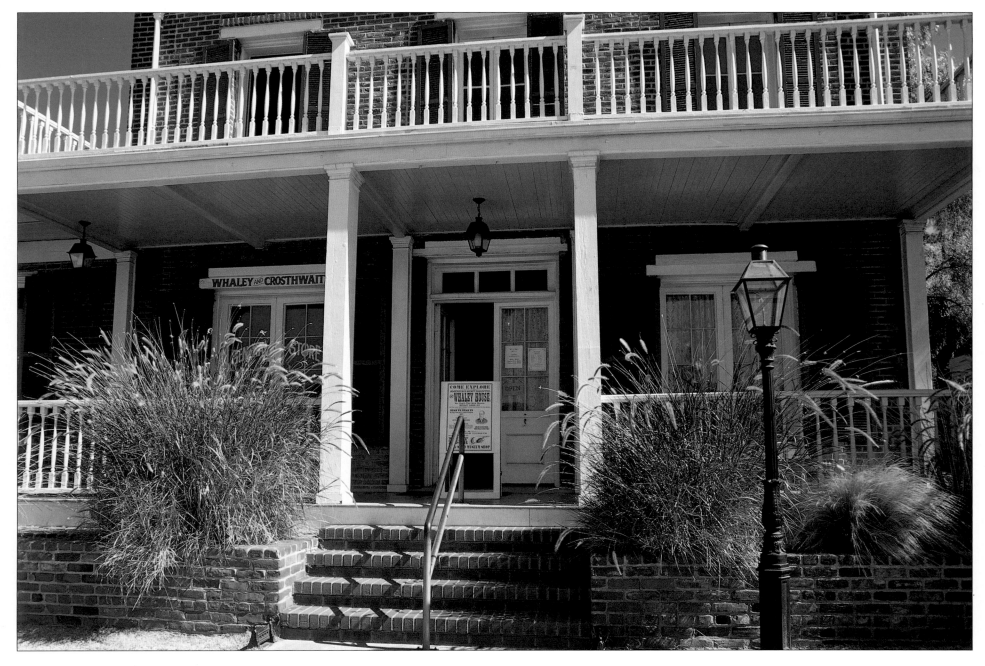

In 1956 the Board of Supervisors of the County of San Diego finally agreed to purchase the Whaley House and restore it to its original condition. For years it had been left to rot as businesses had moved away from old San Diego to new San Diego. There was initially great resistance to moving the courthouse. Without success, in 1871 Judge Thomas H. Bush placed a cannon in front of the building to prevent removal of the county records to new San Diego. Though there is no sign of the acoustic guitar played by Thomas Whaley's son Frank, the building's trustees have located an organ played by his wife, Anna, and two pairs of wooden "bones," an acoustic, handheld item, played by Frank. The house is also known as one of San Diego's most haunted houses. Over the years, visitors have allegedly seen furniture levitating, heard music being played on the old organ, and witnessed windows mysteriously opening and closing.

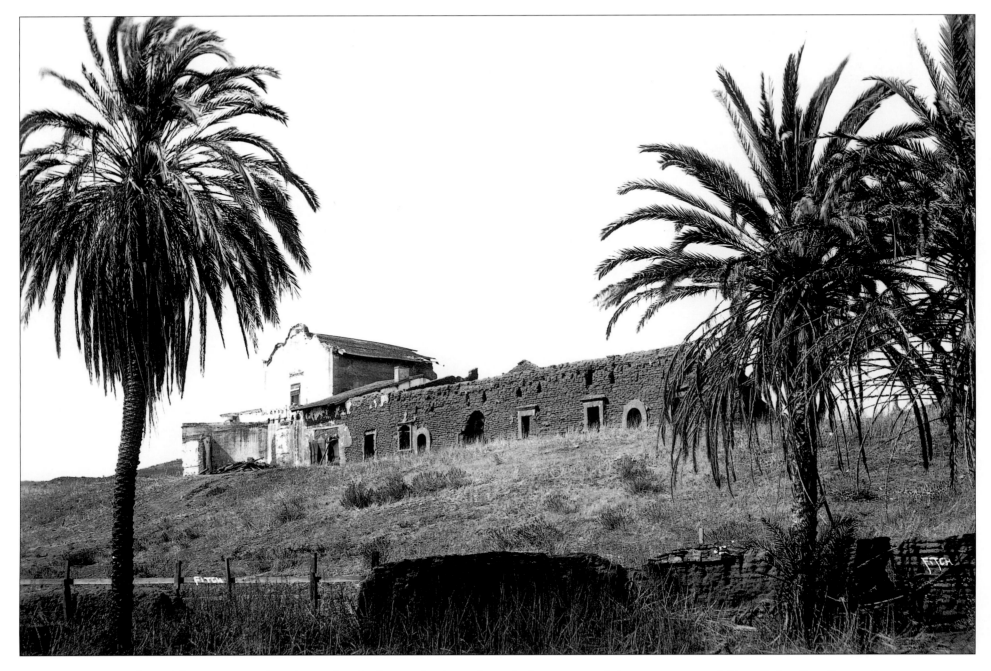

Known as the "Mother of the Missions," San Diego de Alcala was the first of the twenty-one California missions set up by the Spanish. Founded on July 16, 1769, by Father Junipero Serra, the mission was originally located on a hill overlooking the bay. Because of poor soil and scarce water supply, the mission only stayed on this site for five years. A new location was chosen six miles east in what is now Mission Valley. In 1775, though, eight hundred Indians stormed the new mission, killing Father Luis Jayme. Jayme, a Majorcan by birth, became the first Christian martyr in California. Fearing there would be another such raid, Father Serra returned to oversee the rebuilding of the mission, this time to the specification of an army fort. This 1895 photo shows the mission at its second site.

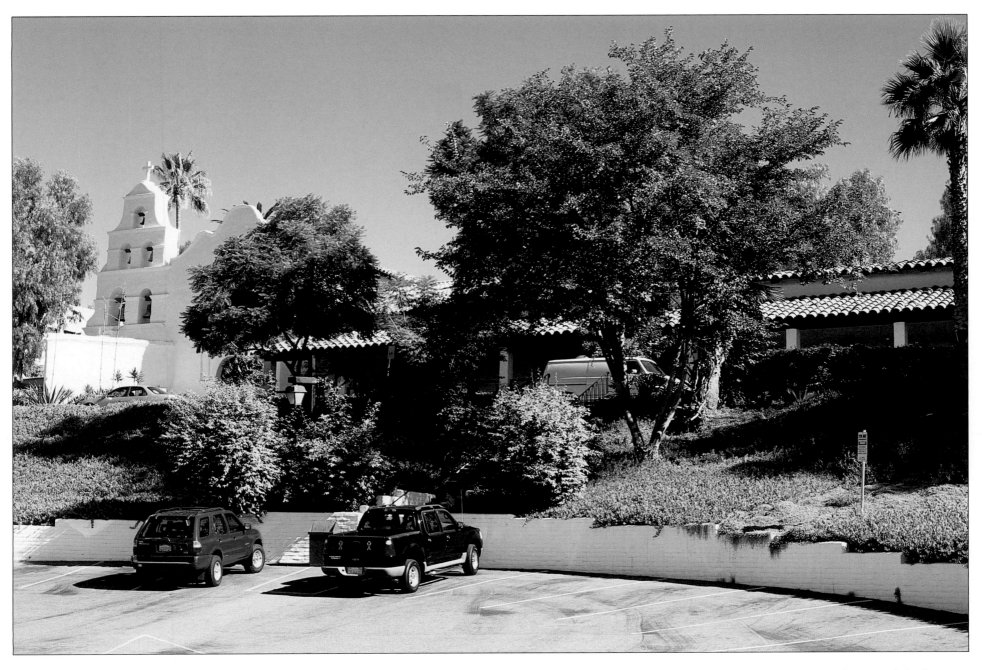

Today the mission church is an active Catholic parish and cultural center in the diocese of San Diego. Since the Franciscans' departure (1834), it has been employed as a barracks for cavalry and artillery regiments (after the United States acquired Mexico), it has endured periods of abandonment, and for seventeen years it served as a school for American Indian children. In 1931 the mission was rebuilt to mirror the 1813 church; remarkably, the new building was the fifth church on this site. The pope bestowed the honor of naming the Mission San Diego de Alcala as a basilica in 1976; it is one of just four in California. In the Catholic Church, a basilica is a church of historical significance. The murdered priest, Father Jayme, remains to this day buried underneath the altar.

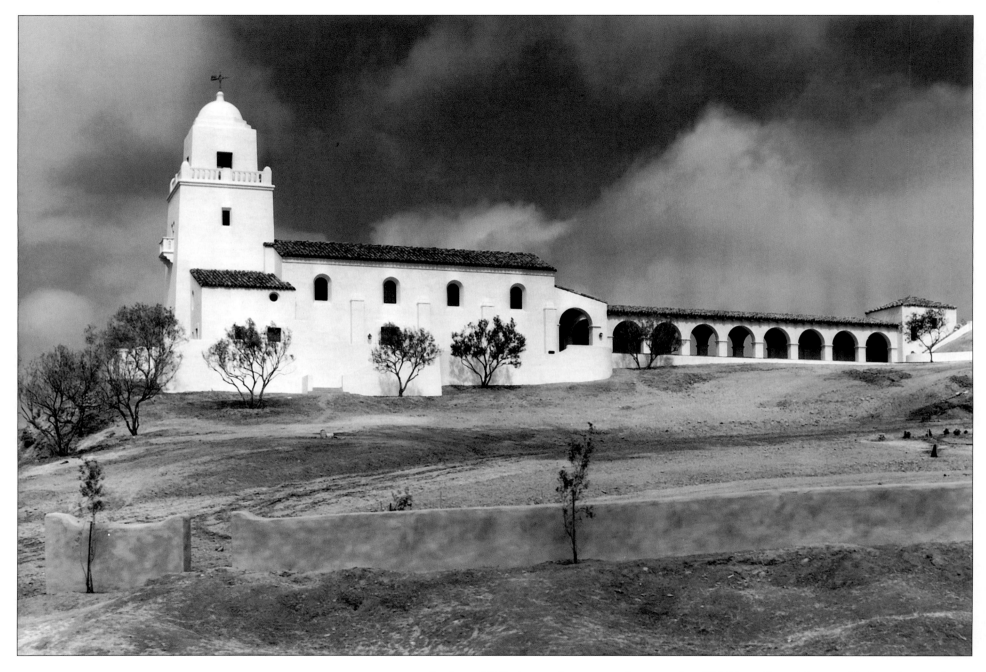

Built in 1929 above what was to become the Old Town State Historic Park and very close to the site of the first Catholic mission, the museum is named after Father Junipero Serra, the founder of that mission. A Spaniard from Majorca, Serra was fifty-six and plagued by a chronic limp when he set up the original settlement in 1769. Six years later he had to return to supervise the rebuilding of the second mission after it had been attacked and its pastor Father Luis Jayme murdered. The museum was the brainchild of George White Marston, a leading San Diego merchant and philanthropist.

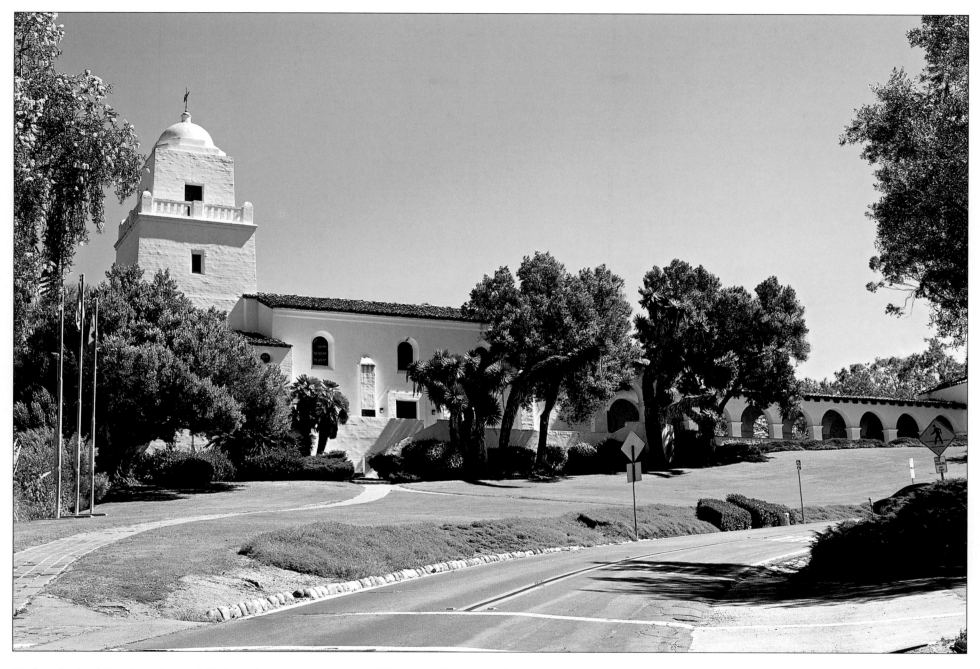

Today the building has changed little in looks or in use. It still houses relics from the area's Native American, Spanish, and Mexican inhabitants. Over the years, archaeological digs have been undertaken near the site. Some 32,289 fragments of ceramic, metal, glass, and stone have been recovered in that time. Indeed the site was chosen in part because it gave researchers the chance to study an old Spanish military compound. This is the only presidio in California that can be excavated in its entirety because the land is on city property and no modern buildings have been built over the ruins.

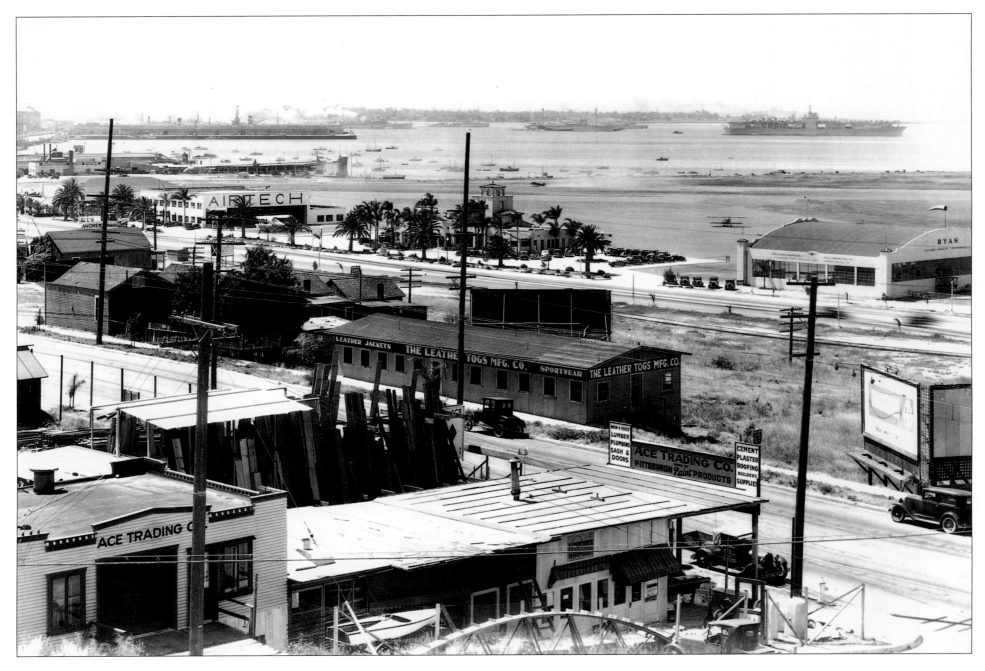

On leaving the Army air cadets in 1922, T. Claude Ryan started his civil flying career as a barnstormer offering flights for $2.50. He set up business at Dutch Flats and opened the Ryan Flying Company, taking whatever work came his way, whether it be passenger business or flying lessons. By 1925 he'd opened the Los Angeles–San Diego Airline, offering scheduled flights.

It was his 1926 design of the Ryan M-1 monoplane that ultimately led to Charles Lindbergh making aviation history. When the city built its own airport on the site, it named the field after Lindbergh, though much credit should go to Ryan's aircraft-design skills. The tree-surrounded terminal can be seen in this 1930 photo, as can Ryan's hangar, to the right.

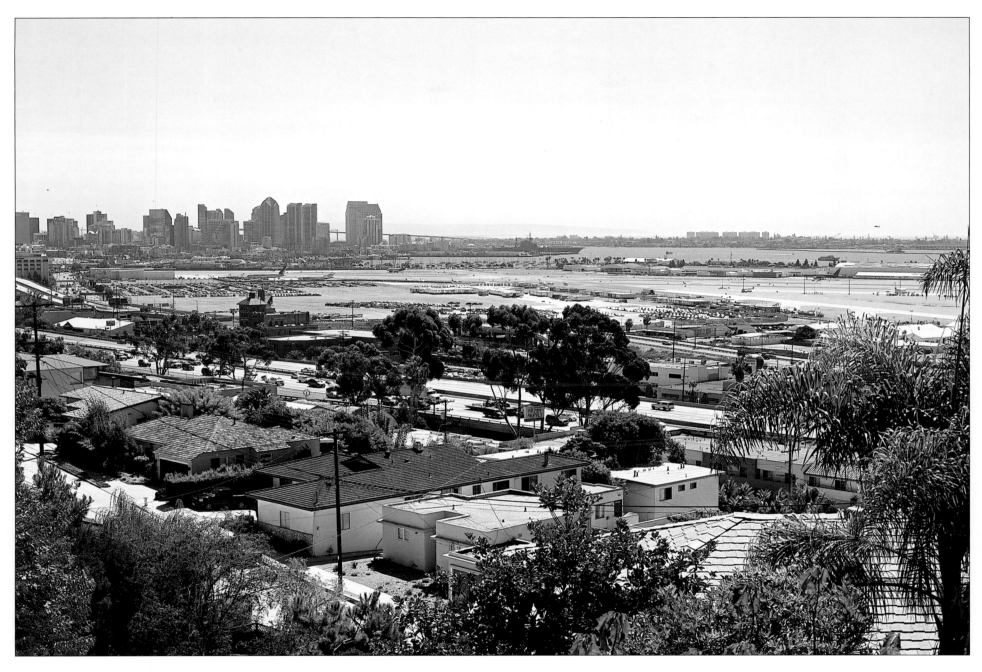

San Diego is one of the few major cities in which the airport is located in the center of the city. Passengers on incoming flights can see many landmarks, including the California Tower, the Navy Hospital, the San Diego Aerospace Museum, and Balboa Park. The airport's proximity to downtown, though perfect for delivering tourists and businessmen swiftly into the heart of the city, has given the airport little room to expand because of land space and the environmental impact on neighboring communities. Today the airport handles around 15 million visitors and that figure is expected to rise to 28.6 million by 2020.

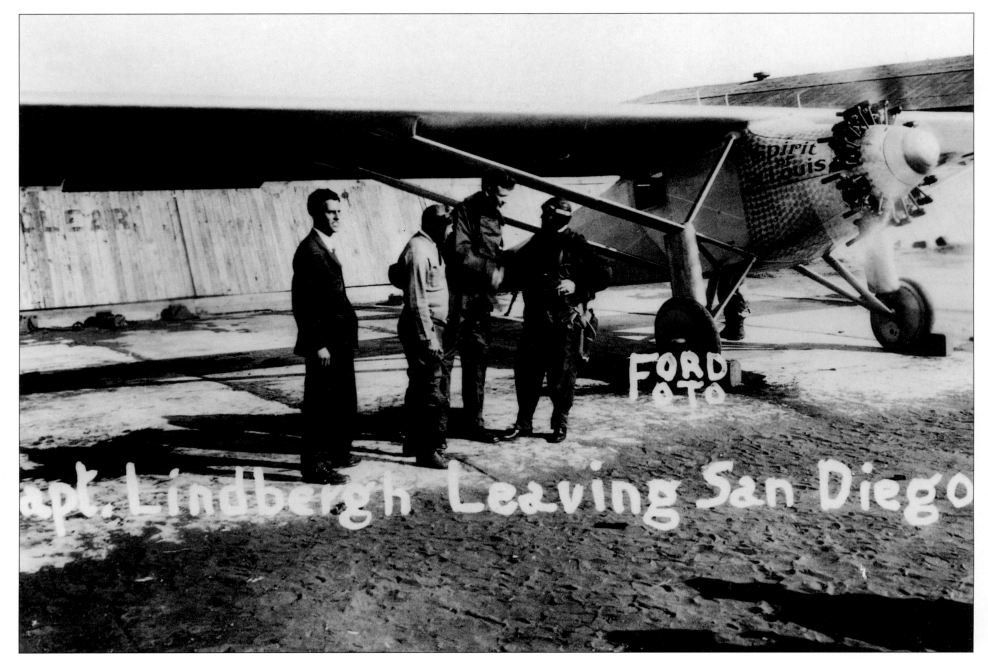

In 1927, Charles Lindbergh came to San Diego in search of a company to build an airplane capable of transatlantic flight. Ryan Aeronautical took on the job. Ryan based it on their own M-2 monoplane, with modifications to include a greater wingspan, greater fuel capacity, and a more powerful engine. Lindbergh named the new plane *Spirit of St. Louis* to honor his St. Louis backers. After several test flights here, he took off on May 10, 1927, for St. Louis, then on to New York and Paris.

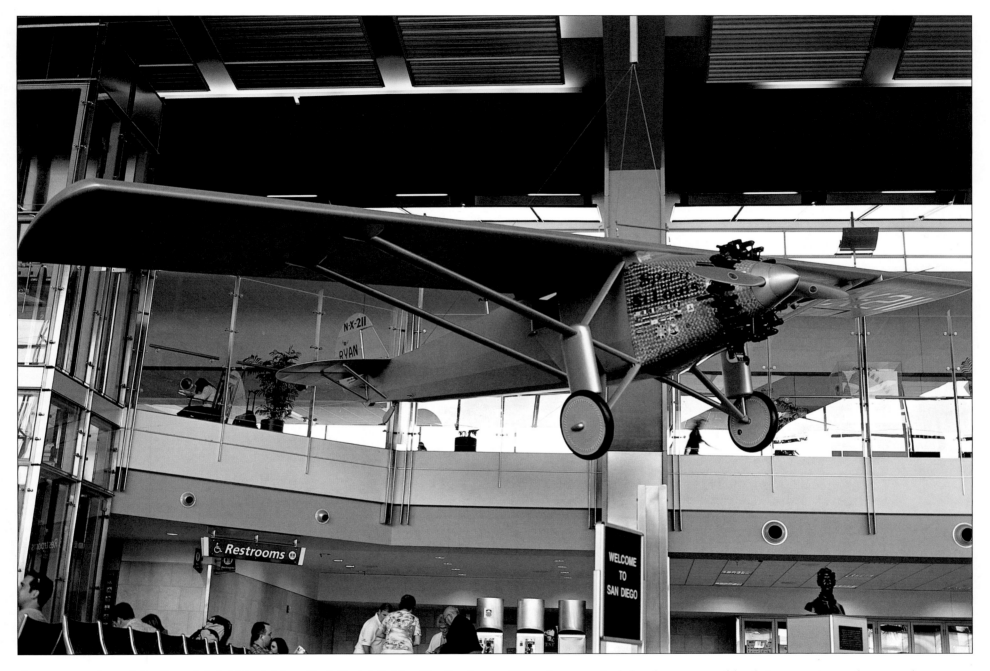

An exact replica of the Ryan Model NYP (New York Paris) *Spirit of St. Louis* can be seen in the San Diego Airport. It hangs over the baggage claim in Terminal 2. The replica was fabricated with authentic materials and includes a vintage Wright J-5 Whirlwind engine. Another *Spirit* replica, built by San Diego Aerospace Museum volunteers and three of the original workers from Ryan Aeronautical, has been pressed back into service and was used to commemorate San Diego Airport's seventy-fifth anniversary in 2003. The original *Spirit* is at the Smithsonian National Air and Space Museum in Washington, D.C.

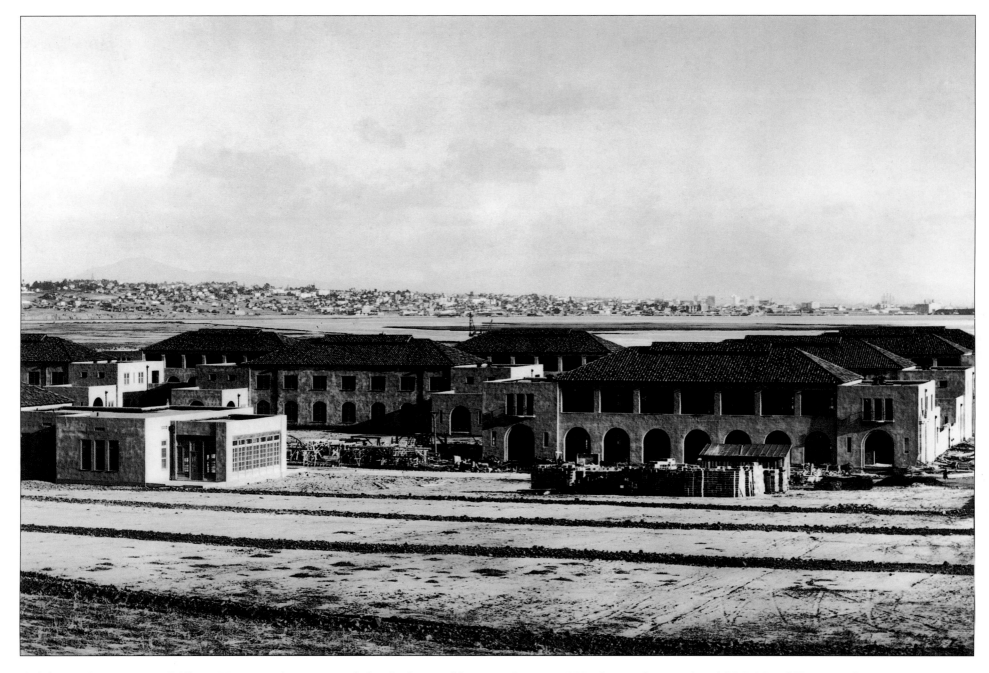

California Congressman William Kettner, who organized the dredging of San Diego Harbor in 1912, first suggested the idea of a naval training center to assistant secretary of the navy Franklin D. Roosevelt in 1916. The plan was well received, but World War I halted any immediate decision. Undeterred, the city of San Diego persisted in its pursuit of the navy and offered them more than 200 acres of land at the north end of San Diego Bay in a bid to entice it to move the Recruit Training Station from San Francisco. On

June 1, 1923, the newly completed U.S. Naval Training Center was commissioned to train groups of 1,500 to 3,000 recruits over a sixteen-week period. This 1922 photo shows the NTC during construction. Over the years around 2 million navy recruits went through the NTC, and more than 28,000 visitors a year came to watch their graduations. The visitors alone contributed more than seven million dollars a year to the local economy.

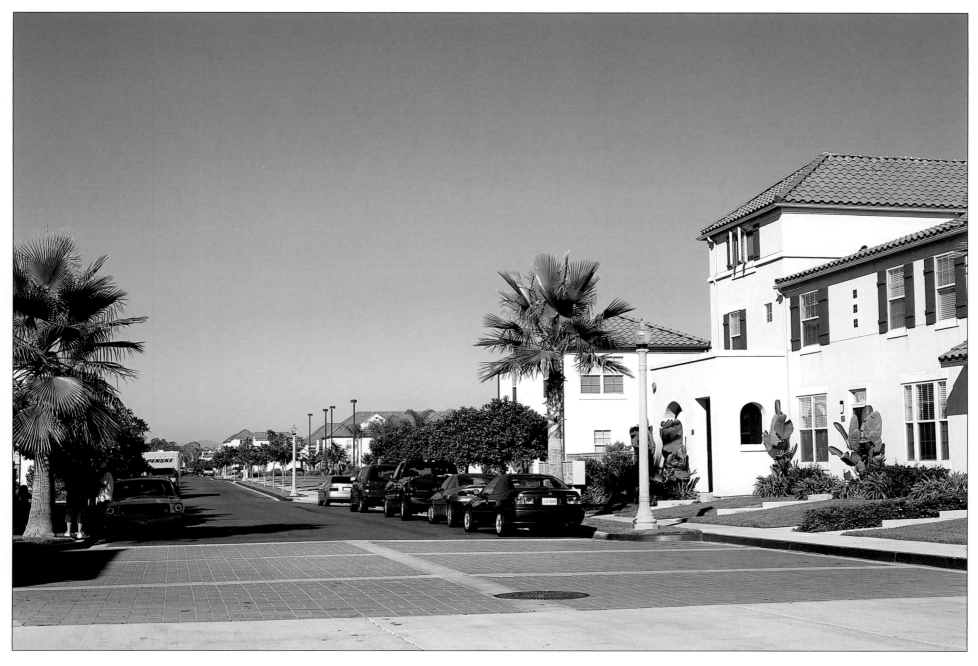

With the end of the Cold War and military downsizing, the NTC finally gave up training recruits in 1997. The base was closed gradually over a four-year period. Today the site has been developed as Liberty Station, a waterfront destination and "urban village" for the people of San Diego that when completed will include housing, stores, a golf course, educational facilities, and restaurants over its 361-acre site. The 500th townhome was completed in September 2003. Twenty-six original buildings make up the historic core of the development. In addition to the land area at the developer's disposal, there are fifty-four acres of boat channel that could further add to the marina capacity of the area.

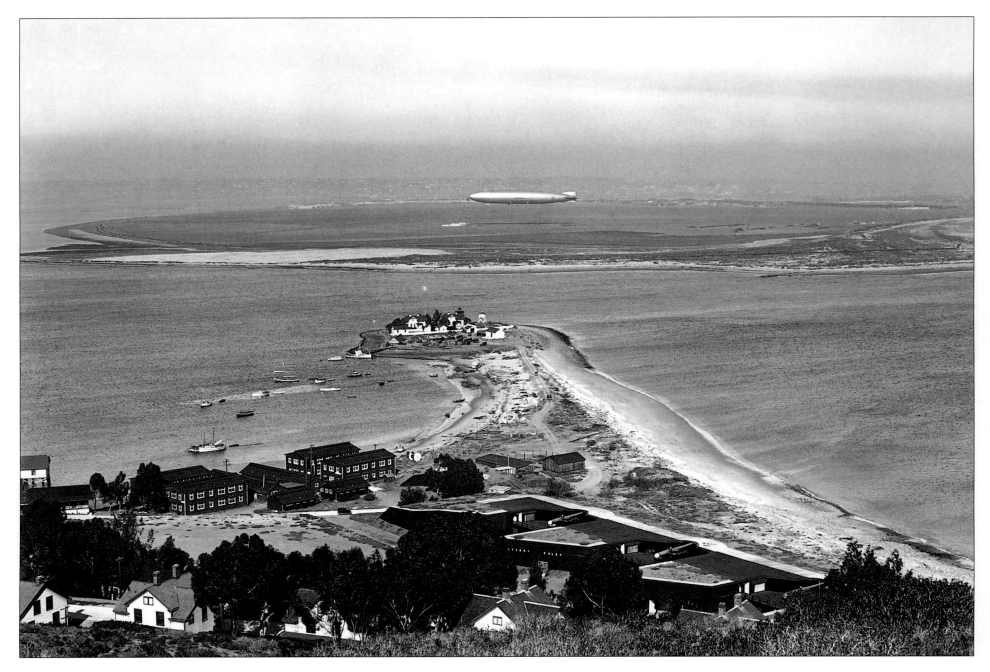

On September 28, 1542, Juan Rodriguez Cabrillo entered what is now San Diego Harbor and anchored at Ballast Point. This became the first landing place of Europeans in Alta (Upper) California. Cabrillo named the sheltered harbor San Miguel. In 1602 Sebastián Vizcaíno renamed the bay San Diego, and the point of land La Punta de Guijarros (The Point of Cobblestones). Fort Guijarros was later established by Spain after a British expedition noted the weak harbor defenses. In later years, a whaling station was in operation at Ballast Point and remained there until 1856. The small spit of land was then acquired by the government for a lighthouse and later used for quarantine purposes. When ships left San Diego, they often stopped here to load up cobblestones as ballast.

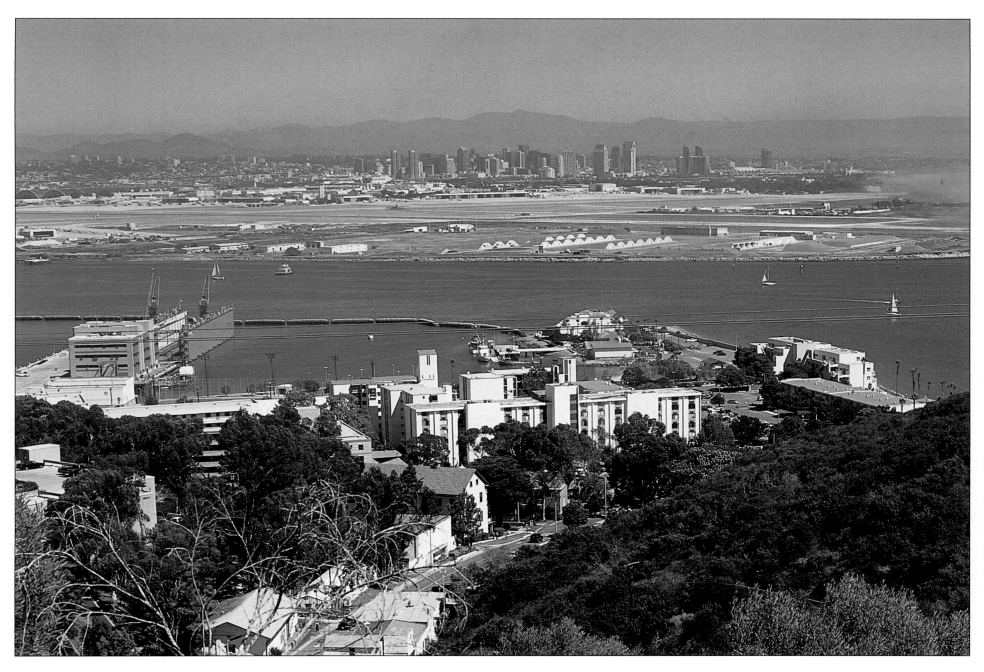

Today Ballast Point is dominated by a naval base that houses eight nuclear-powered attack submarines and is home to the Anti-Submarine Warfare Training Center. The land was transferred from the navy to the army in 1959, and the base was established in 1963. Ironically this came three years after the Ballast Point light was deemed unnecessary and razed, though the clockwork-powered fog bell—hand-powered when the mechanism refused to work—can now be found in the San Diego Maritime Museum. In the wake of the 9/11 terrorist outrages, the navy has decided to increase the boundaries of the security zone around the base, so they have the ability to deploy a boom or barrier to stop small boats. Permission to enter the zone is required from the captain of the port or the commander of the base.

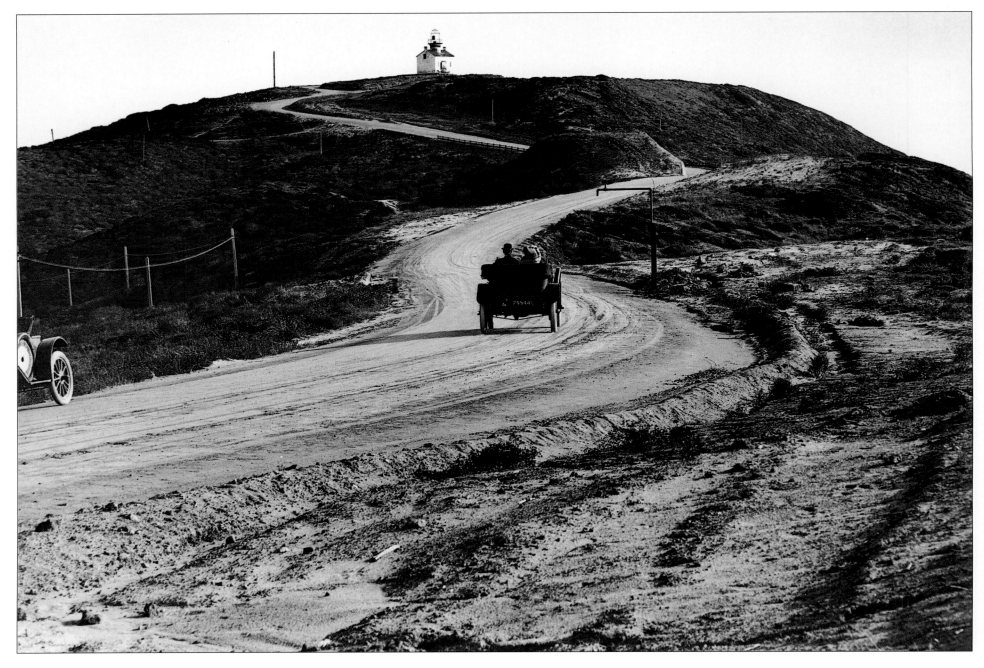

The old Spanish lighthouse atop Point Loma was one of the first on the West Coast. Built with local quarried rock (as well as some bricks manufactured by Thomas Whaley), it was first illuminated on November 15, 1855, and for years was one of the highest lighthouses in the United States. Unfortunately, its height was its major design flaw. The lighthouse was 462 feet above sea level and visible from a distance of thirty-nine miles on a clear night, but fog or low-lying clouds often obscured its beacon. So in 1891, a new lighthouse was built on the shoreline below and the original lighthouse was abandoned.

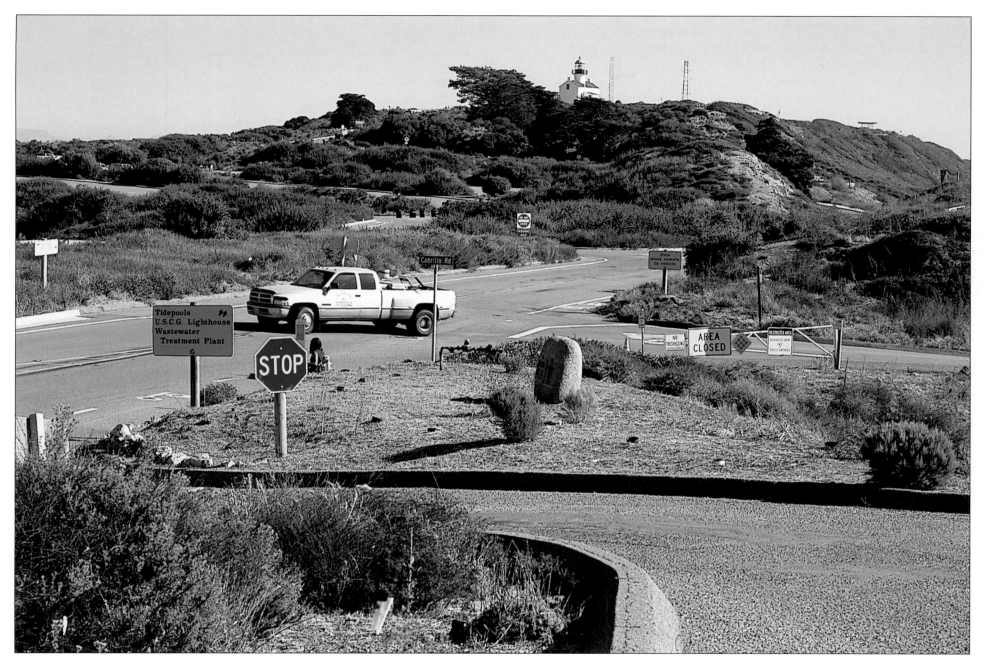

In 1913, President Woodrow Wilson established the Cabrillo National Monument at Point Loma and plans were made to demolish the lighthouse and replace it with a statue of San Diego's discoverer, Juan Rodriguez Cabrillo. Lack of money disrupted those plans and the lighthouse survived. In World War II it found a new use as a signal tower. The light was returned to the Parks Service in 1946, and a fourth order lens was installed from the Table Bluff light in Eureka, California, in 1955. Today it has a third order lens from the Mile Rocks light in San Francisco, which was relit by David Israel, grandson of former lighthouse keeper Robert Israel. There are further plans to restore the site to how it would have looked in the 1880s.

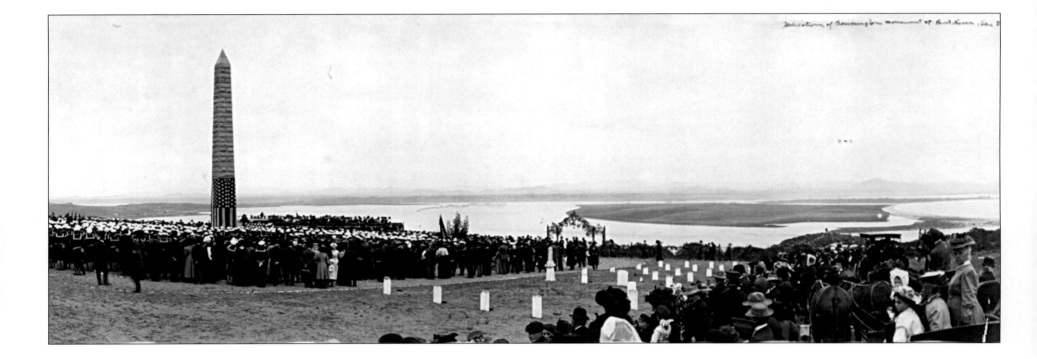

In 1899, men from the USS *Bennington* went ashore at Wake Island, two thousand miles west of Honolulu, and claimed it for the United States. On July 21, 1905, as the crew of the *Bennington* prepared to escort a disabled warship to San Francisco, four of the ship's boilers exploded, killing sixty-three sailors and two officers, and injuring all but twenty-five of the 206 men aboard. More than thirty of the sailors killed were buried in an area known as Bennington Plot, part of a cemetery that would become the Fort Rosecrans National Cemetery in 1934. Quick work by a local steam tug pushed the listing ship onto a nearby mudflat before it sank. In 1908, this granite obelisk was dedicated to the *Bennington* crew who died in the disaster. The ship, which began its career in 1890, was decommissioned in 1905 and in 1926 was towed out to sea and scuttled.

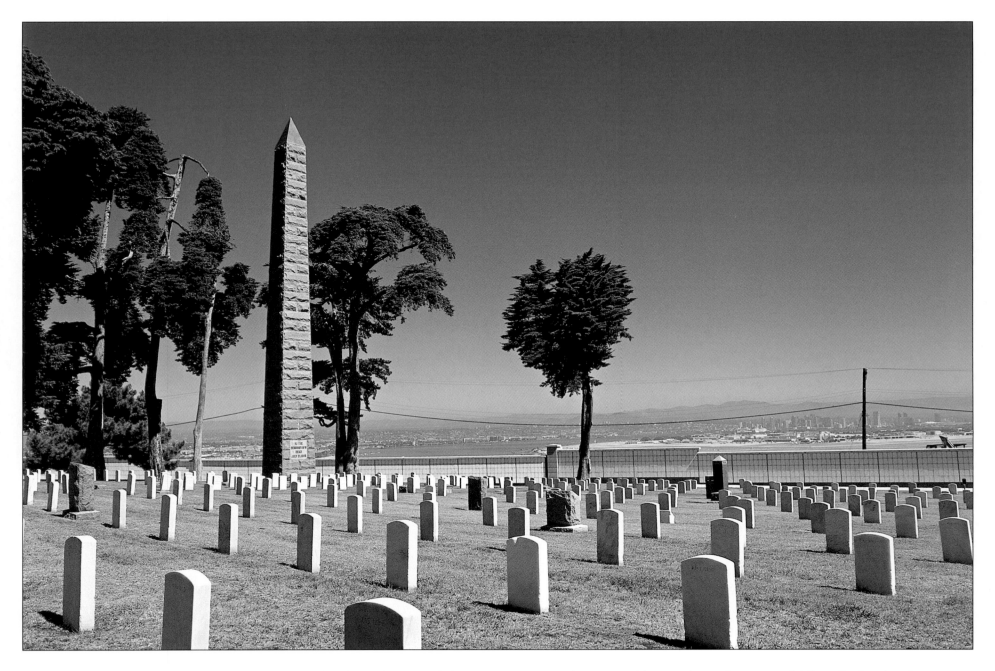

The ground the Bennington Monument stands on has been designated the Fort Rosecrans National Cemetery. It has long been a burial site for military personnel and commemorates medal recipients from World War I, World War II, the Korean War, and the Vietnam War. A brass plaque on a granite boulder pays tribute to the First Dragoons who were killed at the Battle of San Pasqual in 1846. Also nearby is the grave of Albert B. Smith, who is credited with single-handedly spiking the enemy guns at Fort Stockton above Old Town and nailing the Stars and Stripes to the flagpole in the plaza while under fire from the Mexican infantry.

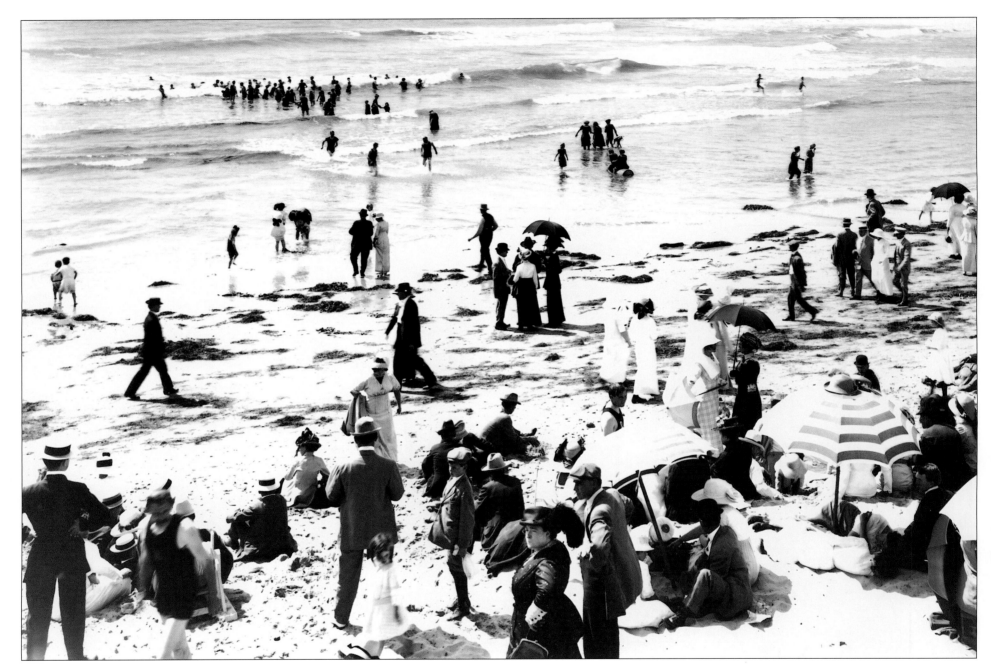

In its early days, Ocean Beach was a favorite for picnickers who came to pry mollusks from the rocks. Back then, fires were built on the beach and mussels cooked in huge kettles. On July 4, 1872, a huge party was held here, with fried, boiled, and roasted mussels, accompanied by music from the Sheet Iron brass band. In 1887, streets were laid out, lots sold, and Ocean Beach was born. Hoping to promote Ocean Beach as a resort town, David Collier, later to become president of the Panama-California Exposition, brought in electricity and a streetcar line. In 1913 the Wonderland amusement park was constructed on the sand at Abbott and Voltaire, but was washed away three years later by high tide, after which the focus of activity in the town shifted to Newport Avenue.

During World War II, Ocean Beach streetlights were painted black to prevent them from silhouetting coastal shipping for enemy submarines, and soldiers manned beachfront bunkers. The relative inaccessibility of the locale attracted a hippie element in the 1960s, and the accompanying liberal lifestyle caused friction with some of Ocean Beach's older residents.

However, as the sixties gave way to the seventies, the new entrepreneurs established alternative businesses. Nowadays Ocean Beach is a favorite gathering place for local surfers, sun-lovers, and sightseers. You'll find quirky stores and eclectic eateries reminiscent of the 1950s and 1960s here, and the Ocean Beach Pier (inset) is the longest concrete pier on the West Coast.

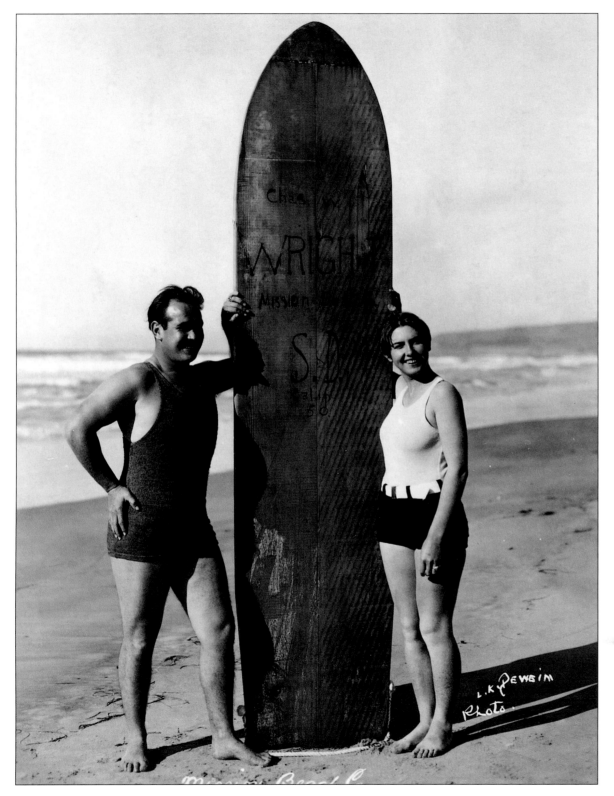

Mark Twain, during his trip to Hawaii in the 1860s, said, "None but the natives could ever master the art of surf-bathing thoroughly." Although surfing almost died out in the Hawaiian islands in the nineteenth century, San Diegans took to it as if it was their native sport. The Hawaiians surfed on wooden planks without fins, using their feet as rudders. Early California surfboards were also big and heavy, as seen in this December 28, 1926, photo taken on Mission Beach.

After a century of surfboard evolution, boards are smaller, considerably lighter, and highly maneuverable. What's more, the sport is no longer the province of twentysomethings, with children, parents, and grandparents heading out into the big blue. Favorite surfing beaches are located up the coast from Mission Beach, Pacific Beach, and Ocean Beach in the south to La Jolla Reefs and Black's Beach in the north.

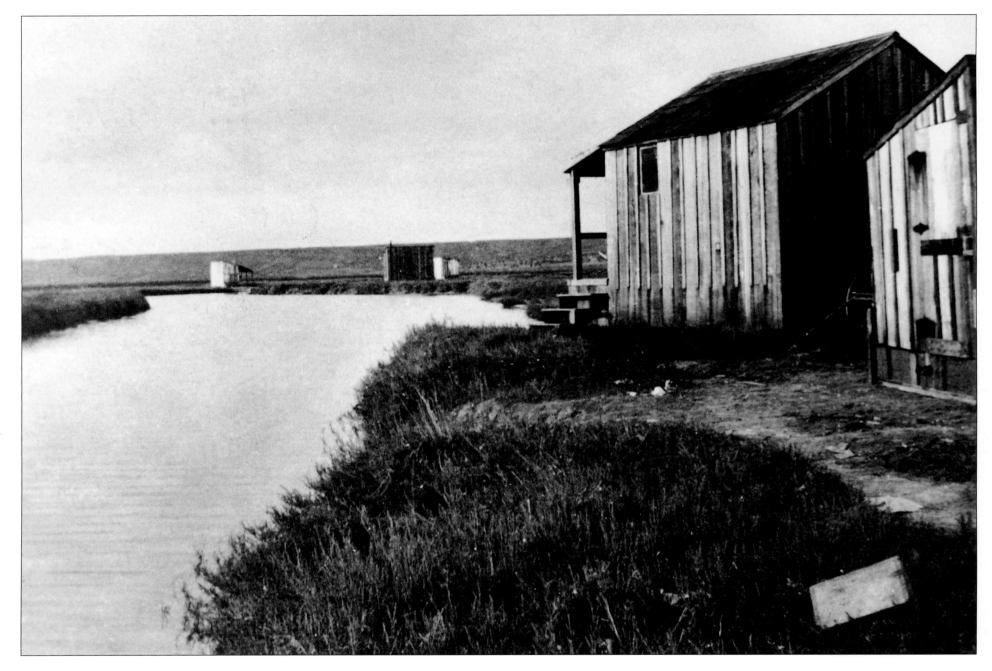

Originally named False Bay by Juan Cabrillo, because its vast areas of tidal marsh led mariners to believe they'd come upon the much larger San Diego Bay, Mission Bay covers 4,200 acres, more of it sea than land. Until the 1960s, it was an area of small shacks and smelly mudflats located at the end of several drainage facilities, including the San Diego River. Civic authorities began to dredge the marsh as early as 1944, and over the years, with the aid of water diversions, it has gradually become one of the world's most beautiful aquatic parks.

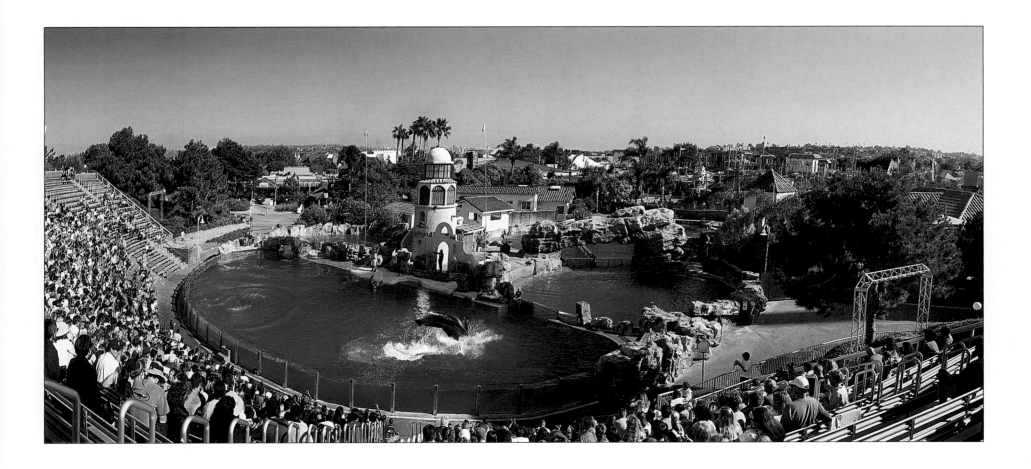

Today more than five million people annually take advantage of Mission Bay's recreational facilities, though some of the original marshland remains. The Kendall-Frost Mission Bay Marsh Reserve provides much-needed habitats for the light-footed clapper rail and Belding's savannah sparrow. The most-visited Mission Bay attraction is SeaWorld. The park opened on March 21, 1964, and since then has hosted more than 100 million guests. The most popular attraction in the park is the Shamu Adventure, which features the world-famous killer whale performing in a seven-million-gallon pool surrounded by a stadium. Mission Bay is also a favorite spot for jet skiers, kayakers, and joggers.

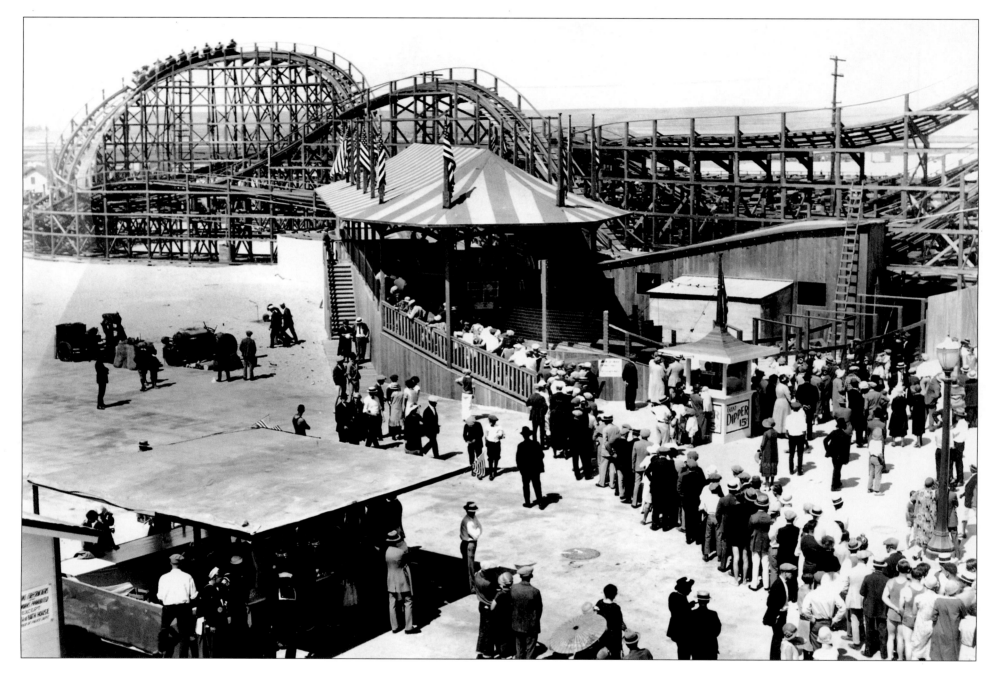

Independence Day, 1925—what better day to open the Giant Dipper Roller Coaster located at the Mission Beach Amusement Center? The 2,600-foot-long coaster was built in less than two months by local suppliers and a crew of up to 150 workers. The project was the idea of John D. Spreckels, the driving force behind the Coronado Beach Company and so many other San Diego schemes. Building costs, including the trains, were $150,000. During the 1930s and 1940s, when the center was renamed Belmont Park, the Giant Dipper remained the most popular ride.

The 1960s and 1970s were less kind to Belmont Park, and in 1976 the roller coaster closed down. It survived several fires, but the peeling paint created an eyesore. In the early 1980s a date was set for its demolition. However, a group of citizens formed the Save the Coaster Committee and had the coaster designated as a national landmark. After a two-million-dollar restoration, the Giant Dipper was reopened to the public in 1990. Because of the nostalgia associated with the Giant Dipper by San Diego residents, rides in the first year of operation were three times the projected number.

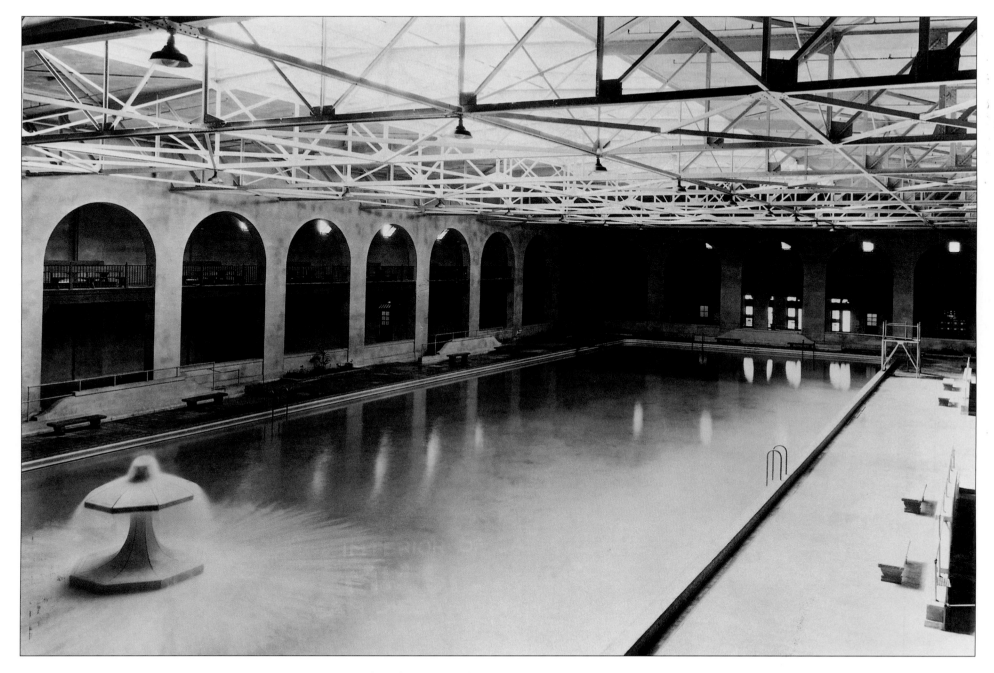

The Plunge was also a part of the allure of the new Mission Beach Amusement Center. Opened the same year as the Giant Dipper, the Olympic-size swimming pool held 400,000 gallons of salt water and was at the time the largest of its kind in the world. John D. Spreckels's idea was to develop what he hoped would become Southern California's foremost resort and convention center. The original park layout included a bathhouse, roller rink, merry-go-round, roller coaster, and the Plunge. The Spanish Renaissance style of the Plunge reflects the same design as that used in the Panama-California Exposition of 1915.

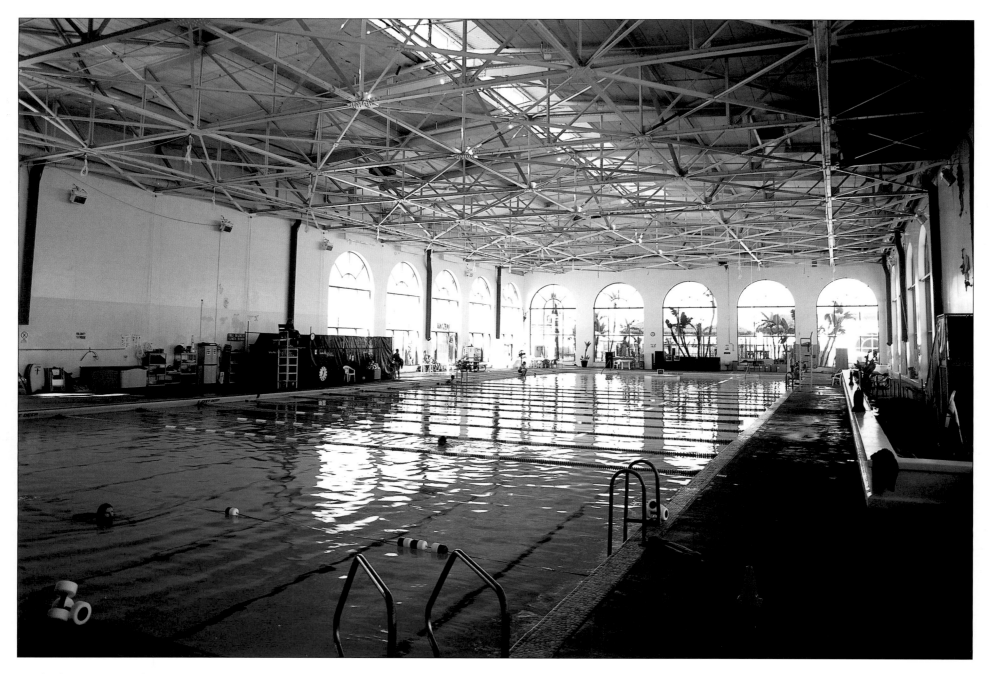

In the late 1960s and 1970s, Belmont Park fell into disrepair and disuse, but the Plunge managed to stay open. It was eventually closed in 1987 because the pool and its building failed to meet city earthquake and fire standards. It was wholly renovated and modified, but the Plunge that emerged in 1988 managed to retain certain historic features such as the steps into the pool and the pedestal at the base of the steps. A fitness club has now taken over operation of the Plunge.

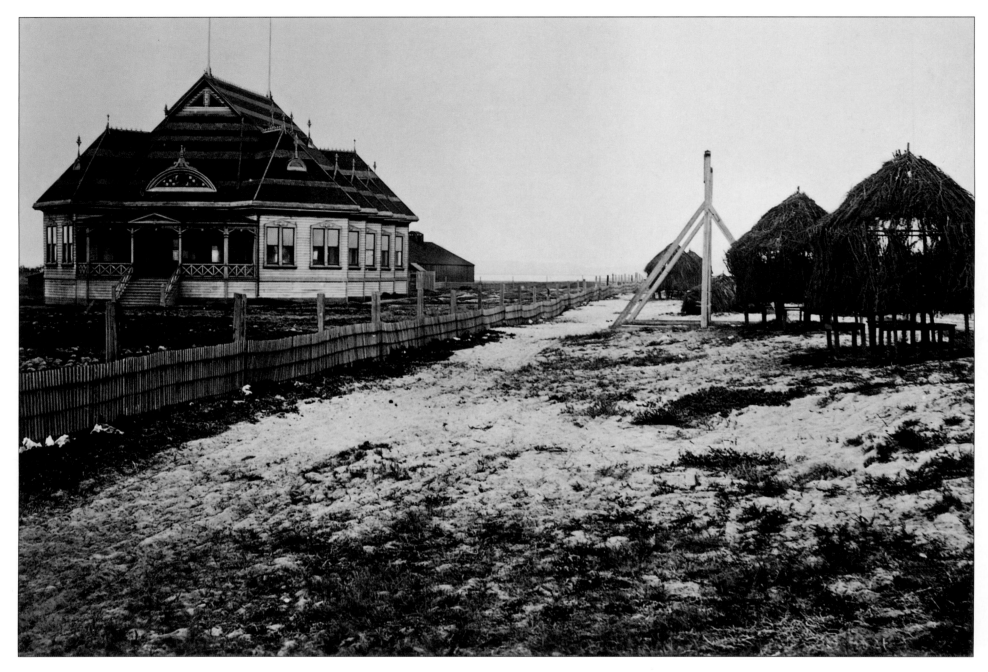

J. B. Bruillette, who sold lots for twenty-five dollars and one-hundred dollars, first developed this stretch of San Diego coast in 1887. Dreams of early developers were to turn the area into a seaside resort and college town, hosting the San Diego College of Letters (where the Pacific Plaza II is today). The cornerstone for the college was laid in 1888, but the depression of the 1890s provoked its collapse as people moved away. The San Diego and Old Town Railway was completed in 1889, and a large dance pavilion and hotel was constructed nearby. But this was not enough to keep the local economy afloat, and the remaining families turned to growing lemons to earn a living. When the economy revived in the new century, the citrus groves made way for a semirural seaside community. This 1895 photo depicts a dance hall that was located at the foot of Garnet Street.

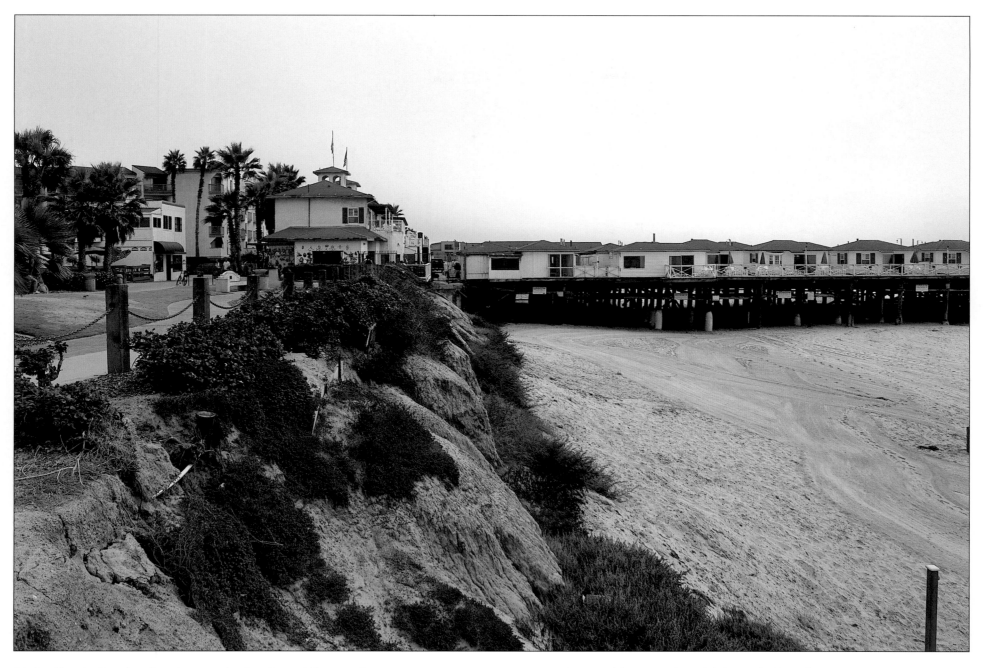

Today Pacific Beach is best known for the Crystal Pier—a long pier jutting out into the ocean, topped with Cape Cod cottages. Originally opened in 1927, the pilings weren't creosoted at first and some of the early woodwork was nibbled away by marine borers. It also suffered in January of 1983 when a Pacific storm ripped away a 240-foot chunk of the pier, which the city helped restore in 1987, adding a widened fishing deck at the same time. Two of San Diego's biggest beach events take place here, the Beach Fest, held each October, and the Block Party and Beach Faire that takes place in May. The Block Party features nine stages with reggae, rock, disco, and jazz performers.

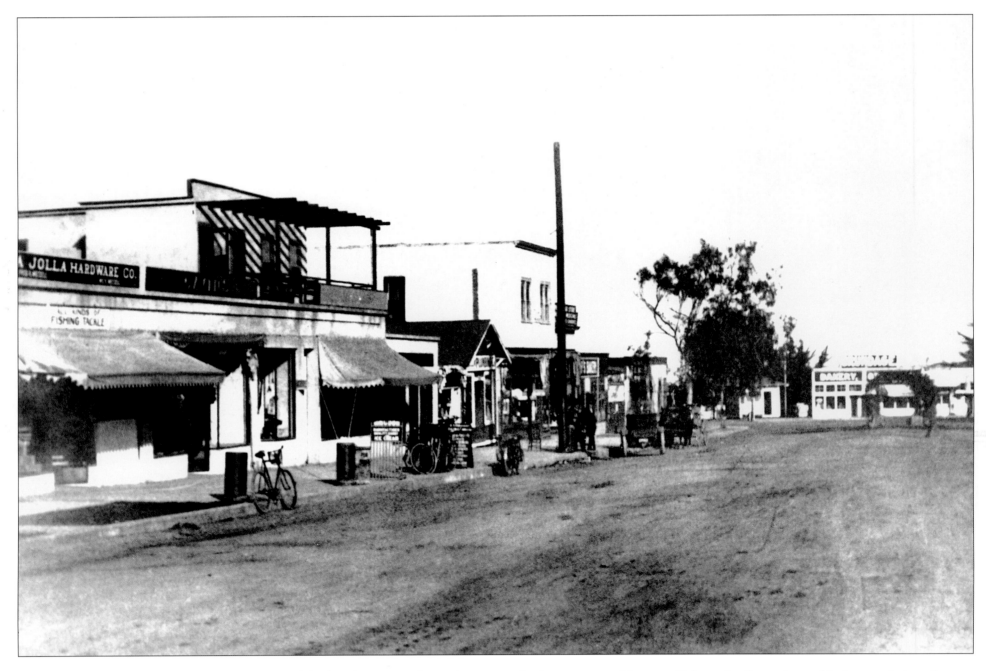

In 1886, Frank T. Botsford came to La Jolla and declared it "magnificent." Two months later he bought over 400 acres of pueblo lands already known as La Jolla Park with the intention of subdividing it and auctioning it off. He and his partners raked in $67,000 for their troubles, and by 1900 the population had risen to 350. It remains unclear where the name originated—whether it means "the jewel" from the Spanish word *la joya* or derives from *woholle*, the Native American term for "hole in the mountains." La Jolla, perched above the Pacific Ocean, is San Diego's most scenic community. Combining natural beauty and elegance, the "gem" has miles of twisting shoreline, caves, and rugged cliffs.

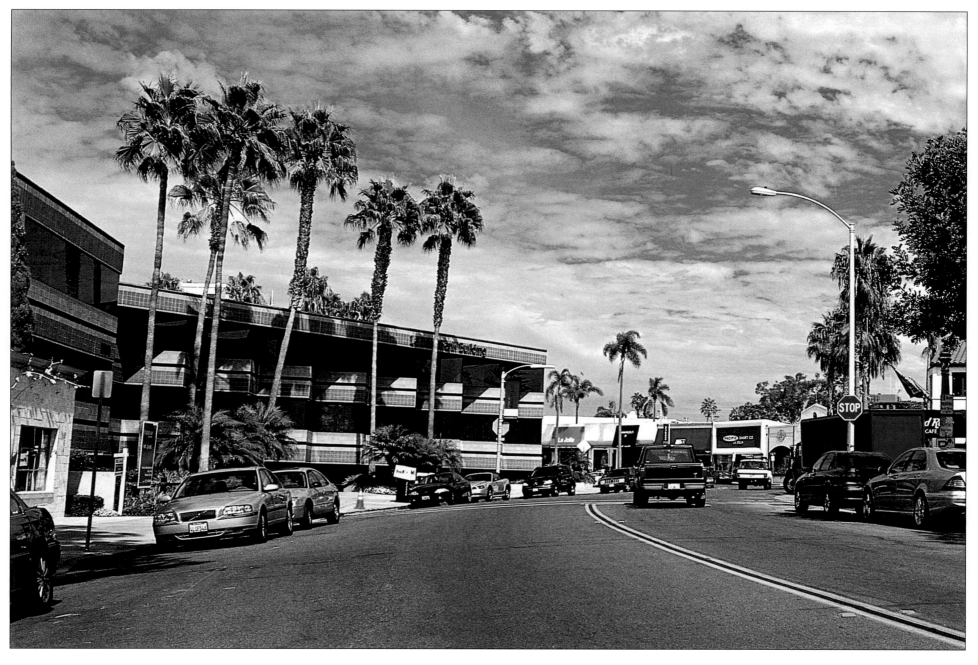

In the late 1800s land in La Jolla sold for $1.25 an acre. The same lots today would sell for close to $1.25 million an acre. The area around Girard and Prospect, seen in this photo, attracts stores that easily rival those on swanky Rodeo Drive in Beverly Hills. La Jolla is home to several medical and scientific research facilities, including the University of California, San Diego, and the Salk Institute. Ellen Browning Scripps, heiress to the Scripps newspaper empire, is perhaps the best known of all La Jolla residents. She was a noted philanthropist and her gifts to the city included the Children's Pool, Scripps Institute of Oceanography, and funding for the Scripps Hospital and Clinic.

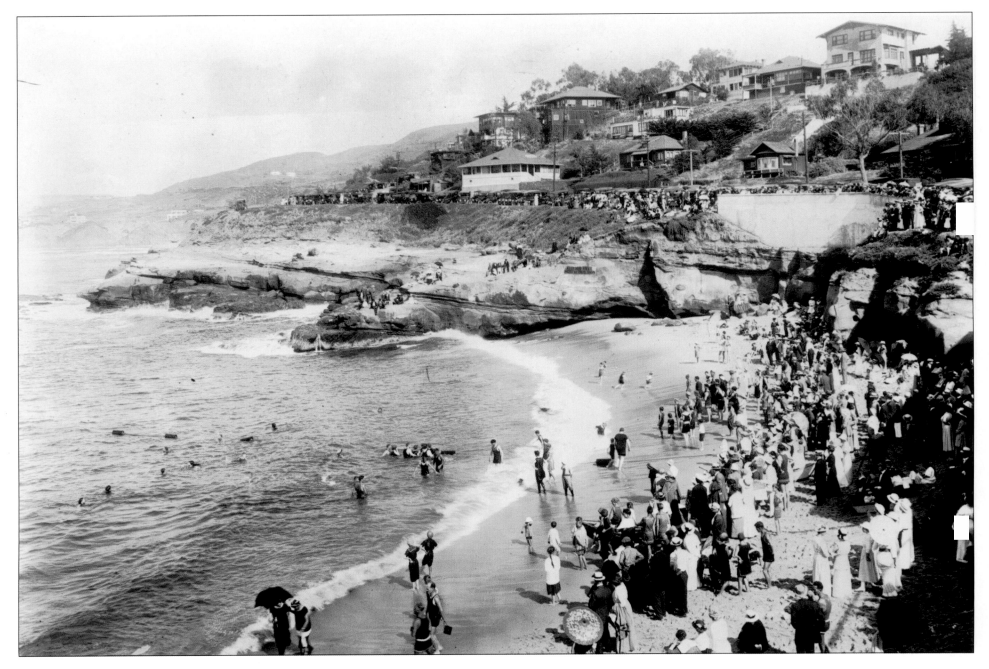

The La Jolla Cove has always been a popular weekend destination for both tourists and residents alike and was safeguarded in the first subdivisions of La Jolla back in 1887, when the surrounding 5.6-acre parcel of land was dedicated as a park. Its pristine beach is protected from heavy surf by rock formations and a jetty of land on its southern edge. By 1900, a small bathhouse was built above the cove. When it was destroyed by fire in 1905, a bigger bathhouse was built, along with a pool (later converted to a dance hall) and auditorium. After World War I, the bathhouse was torn down.

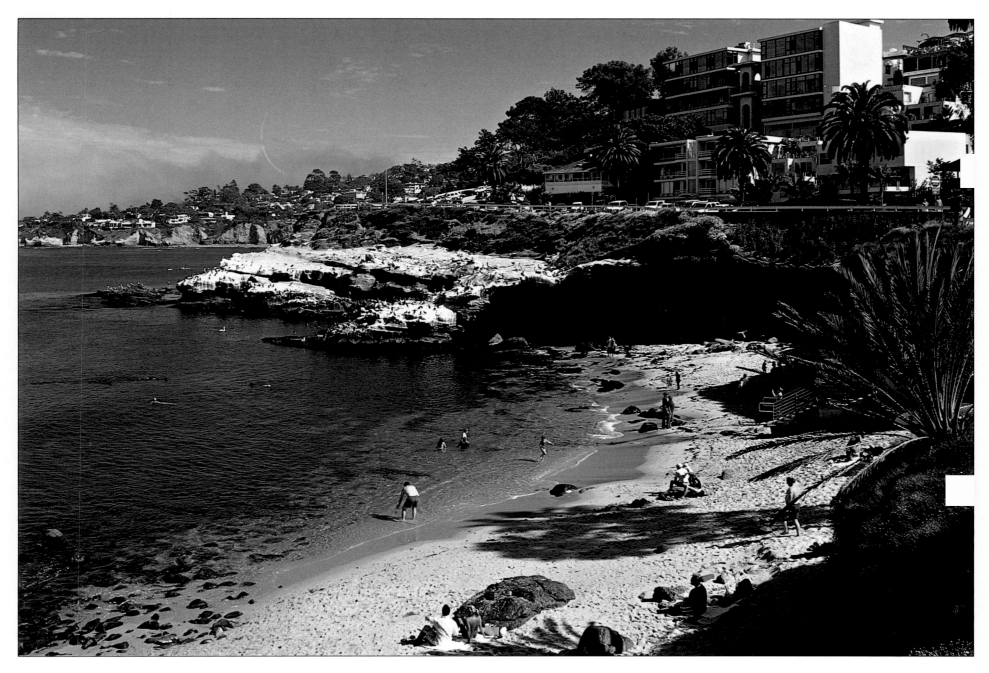

The cove is considered the most photographed beach in Southern California. Because of its exceptionally clear water—sometimes exceeding thirty feet, it is a favorite for scuba divers and snorkelers. Nearby, La Jolla Underwater Park and Ecological Preserve is teeming with marine life, including lobster, garibaldi, and neons. The rock bottom is being slowly eroded away by a horde of boring clams, which gouge away the soft rock with their shells until they make a burrow a foot or more in depth. Many rocks are so weakened by the honeycombed "drills" that they are easily broken up by winter storms.

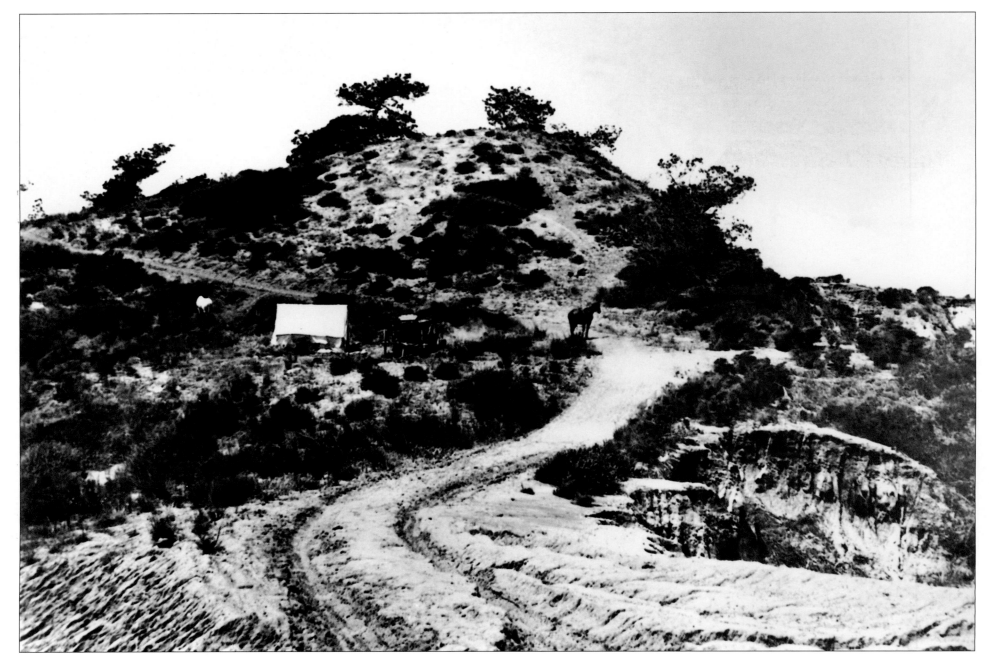

Spanish sailors first spotted Torrey Pines in the 1500s and marked it on their charts as *Punto de Los Arboles*, "Point of Trees," an unusual feature on a coastline where trees were largely confined to growing along streams or further inland on mountainsides. The Torrey pine, or *Pinus torreyana*, has given its name to what is now a state reserve. The trees are believed to be a relic of the ice age—part of an extensive forest that grew along the coastline before the Channel Islands were separated from the mainland. The Torrey is the rarest native pine in the United States and grows along just a small strip of coast from Del Mar to La Jolla and on Santa Rosa Island.

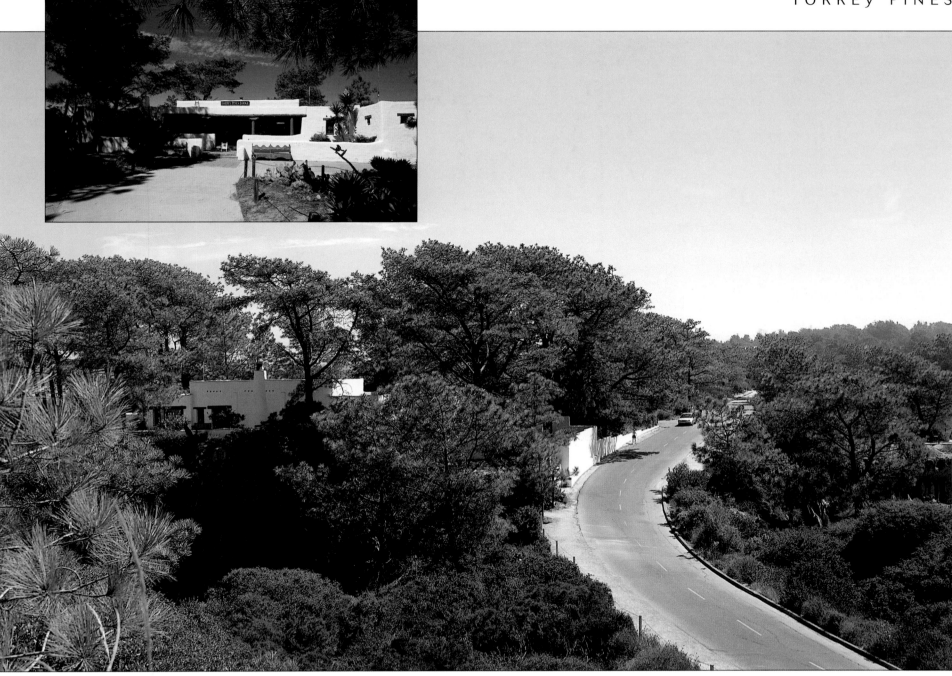

In 1923, the Torrey Pines Lodge (inset) opened, built in a style similar to a Hopi dwelling in northern Arizona. It was used as a restaurant for both locals and tourists and was furnished with stumpy tables and lamp shades made of pine needles. Today it serves as a visitor center and ranger station for the state park. This current photo shows the road approaching the lodge. The reserve itself has eight miles of walking trails that offer stunning views of the Pacific Ocean and the chance to study the landform known as "raised beaches." Golfers will recognize the terrain, too. Torrey Pines Golf Course offers two of the most picturesque and challenging championship golf courses in the world, and the club is a regular stop on the PGA Tour, hosting the Buick Invitational every February.

Located twenty-two miles north of San Diego, Del Mar—meaning "by the sea"—is one of the county's most picturesque seaside villages. It was once part of a Spanish land grant made to Don Juan Maria Osuna. Jacob Taylor, a Texan who made a fortune in the cattle business, bought over 8,000 acres in 1882, laid out the town of Del Mar, and sold divisions. Lots went from $100 to $600. Attractions included the Natatorium, an indoor swimming pool.

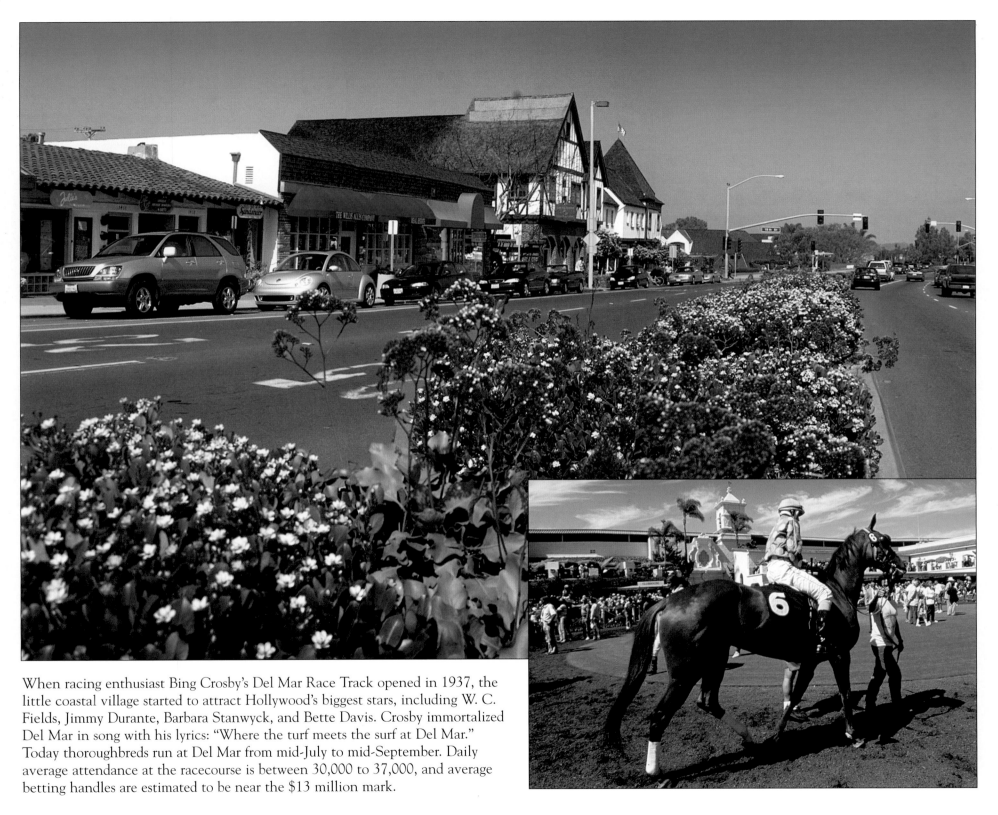

When racing enthusiast Bing Crosby's Del Mar Race Track opened in 1937, the little coastal village started to attract Hollywood's biggest stars, including W. C. Fields, Jimmy Durante, Barbara Stanwyck, and Bette Davis. Crosby immortalized Del Mar in song with his lyrics: "Where the turf meets the surf at Del Mar." Today thoroughbreds run at Del Mar from mid-July to mid-September. Daily average attendance at the racecourse is between 30,000 to 37,000, and average betting handles are estimated to be near the $13 million mark.

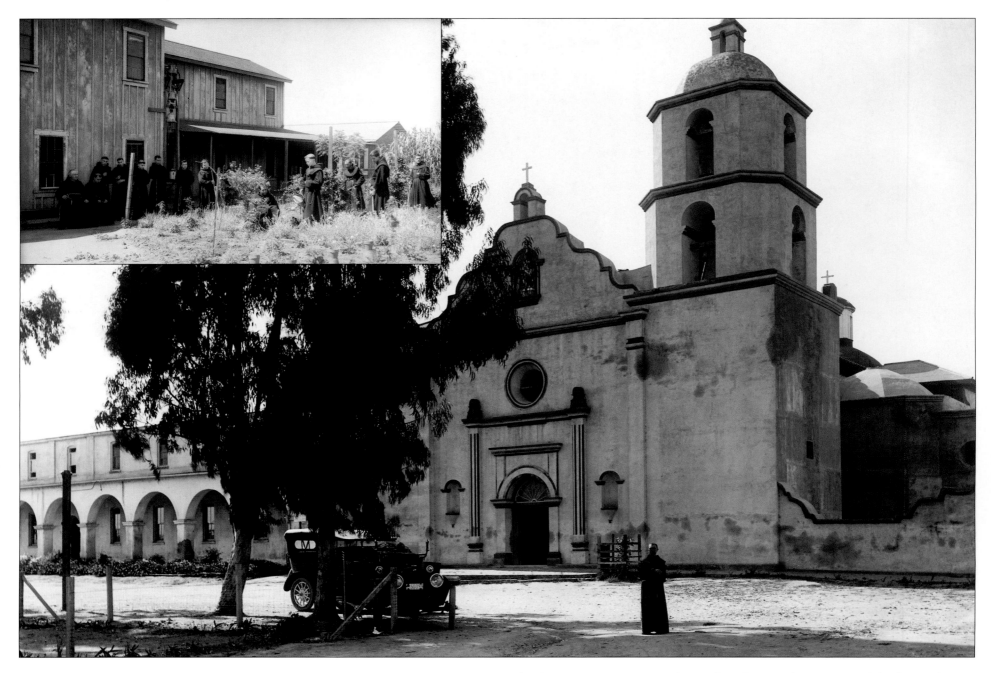

The San Luis Rey Mission, located in Oceanside, was one of the last to be established in California. Though it was not founded until 1798, it soon became the largest and wealthiest, administering a series of outposts and ranchos over a thousand square miles in San Diego and Riverside Counties. Mexico's split with Spain brought secularization of Father Peyri's mission by its Mexican administrators, and the Franciscan padre's lands were subdivided and handed out as political favors long before America took control in 1846.

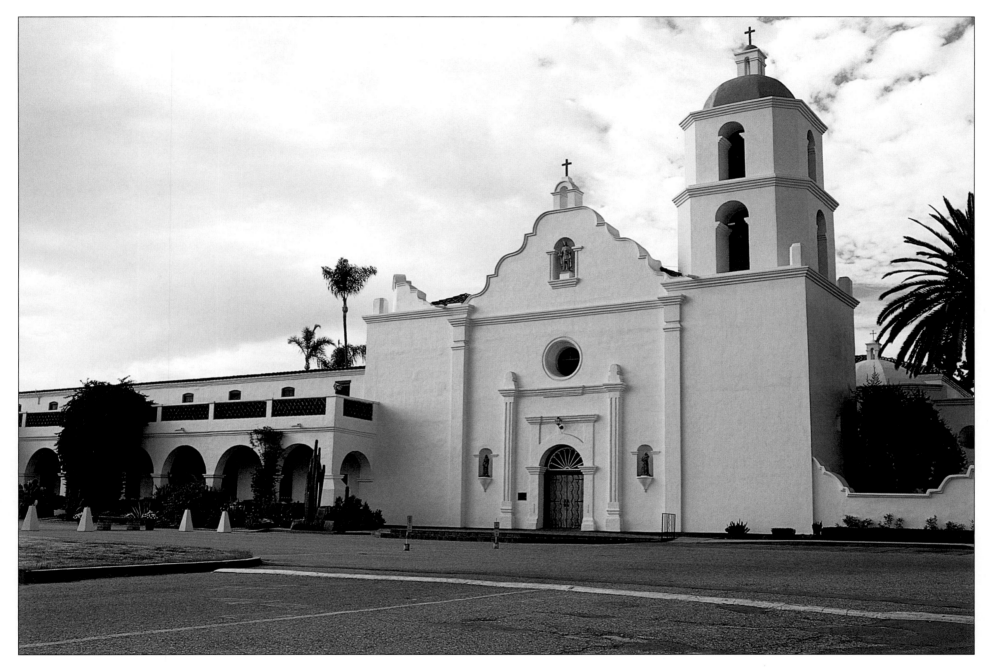

In 1890, Franciscans from Mexico returned to repair and preserve their "King of the Missions," though it was not until 1905 that the job of restoration was complete. The church was rededicated in 1892, and today the mission still serves as a parish church, holding all the associated services and carrying out all the functions of a Catholic church. In 1959 the lavanderia and sunken gardens were uncovered, and visitors can now enjoy them as they were intended by Father Peyri—for quiet contemplation.

Miramar is located on land that was once owned by Don Santiago Arguello, the former Mexican Army commandant of San Diego's Old Town Presidio. Arguello had twenty-two children, one of whom, Refugia Arguella, married Don Juan Bandini, the man who built Casa Bandini. A 2,000-acre ranch was established here in the 1880s and was bought by the Jessops, a prominent family of jewelers. Part of the Jessop Ranch is seen in this 1891 photo. During World War I, the army moved in and purchased the land.

The Miramar Naval Air Station gained fame when it was featured in the 1986 Tom Cruise film *Top Gun*. The Top Gun school, commissioned in 1972, was a graduate-level school for fighter pilots and aircrews. The school taught refined fighter techniques, including threat simulation, effective threat presentation, and adversary tactics. In 1993, the 23,000-acre base was redesignated the Marine Corps Air Station Miramar, its 11,000 personnel tasked with supporting U.S. Marine Corps aviation missions. Apart from state-of-the-art machinery, the base still holds some historic aircraft (inset).

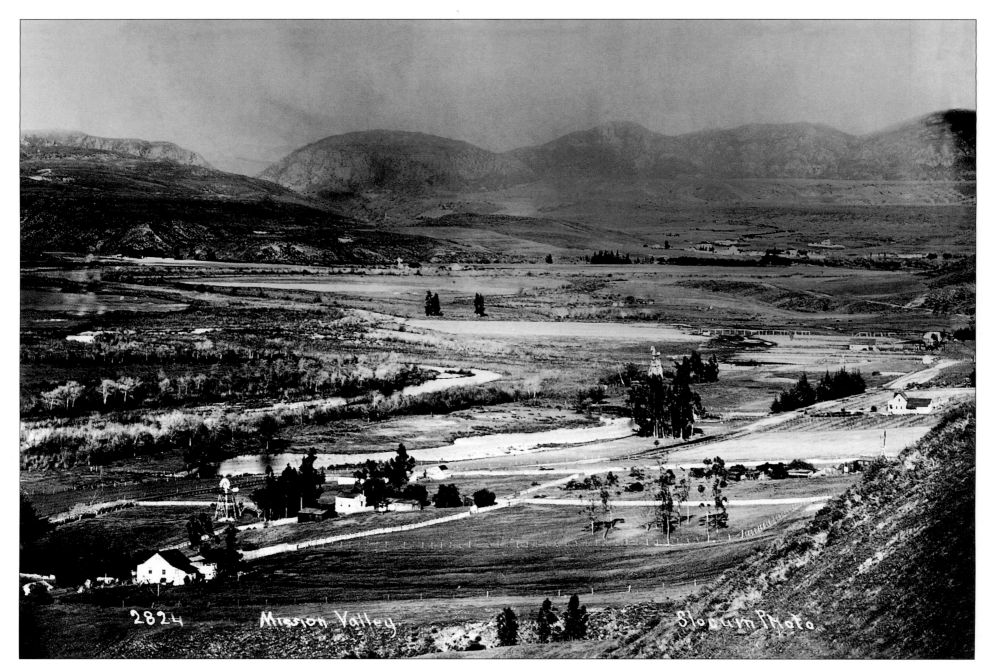

2824 Mission Valley Slocum Photo

Mission Valley—named after the Franciscan mission built there in 1774—is a broad east-west river valley that was used largely for agricultural and dairy farming up until the 1950s. In 1775 there were some twenty-five Native American villages within a radius of about thirty-six miles of the mission settlement. By 1797 the Spanish had built up stocks of 20,000 sheep, 10,000 cattle, and over a 1,000 horses on 50,000 acres of what had originally been dry chaparral land.

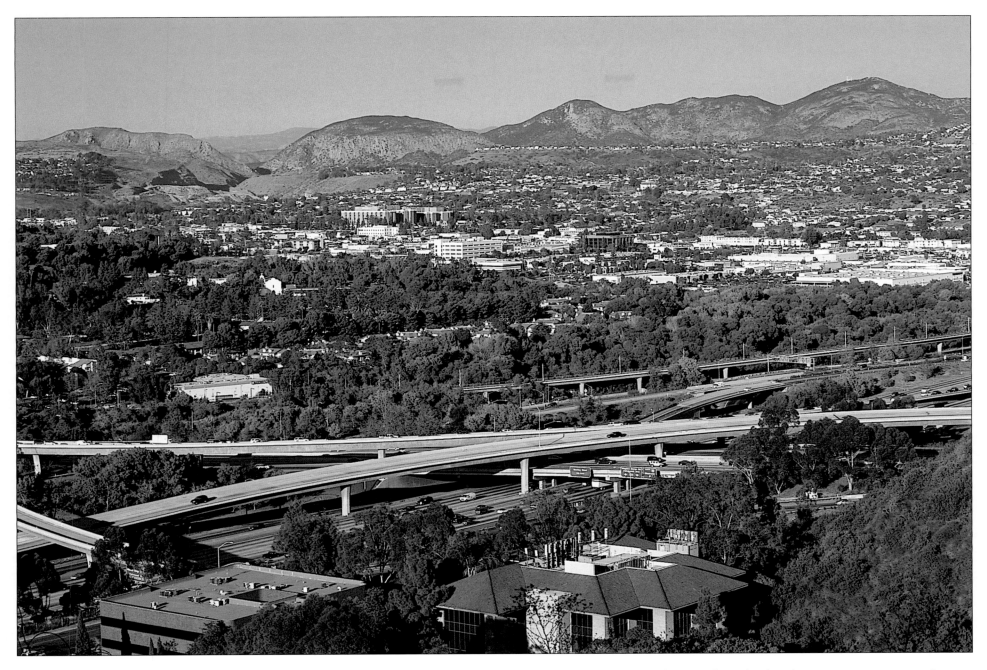

Today Interstate 8 dominates the valley. In 1953, city planners gave the go-ahead for hotel development in what is now known as Hotel Circle. At about the same time, the Pacific Coast League San Diego Padres left downtown and moved to a new ballpark in Mission Valley called Westgate Park. In the 1960s, May Department Stores began construction of the Mission Valley shopping center, and later a second large shopping center, Fashion Valley, was built, along with multiplex theaters, restaurants, and bookstores. An expansion team for the National League, the Padres first played as a major league team in 1969 at the new San Diego Stadium (later called Jack Murphy Stadium, then Qualcomm Stadium) until they moved into Petco Park in 2004.

El Cajon Boulevard is a historical, several-mile-long strip that helped move San Diego's postwar development eastward toward the city of El Cajon and other East County cities. In 1910 there were only three businesses along El Cajon Boulevard (informally known as "the Boulevard"): a building contractor and two grocers. Despite the city's expansion, by 1920 there were only a few more businesses: two contractors, two grocers, a storage center, and two garages. The big boom came during the 1920s, and by 1930, over 180 businesses lined the strip from Park Boulevard to Seventieth Street. The growth of the automobile industry brought twenty-five gas stations to the Boulevard—by 1940 there were 415 businesses, of which forty-nine were gas stations. Until the freeway was built in Mission Valley, the Boulevard was the main east-west road and one of the oldest suburban thoroughfares.

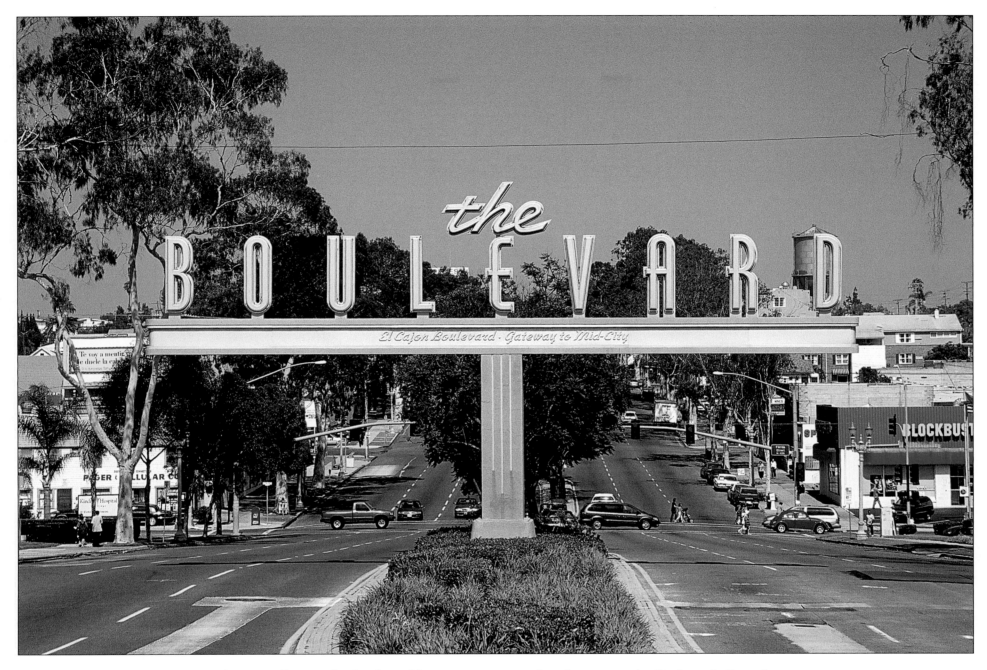

Today, though the auto businesses haven't all gone, the Boulevard has undergone a transformation. With the loss of the route as a major highway, the type of fast-paced, automobile-oriented commerce has given way to a more ethnic mix. After the Vietnam War, thousands of Vietnamese immigrants, along with Filipinos and Chinese, moved into the area and purchased stores on the Boulevard. Over the past years, many improvements have been made, including median landscaping, tree-lined sidewalks, and new lighting. Every Sunday San Diegans can shop for fresh flowers, baked goods, and organic produce at the Farmers' Market at El Cajon Boulevard and Marlborough.

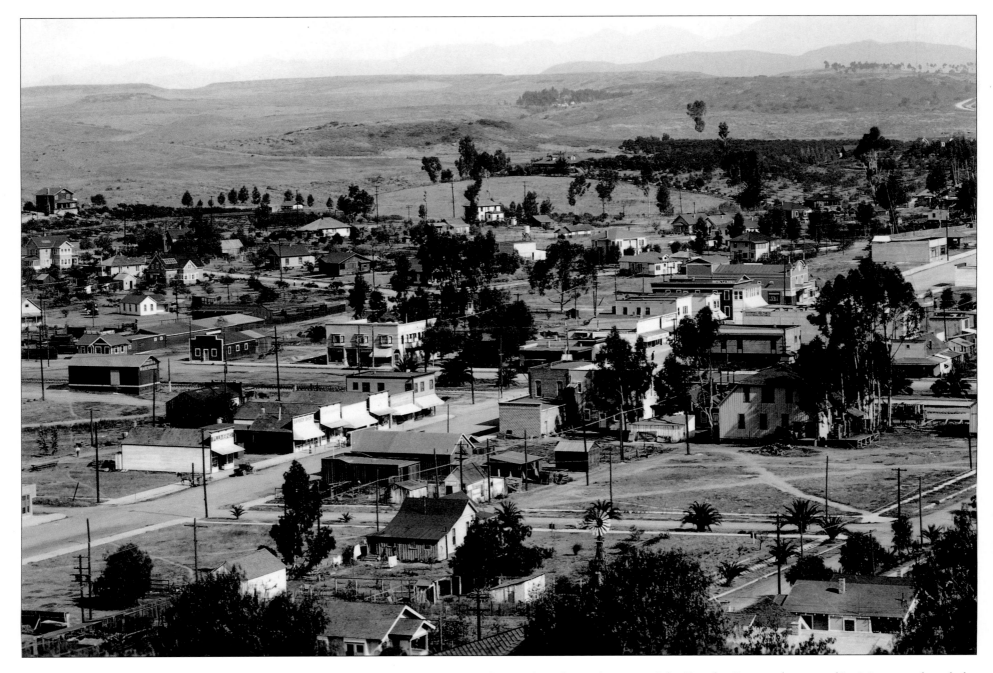

Located twelve miles east of the Pacific Ocean, the city of La Mesa was founded in 1869 and incorporated in 1912. La Mesa was occupied for several centuries by the Kumeyaay branch of the Diegueno Indians. After Father Serra established the mission, La Mesa was used for grazing sheep and cattle. In 1869, Robert Allison purchased lots here, built a boarding house, and established a sheep operation at the nearby springs.

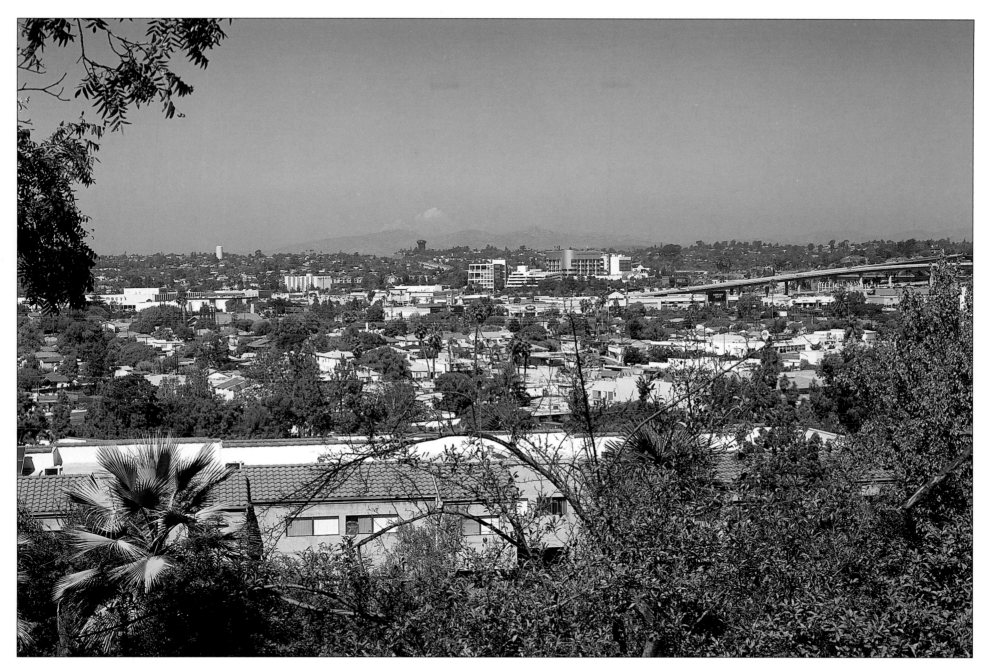

La Mesa's growth was due in part to the discovery of gold near the town of Julian in the local mountains and the coming of the California Southern Railroad in 1885. Between 1911 and 1912, the Flying A Studios arrived in San Diego and produced over 150 silent movies in Lakeside and La Mesa. The "Jewel in the Hills" has adopted the bougainvillea as its city flower and is home to over 55,000 people. It holds the United States record for the hottest December day—100 degrees—recorded in 1938.

The historic Knox Hotel, built in 1876, was originally a two-story, seven-room hotel and residence, sited at the junction of two wagon trails. The hotel was built when Amaziah Knox realized that miners heading for the gold fields in Julian needed a hotel located halfway between San Diego and the gold mines. The hotel and corrals cost an estimated $1,000 to build. In the 1940s the building was purchased to serve as a single-family dwelling.

In 1972, the city of El Cajon purchased the hotel and moved it to its present location on North Magnolia. Today it's a museum and the home of the El Cajon Historical Society. Members of the Historical Society maintain the interior rooms, including the Knox bedroom, children's room, and kitchen. Today the original site of the hotel—at the corner of Main Street and Magnolia Avenue—is one of El Cajon's busiest intersections.

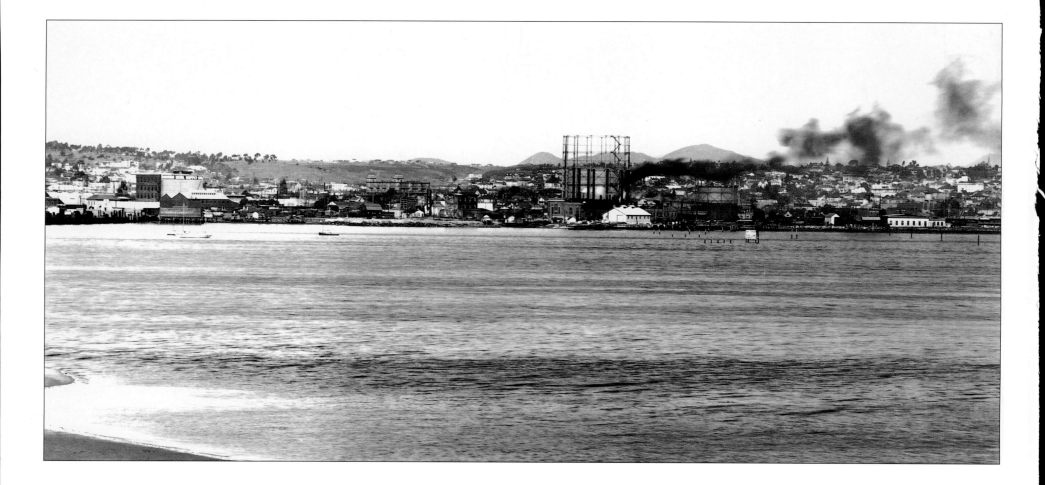

Within a month of arriving in San Diego, Alonzo Horton had purchased his 960 acres of New Town and embarked on his grand plan. He laid out a street grid with small blocks without alleys in the hopes of selling corner lots for a higher price. In a short period of time, the value of downtown property doubled and then tripled. New Town quickly became the center of San Diego, taking the spotlight from Old Town. This 1913 photo clearly depicts the industrial nature of the early skyline. In 1870, when Horton opened his ambitious Horton House hotel, the population of the city of San Diego was just 2,300. By the time of the 1910 census, the figure had risen to 39,578, and in 1920 it was up to 74,361.

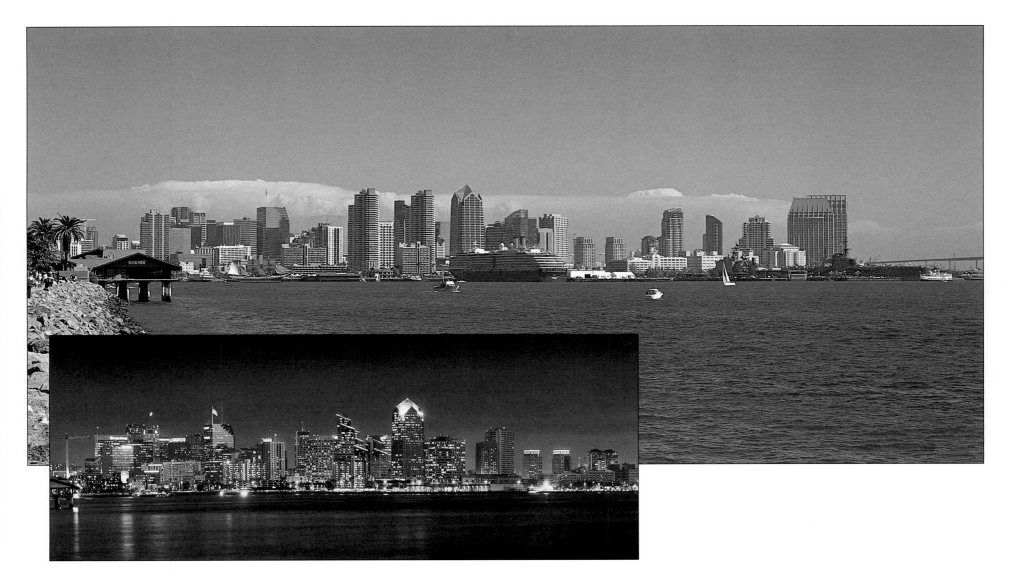

These photos, taken from man-made Harbor Island—a product of harbor dredging in the 1960s—show the changing nature of the city. High-rise apartment complexes and businesses now dominate the skyline, taking over the area once filled with factories and warehouses. Clearly seen on the inset are the green lights outlining the top of the Emerald Plaza, a hexagon-shaped structure with the Wyndham Hotel in the front and office space in the back. Since 1920, the population of the city of San Diego has risen to 1.25 million, making it the seventh-largest city in the country and the second-largest in California. San Diego is a young city; just over half its population is under age thirty-five, and only 10 percent is over sixty-five.

INDEX